CANON EOS REBEL
T6s/760D & T6i/750D

THE EXPANDED GUIDE

CANON EOS REBEL
T6s/760D & T6i/750D

THE EXPANDED GUIDE

David Taylor

AMMONITE
PRESS

First published 2015 by
Ammonite Press
an imprint of AE Publications Ltd
166 High Street, Lewes, East Sussex, BN7 1XU, UK

Text © AE Publications Ltd, 2015
Images © David Taylor, 2015 (unless otherwise specified)
Copyright © in the Work AE Publications Ltd, 2015

ISBN 978-1-78145-221-9

While every effort has been made to obtain permission
from the copyright holders for all material used in this
book, the publishers will be pleased to hear from anyone
who has not been appropriately acknowledged, and to
make the correction in future reprints.

The publishers and author can accept no legal
responsibility for any consequences arising from the
application of information, advice, or instructions given
in this publication.

British Library Cataloging in Publication Data: A catalog
record of this book is available from the British Library.

Editor: Chris Gatcum
Series Editor: Richard Wiles
Design: Robin Shields

Typefaces: Giacomo
Color reproduction by GMC Reprographics
Printed in China

PAGE 2 **«**
The Royal Pavilion,
Brighton, England.

» CONTENTS

1 OVERVIEW

Canon's EOS Rebel T6s/760D and EOS Rebel T6i/750D share many features and are designed specifically for photography enthusiasts who are keen to move up from a smartphone or compact camera.

The EOS Rebel T6s/760D and EOS Rebel T6i/750D were announced on February 6, 2015. Although they have different names, they are essentially the same camera, with a shared basic specification that includes a new, 24.2 megapixel sensor, and a Digic 6 image processor.

The EOS Rebel T6s/760D is slightly more expensive, with a sprinkling of additional features that were previously found on higher-end Canon cameras, such as a top plate LCD and rear control dial. However, you could pick up either camera and create still images or movies with the same ease and with the same image quality. This is testament to the design consistency that Canon has maintained over the years.

Both cameras feature a Hybrid CMOS AF system, which allows the cameras to continuously autofocus when recording movies (when fitted with an STM lens).

Other features include a touch-sensitive LCD screen, which allows you to set many of the camera's functions via the LCD screen, rather than using the physical controls; a range of shooting modes designed for specific shooting scenarios; a 5fps (frames per second) frame rate; and built-in Wi-Fi with a—new for the EOS range—NFC mode.

LCD SCREEN ⌃
The adjustable LCD screen makes it far easier to shoot from a high or low angle.

READY »
The autofocus system is fast and accurate, with 19 AF points that can track movement across the viewfinder.

» MAIN FEATURES

Body

Dimensions (W x H x D):

EOS Rebel T6s/760D:
5.2 x 3.9 x 3.1in (131.9 x 100.9 x 77.8mm)

EOS Rebel T6i/750D:
5.2 x 3.9 x 3.1in (131.9 x 100.7 x 77.8mm)

Weight:

EOS Rebel T6s/760D:
18.3oz (520g) without battery
20oz (565g) with battery

EOS Rebel T6i/750D:
18oz (510g) without battery
19.6oz (555g) with battery

Body materials: Composite material body with aluminum sub-frame

Lens mount: Canon EF/EF-S

Operating environment: 32–104°F (0–40°C) at 85% humidity maximum

Sensor and processor

Sensor: 0.86 x 0.58in (22.3 x 14.9mm)

APS-C format CMOS

Aspect ratio: 3:2

Effective resolution: 24.2 megapixels

Image processor: DIGIC 6

Still images

JPEG resolution (pixels): 6000 x 4000 (L); 3984 x 2656 (M); 2976 x 1984 (S1); 1920 x 1280 (S2); 720 x 480 (S3)

JPEG compression: Fine; Normal (not available when S2 or S3 are selected)

Raw resolution (pixels): 6000 x 4000

Raw format: .CR2 (14-bit)

Raw + JPEG shooting: Yes

Movies

Movie format: MP4

Image compression: MPEG-4 AVC/H.264

Audio compression: AAC

Movie resolution: Full HD (1920 x 1080 pixels at 29.97p, 25p, or 23.98p); HD (1280 x 720 pixels at 59.94p, 50p, 29.97, or 25p); SD (640 x 480 pixels at 29.97p or 25p)

LCD monitor

Type: Touch screen variangle Clear View II TFT

Resolution: Approx. 1.04 million pixels

Size: 3.0in (77mm) diagonal

Live View: Yes

Brightness levels: 7 user-selectable levels

Viewfinder

Type: Eye-level pentamirror

Coverage: Approx. 95%

Magnification: Approx. 0.85x

Eye point: 19mm

Diopter adjustment: $-3-+1m^{-1}$

Note: Includes transparent LCD capable of displaying camera-dependant information

Focusing (viewfinder)

Focus modes: One Shot; AI Servo AF; AI Focus AF; Manual

AF type: Phase detection

Focus points: 19 cross-type AF points that can be selected individually

AF assist beam: Yes

Focusing (Live View)

Focus modes: Face Detection and Tracking AF; FlexiZone-Multi; FlexiZone-Single; Manual

AF type: Hybrid CMOS AF

Magnification: 5x; 10x

Exposure

Modes: Scene Intelligent Auto; No Flash; Creative Auto; Portrait; Landscape; Close-up; Sports; SCN (x6); Program (P); Shutter priority (Tv); Aperture priority (Av); Manual (M)

Metering patterns: Evaluative; Center-weighted average; Partial (approx. 6% of viewfinder at center); Spot (approx. 3.5% of viewfinder at center)

Metering range: EV 1–20 (with 50mm f/1.4 lens, ISO 100)

Exposure compensation: ±5 stops in ⅓- or ½-stop increments

Automatic exposure bracketing: ±2 stops in ⅓- or ½-stop increments (3 shots)

ISO: 100–12,800 (expandable to H: ISO 25,600 equivalent)

Shutter

Type: Electronically controlled, focal-plane shutter

Shutter speeds: 1/4000–30 sec. plus Bulb (mode dependant)

Drive modes: Single; Continuous

Max. frame rate: 5fps

Max. burst depth: 940 shots JPEG (Large/Fine); 8 shots Raw (with UHS-1 SDHC/SDXC memory card)

Self-timer: 2 second; 10 second; 10 second continuous (2–10 shots)

Flash

Built-in flash: GN 39.4ft (12m) at ISO 100

Hotshoe: Yes (compatible with Canon EX Speedlite flashes)

Sync speed: 1/200 sec.

Flash modes: Auto, Manual, Red-eye reduction; 1st/2nd curtain sync; Integrated Speedlite Transmitter

Flash exposure compensation: ±2 stops in ⅓- or ½-stop increments

Memory card

Type: SD, SDHC, or SDXC

Eye-Fi compatible: Yes

Supplied software

Digital Photo Professional (DPP) 4; EOS Utility; Picture Style Editor; EOS lens registration tool; EOS web registration tool; EOS sample music

1 » FULL FEATURES & CAMERA LAYOUT

FRONT OF CAMERA

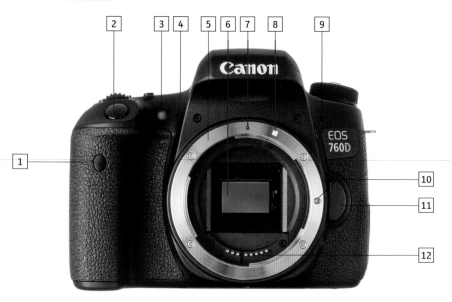

1	Remote control sensor	12	Lens electrical contacts
2	Shutter-release button	13	OFF/ON/Movie shooting switch
3	Red-eye reduction / self-timer lamp	14	MENU button
4	Right microphone	15	**INFO.** button
5	Lens mount	16	LCD screen
6	Reflex mirror	17	Eyecup
7	EF lens mount index	18	Viewfinder eyepiece
8	EF-S lens mount index	19	Display off sensor (EOS 760D/Rebel T6s only)
9	Left microphone	20	Diopter adjustment
10	Lens lock pin	21	Live View / Movie shooting button
11	Lens-release button		

BACK OF CAMERA

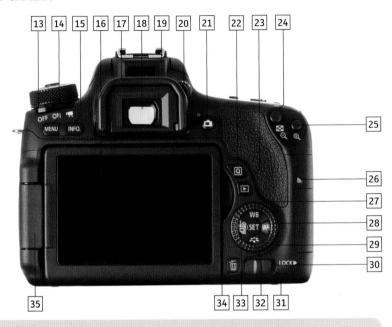

22	Q Quick control button	
23	▶ Playback button	
24	✱ AE/FE lock / ▦ Image index /	
	⊖ Reduce button	
25	⊞ AF-Point selection / ⊕ Magnify	
	button	
26	Access lamp	
27	▲ / White balance selection button	
28	◯ Quick Control dial (EOS 760D/Rebel	
	T6s only)	
29	▶ / AF operation selection button	

30	⚙ Setting button
31	Multi-function lock switch
32	▼ / ✵ Picture Style button
33	◀ / ⊒ Drive mode selection button
34	🗑 Delete button
35	LCD monitor hinge

1 » FULL FEATURES & CAMERA LAYOUT

TOP OF CAMERA

LEFT SIDE

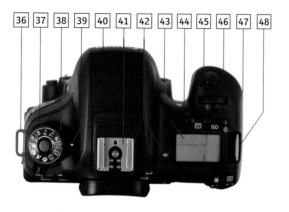

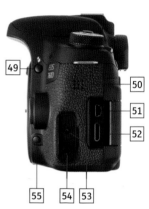

36 Left strap mount	**45** ISO speed setting button	**49** Flash-release button
37 Mode dial	**46** Main dial	**50** Speaker
38 Mode dial lock	**47** LCD illumination button (EOS Rebel T6s/760D only)	**51** Audio/Video out / USB terminal
39 Mode dial index mark		**52** HDMI out terminal
40 Built-in flash	**48** Right strap mount	**53** Remote release terminal
41 Hot shoe		**54** External microphone terminal
42 Focal plane mark		**55** Depth of field preview button
43 Top LCD (EOS Rebel T6s/760D only)		
44 AF area button		

BOTTOM OF CAMERA

RIGHT SIDE

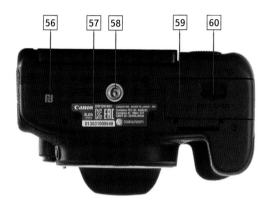

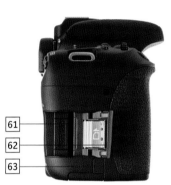

56	NFC mark
57	Information panel / serial number
58	Tripod socket
59	Battery cover
60	Battery cover lock release

61	Memory card slot
62	Memory card cover
63	DC cord hole

1 » PLAYBACK SCREEN

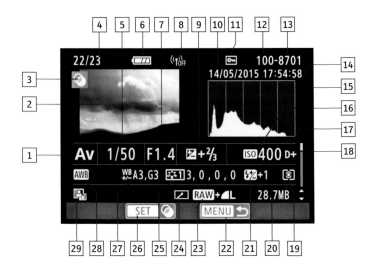

1	Shooting mode	15	Image histogram
2	Image thumbnail	16	ISO setting
3	Creative filters icon	17	Highlight tone priority
4	Image number / Number of images on card	18	Extended information scroll bar
5	Shutter speed	19	Metering mode
6	Battery status	20	Image file size on memory card
7	Aperture	21	Flash exposure compensation
8	Wi-Fi status	22	Menu return indicator
9	Exposure compensation	23	Image recording quality
10	Shooting date	24	Edited image icon
11	Protection icon	25	Picture Style
12	Folder number	26	⑆ indicator
13	Image file number	27	White balance adjustments
14	Time of shooting	28	White balance setting
		29	Auto Lighting Optimizer

» LIVE VIEW

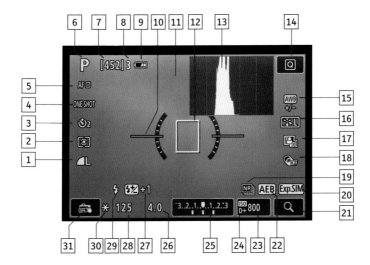

1 Image quality	**13** Histogram	**25** Exposure level mark / AEB range
2 Exposure metering mode	**14** Quick Control	**26** Aperture
3 Drive mode	**15** White balance setting	**27** Flash exposure compensation
4 AF mode	**16** Picture Style	
5 AF setting	**17** Auto Lighting Optimizer	**28** Shutter speed
6 Exposure mode	**18** Creative filters	**29** Flash mode indicator
7 Possible shots	**19** Multi-shot noise reduction indicator	**30** Exposure lock
8 Maximum burst		**31** Toggle touch shutter on/off
9 Battery status	**20** Exposure simulation	
10 Electronic level (EOS Rebel T6s/760D only)	**21** Magnify view	
	22 AEB/FEB indicator	
11 Main Live View image	**23** ISO setting	
12 Focus point	**24** Highlight tone priority	

1 » VIEWFINDER

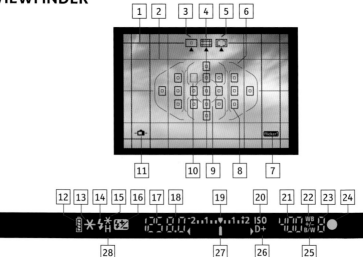

1	Aspect ratio guides	14	Flash ready indicator
2	Grid lines	15	Flash FE lock / FEB in progress
3	Single AF point indicator	16	Flash exposure compensation
4	Zone AF indicator	17	Shutter speed / FE lock (FEL) / Busy (buSY)/ Built-in flash recycling (buSY) / Multi function lock warning (L) / Card full warning (FuLL) / Card error & No card warning (Card) / Error code (Err)
5	19-point automatic selection AF indicator		
6	AF area frame		
7	Flicker warning		
8	Inactive focus point		
9	Spot metering circle	18	Aperture
10	Active focus point	19	Standard exposure index
11	Electronic level (EOS Rebel T6s/760D only)	20	ISO indicator
12	Battery check	21	Selected ISO speed
13	AE lock / AEB in progress		

22	White balance correction warning
23	Maximum burst indicator
24	Focus confirmation indicator
25	Monochrome Picture Style warning
26	Highlight tone priority
27	Exposure level mark (also used to display: Exposure level indicator / Exposure compensation amount / AEB range / Red-eye reduction lamp-on indicator)
28	High-speed flash indicator

QUICK CONTROL SCREEN

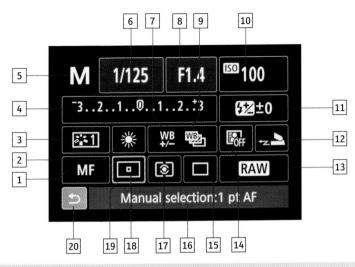

1 Focus mode	**13** Image quality setting
2 White balance setting	**14** Auto Lighting Optimizer
3 Picture Style	**15** Drive mode
4 Exposure level indicator / AEB range / Exposure compensation	**16** Quick Control description panel
5 Shooting mode	**17** Metering mode
6 Shutter speed	**18** AF area selection mode
7 White balance compensation	**19** Currently selected Quick Control indicator
8 Aperture	**20** Exit Quick Control touch button
9 White balance bracketing	
10 ISO setting	
11 Flash exposure compensation	
12 Flash settings	

1 » TOP LCD PANEL (EOS REBEL T6S/760D ONLY)

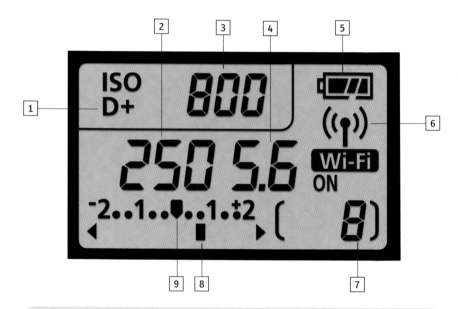

1 Highlight tone priority

2 Shutter speed / FE lock (FEL) / Busy (buSY) / Built-in flash recycling (buSY) / Multi function lock warning (L) / Card full warning (FuLL) / Card error & No card warning (Card) / Error code (Err) / Cleaning sensor (Cln)

3 ISO setting

4 Aperture

5 Battery status

6 Wi-Fi status

7 Possible shots / Self-timer countdown / Bulb exposure time elapsed / Possible shots during WB bracketing / Error number

8 Exposure level indicator / Exposure compensation amount / AEB range

9 Standard exposure index

» COLOR

Successful photography means being open to seeing potential shots everywhere. This includes looking up above your head or down at your feet. If you don't, you may miss the opportunity for an interesting—and often unusual—image.

Settings
> Focal length: 22mm
> Aperture: f/16
> Shutter speed: 0.8 sec.
> ISO: 100

2 FUNCTIONS

The EOS Rebel T6s/760D and EOS Rebel T6i/750D share many design features with Canon's other DSLRs. Although this may sound conservative on Canon's part, it makes it easy to swap between different models in the range.

If you have not used a Canon DSLR before, this chapter will be of particular interest. We will work through the various controls of your camera, starting with the basic principles, before moving onto the nitty-gritty of using the EOS Rebel T6s/760D and EOS Rebel T6i/750D.

However, if you're reasonably familiar with Canon DSLRs you may want to skip the first half of this chapter and move straight to the more detailed explanations of the cameras' functions.

In either case, current Canon DSLRs have benefited from the experience that Canon has gained over many decades of making cameras. Ergonomically, the bodies of both the EOS Rebel T6s/760D and EOS Rebel T6i/750D have buttons and dials that are logically laid out and fall easily to hand. If you've moved to Canon from another camera system you may find that it takes time to adjust, but once you have, you might well wonder why all cameras aren't designed the Canon way.

TWO CAMERAS ⌃
Although the design of the EOS Rebel T6s/760D and EOS Rebel T6i/750D differs slightly, at heart they are essentially the same camera.

SUNBURST »
Some photographic opportunities are fleeting; being able to use your camera without dithering means you won't miss those opportunities.

2 » CAMERA PREPARATION

› Attaching the strap

Having invested in a new camera, the last thing you want to do is to drop it. The simplest way to minimize this risk is to fit the supplied neck strap. You can then wear your camera around your neck or wrap the strap securely around your wrist.

To attach the strap, pull one end of the strap out of the attached buckle and plastic loop, and then feed it through either the right or left strap mount on the side of the camera. Feed this end back through the plastic loop and then under the length of strap that is still in the buckle. Pull the end of the strap so that it fits snugly in the buckle. For safety, allow at least 2in (5cm) of strap to extend beyond the buckle. Repeat the process on the opposite side of the camera.

› Using the viewfinder

Composing and shooting with the eye-level viewfinder is the recommended way of using your camera, although you can also shoot using the LCD with the camera set to Live View. However, there are certain disadvantages to this approach—a more rapid depletion of the camera's batteries being the main one.

The main downsides to using the viewfinder are its tunnel-like view and

EYESIGHT ⌃
The focus (or diopter) of the viewfinder can be adjusted to compensate for individual variations in eyesight. To adjust the diopter, look through the viewfinder and move the wheel up or down until the display at the bottom of the viewfinder is sharp.

the fact that it only shows you 95% of the scene. This latter fact means that compositions will be less accurate, so you may need to crop your images slightly in postproduction to reproduce exactly what you saw at the time of shooting.

> **Note:**
> Using Live View and holding your camera at arm's length is not ideal when it comes to keeping the camera steady. Using the viewfinder—with the camera against your face—makes it far easier to hold your camera still.

› Fitting and removing a lens

One of the key selling points of Canon's EOS camera range is the large choice of lenses that can be fitted to the cameras. The first Canon lens you'll own is likely to be the kit lens supplied with your camera. However, you may soon find you want to add more lenses to your collection.

To fit an EOS lens, first switch off your camera. Next, hold the camera with the front facing toward you. Remove the body cap (or lens if one is already fitted) by pressing the lens-release button in fully and turning the cap to the left until it comes free easily.

Remove the rear protection cap from your lens. If you're fitting an EF-S lens (such as the kit lens), align the white index mark on the lens barrel with the one on the camera lens mount. If you're fitting an EF lens, align the red mark on the lens with the red mark on the camera lens mount. Then, holding the solid part of the lens, gently push it into the lens mount until it will go no further and turn the lens to the right until it clicks into place. To remove a lens, reverse this procedure.

DON'T LINGER »
Change lenses as quickly and smoothly as possible. This is particularly important in dusty environments.

If you're not fitting another lens immediately, replace the body cap on the camera and fit the rear cap onto the lens you've just removed. See chapter 4 for more information about lenses.

2 » POWERING YOUR CAMERA

› Battery charging

Before you use your camera you must first fully charge the supplied LP-E17 battery. Remove the cover from the battery and slide it in and then down into the supplied LC-E17 or LC-E17E charger so that the word "Canon" is in the same orientation on both the charger and battery.

Connect the LC-E17 charger to the AC power cord and insert the plug into a wall socket, or plug the LC-E17 charger directly into a wall socket after flipping out the power terminals. The charge lamp will glow orange. When charging is complete, the full-charge lamp will glow green (a fully depleted battery will take approximately two hours to recharge).

Once the battery is charged, unplug the charger from the wall socket and remove the battery by pulling it up and out from the charger. An icon on the rear LCD screen shows the current charge status of the battery (above right).

When fully charged, the battery should power your camera for approximately 550 shots when you use the viewfinder to compose your photographs (reducing to 440 shots with 50% flash use), or 180 shots when using Live View. These figures will be lower when shooting in cold conditions.

Battery charge indicator

▉▉	Battery adequately charged
▉	Battery less than half charged
▉	Battery almost depleted
☐	Battery fully depleted

Notes:
The battery use figures given (left) are based on CIPA standards. CIPA is the Camera & Imaging Products Association, a Japanese group of camera equipment manufacturers of which Canon is a member.

You can also power your camera using Canon's ACK-E18 AC adaptor kit (sold separately). This is useful when using your camera to display images or movies on a TV or when transferring a large number of files to your computer or printer.

› Inserting and removing the battery

To insert the battery, make sure that the camera is switched off and turn it upside-down. Push the battery cover release lever toward the front of the camera and the cover door should open easily.

With the battery contact terminals facing down and toward the front of your camera, push the battery into the compartment with the side of the battery pressing against the gray lock lever as you do so. Once the battery has clicked into place, close the battery cover.

To remove the camera battery, push the lock lever away from the battery and gently pull it out.

› Battery life

The LP-E17 battery supplied with your camera is a rechargeable lithium-ion unit. Lithium-ion, or Li-ion, batteries are small and lightweight for their power capacity, but will deplete slowly over time, even when removed from your camera. It's therefore a good idea to recharge the battery fully on the day of use.

Your camera's LP-E17 battery is rated for approximately 500 to 800 charge cycles before it needs replacing. A charge cycle is when 100% of the battery's power is used

and then recharged. However, this does not mean the battery needs to be discharged completely before recharging—using 25% of the charge in the battery, recharging it, and then repeating this three more times would complete one full charge cycle. Indeed, recharging frequently—before the battery is completely depleted—will actually prolong the life of your battery.

> **Note:**
> The ambient temperature has a significant effect on the efficiency of a battery. Cold conditions will cause your battery to deplete more quickly than usual, so it's worth carrying a fully charged spare battery with you on days when the temperature is close to freezing.

AUTHENTIC　　　　　　　　　　　　　　　　　❯
Canon batteries feature a distinctive hologram to confirm their authenticity.

Practice makes perfect, and time spent familiarizing yourself with the controls of your EOS Rebel T6s/760D or EOS Rebel T6i/750D will be time well spent—you don't want to miss a shot because you were trying to find the right button.

› Dials and buttons

The EOS Rebel T6s/760D and EOS Rebel T6i/750D are ergonomically designed, with the various buttons and controls on the camera body positioned in a logical and intuitive way.

Throughout this book, these buttons and controls will be referred to by shortcut symbols. To use the various menus and functions (assuming you're not using the touchscreen) you'll mostly use the Main dial ⚙ and the direction buttons. The individual direction buttons will be shown as ◀ (left), ▲ (up), ▼ (down), and ▶ (right). If any of these four buttons can be used (such as when moving the focus point around the LCD), you will see ✛.

The Setting button, or (SET), is used to select a function or menu choice, and on the EOS Rebel T6s/760D you also have a ◯ Quick Control dial.

Other buttons on the cameras will be referred to by their name or relevant symbol; when you come across words in bold type these signify options that are visible on a menu screen.

In shooting mode, you can switch between several different screens of shooting information on the LCD by repeatedly pressing **INFO.**. This applies whether you're using the viewfinder or Live View. Pressing **INFO.** in playback mode will cycle through a series of screens showing varying degrees of information about the currently displayed image.

Freespace	6.60 GB
Color space	sRGB
WB Shift/Bkt.	0,G3/±0
🗀 Enable	🚶 Standard
🗁 Enable	👁 Enable
🔋 4 min.	🔌 On🗀🖳
📣 Disable	🔲 Enable
✳ 16/05/2015 13:02:15	

INFORMATION «

In shooting mode, press **INFO.** once to view a screen showing a summary of various camera settings.

› Switching the camera on

The power switch is found to the right of the Mode dial. Switched to OFF, the EOS Rebel T6s/760D and EOS Rebel T6i/750D are inactive.

When the power switch is set to ON, the access lamp will flicker briefly and automatic sensor cleaning will be activated. Your camera is then ready to shoot still images. Move the power switch to '🎥 to begin shooting movies.

› The LCD screen

Looking at the information strip at the bottom of the viewfinder is a quick and simple way to see the current shooting settings. More detailed information can be found on the rear LCD screen. This includes information such as the currently selected shooting settings, a Live View display that displays a live image directly from the camera's sensor (optional when shooting still images or automatically selected when shooting movies), a comprehensive menu system, and the camera's playback function that enables you to review your images.

POWERED DOWN　　　　　　**»**
If you leave your camera switched on, it will eventually enter "sleep" mode to preserve battery power.

The LCD is hinged and can be rotated so that it faces into the camera. This is useful for protecting the screen when you're not using your camera. To view the LCD, first pull it out from the camera 180° and then rotate it forward, toward the front of the camera a further 180°. Push the screen back into the camera so that it fits snugly with the screen facing outward. The LCD can be set at any angle, which is useful if you want to shoot from close to the ground or above head height.

› Using the touchscreen

The rear LCD screen on both the EOS Rebel T6s/760D and EOS Rebel T6i/750D is touch-sensitive. This means that you can bypass many of the buttons or dials when setting camera functions.

There are three ways to use the touchscreen. The first method is to simply touch an on-screen option to select it. This

is mainly useful when using the menu system or screen. When **OK** or **Cancel** is displayed on screen you can touch either to confirm or reject a particular setting.

If you are using Live View, you can touch the screen to set the position of the focus point. Depending on how **Touch Shutter** on the ◻ menu is set, this will either focus the lens, or focus and fire the shutter. Whenever arrows are displayed on screen you can touch these to make alterations to settings in much the same way as using the ✛ buttons.

The second way to interact with the LCD is to slide your finger across or up and down the screen. This action is used to adjust on-screen sliders, such as exposure compensation, or—when viewing images in playback—to quickly skip through images on the memory card.

The third way to interact with the LCD is to use two fingers and either bring them together or pull them apart. This action can be used to zoom out or in respectively when viewing images.

> ### Tips
>
> *You cannot use the touchscreen when wearing normal gloves. Either wear fingerless mittens or invest in a pair of touchscreen gloves that mimic the electrical conductivity of your fingers.*

EXPANDED
Pull your fingers apart to smoothly zoom into a still image during playback.

› Date/Time/Zone

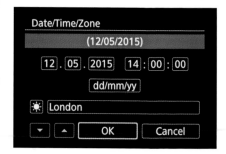

When you first switch on your camera you will be prompted to set the correct date and time. It is important not to skip this step, even though it's tempting to start shooting immediately. This is because every shot you take has the shooting date and time embedded into the image's metadata.

Metadata is non-image data that can be used to store information such shooting time and the exposure settings used. This can be read and displayed by image-editing software once an image has been copied to a computer, and can be used to find and sort images, amongst other things.

Setting the date and time for the first time

1) Turn your camera on.

2) Press ◄ / ► to highlight the date or time value you want to alter, and then press ⑤ET. Press ▲ / ▼ to change the value followed by ⑤ET to confirm your selection.

3) Press ◄ / ► to highlight ☀️. Press ⑤ET to set whether a daylight-saving adjustment needs to be made to your time setting. When ☀️ is displayed, the time is advanced by one hour. Press ⑤ET.

4) Press ◄ / ► to highlight the time zone box and press ⑤ET. Press ▲ / ▼ to find your current time zone. Press ⑤ET to confirm your selection.

5) Press ◄ / ► to highlight **OK**, and press ⑤ET to save your new settings. Alternatively, highlight **Cancel** and press ⑤ET to exit without saving.

Notes:
If you want to alter your date and time settings at any time, press MENU to navigate to ♀ and select **Date/Time/Zone**.

If you don't set the date and time when you first power up your camera you will be prompted to do so every time you turn the camera on subsequently.

You can also use the touchscreen to set the time and date.

2 » MEMORY CARDS

› Inserting and removing a memory card

Before you can begin shooting, you need to install a memory card to store your images and movies. Both the EOS Rebel T6s/760D and EOS Rebel T6i/750D use readily available SD (Secure Digital) memory cards, and both cameras are compatible with Eye-Fi cards. This is a proprietary type of SD memory card that has a built in Wi-Fi transmitter, allowing you to copy files wirelessly from your camera to a computer (see chapter 8 for more details).

Fitting and removing a memory card

1) Make sure your camera is switched off, and open the memory card cover on the right side of the camera.

2) With the memory card contacts facing into and toward the front of your camera, push the card into the slot until it locks with a click. Close the memory card cover.

3) To remove the memory card, push it into the slot slightly until you hear a click. The card should now come free. Pull it out gently and close the memory card cover.

› Preparing a memory card

Most SD memory cards are pre-formatted, but it's good practice to format a memory card when it is first used in your camera. This is also important if a memory card has been used in another camera previously. Any files saved by another camera may not be visible to your camera, yet they will still take up space on a memory card.

Notes:
If your memory card has a write-protect tab, slide the tab to the "unlocked" position. If the card is locked, *Card's write protect switch is set to lock* will appear on the LCD and you will not be able to take any photographs. Locking the card will help to ensure that images are not erased accidentally.

If there is no memory card in the camera, it's still possible to shoot photos by setting **Release shutter without card** to **Enable** on the ○ menu. However, even though you can fire the shutter, your photographs will not be saved. See chapter 8 for a use for this function.

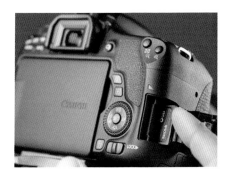

SMOOTHLY　　　　　　　　⌃
The memory card should slide in smoothly—
if it sticks, don't try to force it.

Formatting a memory card

1) Press MENU and navigate to ⚐. Highlight
Format card and press ⒮⒠⒯.

2) Highlight **OK** and press ⒮⒠⒯ to begin
formatting the card, or highlight **Cancel**
and press ⒮⒠⒯ to return to the ⚐ menu.

3) As the card formats, *Busy...Please wait*
will be displayed on screen. Once
formatting is complete, the camera returns
automatically to the ⚐ menu screen.

Note:
In order to keep track of what's
on a memory card, a camera looks
at a list of contents on the card
(this list of contents is updated
every time you add or remove an
image). When a card is formatted,
only the list of contents is altered
(effectively resetting it to zero).
This means that the images remain
on the memory card, but the
camera cannot "see" them and so
ignores them. As you create more
images, these leftover files are
gradually overwritten.

　If you accidentally format a
memory card, you can often
recover these hidden files with file-
recovery software, provided you
don't use the card before then. To
erase a memory card completely—
so the images cannot be
recovered—you need to select **Low
Level Format** (on the **Format card**
menu screen). It takes the camera
longer to format the memory
card when you use this option, but
it is worth doing every so often,
particularly if you shoot video.

　To select **Low Level Format**, press
⑪ when you first enter the **Format
card** screen. A ✓ will be displayed
next to **Low Level Format** to show
that it has been chosen.

The basic SD memory card specification has improved since the introduction of the standard in 1999. To track these changes, the name SD is followed by a two-letter suffix—the latest variant is SDXC, which is available in sizes up to 256GB.

There is a wide range of SD cards available, so it can be confusing searching for one that suits your needs. The two basic factors that need to be taken into account when buying a memory card are capacity (the size of the card in gigabytes or GB) and speed (the read/write speed, which is how quickly data can be transferred to and from the card). The general rule is that the higher the capacity and the faster the card, the more expensive it will be.

The greater the capacity of a card, the more images or video clips you will be able to fit onto it. This is important, especially if you shoot a lot of video, which typically generates large files.

As video files involve writing a lot of data to the memory card, you may also want to buy a fast card. This also applies if you need to shoot long bursts of still images (when shooting sports, for example). However, if your photography is not so speed dependent (if you mainly shoot landscapes, for example), you may find that you can compromise on the speed, in order to buy a higher capacity memory card.

The speed of an SD memory card is often shown as a Class Rating: the higher the Class Rating, the faster the card. The speed is also sometimes shown as a figure followed by an "x," which refers to the speed of the card compared to the read/write speed of a standard CD-ROM drive. Canon recommends a Class 6 (or 40x) memory card or higher for shooting video.

Warning!

When the access lamp on the back of your camera is flashing, it means the camera is either reading, writing, or erasing image data on the memory card. Do not open the memory card cover—or remove the card or the battery—when the lamp is flashing. Doing this may cause data on the card to be corrupted, and potentially damage your camera.

Note:
You can also use UHS-1 (Ultra High Speed) SD memory cards. UHS-1 memory cards have a data transfer rate of 104 Mb/s, which is far faster than the minimum required for shooting video.

⬫ LIVE VIEW

Live View lets you use the LCD on the rear of your camera to compose and focus your images. When you switch to Live View, the mirror inside the camera is flipped up (blocking the viewfinder), the shutter is opened, and a live feed from the sensor is directed to the LCD.

Live View has several advantages over using the viewfinder: you can see exactly how adjusting functions such as Picture Style will affect your image before you take a shot, and you can also see a reasonable simulation of the final exposure when **Exp. SIM** is colored white on the LCD. If the image on the LCD is displayed at a different brightness to the final exposure, **Exp. SIM** will blink, or if the final exposure cannot be simulated (when you're using flash, for example) **Exp. SIM** will be grayed out.

Another advantage of Live View is that you can see 100% of the image you will be recording, compared to the viewfinder's 95% view. However, it pays to keep the LCD display as clear as possible, particularly when you frame your shots (you don't want important details in a scene hidden by an on-screen icon). Pressing the **INFO.** button will allow you to switch between different levels of overlaid information.

There are downsides to Live View, though. The main one is that it's more difficult to hold a camera steady at arm's length, which increases the risk of camera shake. Using Live View will also deplete your camera's batteries more quickly than when you use the viewfinder.

> **Notes:**
> Pressing 🔲 toggles the Live View Quick Control options on the LCD.
>
> A Live View histogram can be displayed showing the tonal range of a scene before shooting. Press **INFO.** until the histogram is displayed.

FRAMING　　　　　　　　　　　　　　☆
The 5% difference in the framing of an image between the viewfinder and Live View may sound small, but it's enough that you may miss an important detail at the edge of the frame when using the viewfinder. The yellow border on the image above shows the difference.

Using Live View

1) With the power switch set to ON, press ◻️. The mirror inside the camera will rise and the Live View image will be displayed on the LCD.

2) Move the white focus point rectangle around the LCD by pushing ✛, or touch the LCD where you'd like the focus point to be set. Pressing (SET) will center the focus point again.

3) Press the shutter-release button halfway down to focus. Once the camera has focused, press the shutter-release button down fully to take the shot.

Notes:
Live View functions can be adjusted either on the ◻️ menu (see chapter 3) or by using the Q screen.

Using Live View above assumes that **AF method** on the ◻️ menu is set to **FlexiZone-Single**.

Live View can be disabled entirely by setting **Live View shooting** on the ◻️ menu to **Disable**.

You can magnify the Live View image by 5x or 10x: press ⊕ to magnify the Live View image 5x; again to magnify it 10x; and once more to restore the display to normal. Magnifying the Live View image is particularly useful for checking critical focus in the scene. Use ✛ or touch the arrows on the LCD screen to pan around the magnified image if desired.

DOUBLE DUTY ««
The ◻️ button is also used to start recording movies when the power switch is set to 🎥.

» THE SHUTTER-RELEASE BUTTON

Your camera's shutter-release button has two separate stages. The first is activated when you press the shutter-release button lightly halfway down—the camera's AF and camera metering are activated (cancelling playback mode automatically).

What happens next depends on the AF mode selected (see page 39). If the AF system is set to One Shot AF, the camera focuses and the exposure and focus point are locked. They remain locked unless you release the shutter-release button.

In AI Servo AF mode, neither the exposure nor focus are locked until the shutter-release button is depressed fully and the photograph taken.

Finally, using AI Focus AF results in a hybrid of the two systems—focus is initially locked when the shutter-release button is pressed down halfway, but if the subject begins to move, the focus will "unlock" automatically and track the movement. In each instance, press down fully on the shutter-release button to take a shot.

If you keep you finger pressed down on the shutter-release button, and the drive mode is set to Single shooting ☐, the shutter will fire once. If you want to shoot again the shutter-release button must be released fully and then pressed

down once more. However, if the drive mode is set to Continuous shooting ⊒ᵢ, your camera will continue firing at the maximum possible frame rate until either the memory card or the buffer is full, or you release the shutter-release button.

> **Note:**
> When you use Live View, the shutter is open all the time. When you take a shot, the shutter has to close briefly, before opening again to start the exposure. The shutter then closes to end the exposure, before opening once more to resume Live View. The extra opening and closing of the shutter makes shooting in Live View slightly slower than when using the viewfinder.

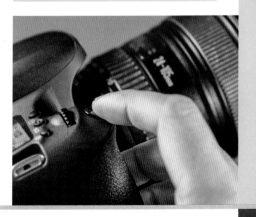

GENTLES DOES IT　　　　　　　　»
GENTLY DOES IT　　　　　　　　»
Don't jab at the shutter-release button—press it down smoothly, but firmly.

2 » QUICK CONTROL MENU

Your camera's menu system (see chapter 3) can be used to make changes to the way your camera functions, but you don't always need to delve into the menus to make certain changes. The Quick Control menu (activated by pressing the [Q] button located at the right of the LCD) is a useful shortcut. The available options vary depending on whether you're using a Basic or Creative Zone shooting mode, or whether you're viewing images or movies.

There are two ways to use the Quick Control menu. The first is to press ✚ to highlight the required option and then press (SET) to view a detailed option screen where changes can be made. Alternatively, with the option highlighted on the Quick Control screen, turn 🖮 to make the desired change.

Quick Control shooting options	Comments
Shutter speed	**Tv/M** modes only.
Aperture	**Av/M** modes only.
Highlight tone priority	Not Basic Zone modes.
ISO	Not Basic Zone modes.
Exposure compensation	Not **M** or Basic Zone modes.
Auto exposure bracketing	Not Basic Zone modes.
Flash exposure compensation	Not Basic Zone modes.
Picture Style	Not Basic Zone modes.
White balance	Not Basic Zone modes (except 🐦, 🏔, 🌷, and 🏃).
White balance correction	Not Basic Zone modes.
White balance bracketing	Not Basic Zone modes.
Auto Lighting Optimizer	Not Basic Zone modes. Disabled when Highlight tone priority is activated.
Built-in flash settings	Not Basic Zone modes (except basic control options in 🐦, 🏔, 🌷, and 🏃).
AF mode	Not Basic Zone modes. MF only when lens is set to manual.
AF area selection	Not Basic Zone modes.
Metering mode	Not Basic Zone modes.
Drive mode	–
Image quality	–

» DRIVE MODE

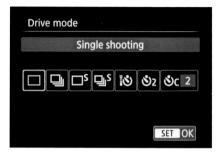

The drive mode determines whether your camera shoots one frame and then stops (Single shooting ☐) or shoots multiple frames at up to 5fps if you hold the shutter-release button down (Continuous shooting ☐). You can also select variations of these two modes: Silent single ☐ˢ and Silent continuous ☐ˢ. These two drive modes muffle the noise of shooting in exchange for a slight drop in responsiveness as you press the shutter-release button (and a reduction to 3fps in ☐ˢ).

There is also a choice of three self-timer modes that fire the shutter-release button after a short delay: ⏱ (10-second delay); ⏱2 (2-second delay); and ⏱c (up to 10 shots fired after a 10-second delay).

Your camera has a built-in frame buffer, where images are temporarily stored until they have been written to the memory card. If you shoot using ☐ or ☐ˢ the buffer will gradually fill up to a point where the camera can no longer continue

shooting. This is most likely to happen when you're shooting Raw+JPEG, as the camera needs to process large amounts of data.

When the frame buffer is full, the maximum burst indicator in the viewfinder will show *0*, and *buSY* will flash up. When this happens, you won't be able to shoot any more images until the frame buffer is sufficiently clear and the queue of files is written to the memory card.

Notes:
When your camera is set to ☐ or ☐ˢ the maximum achievable frame rate will depend on the write speed of your memory card and the shutter speed.

The drive mode can be set either by pressing ◄, or via the Quick Control menu.

Using the self-timer is most useful when your camera is mounted on a tripod. It can also help reduce the risk of camera shake with a tripod-mounted camera.

2 » FOCUSING

There are two methods of focusing the lens attached to your camera. You can either use manual focus (MF) and physically turn the focus ring of the lens until focus is achieved, or you can allow the camera's autofocus (AF) system to set the focus distance. All Canon EOS lenses have an AF/MF switch on the lens barrel so you can quickly switch between AF and MF.

It's easy to believe that MF is a redundant option, but no AF system is perfect and there are situations when it can get confused and fail to operate correctly. AF can struggle when ambient light levels are low, for example, or when there is insufficient contrast in a scene. In these situations the lens may start to "hunt" and fail to lock the focus, requiring you to step in and manually focus the lens.

Using MF (viewfinder)

With the lens set to MF, hold the shutter-release button down halfway and rotate the focusing ring on the lens to focus. When the subject is in focus, the green ● confirmation light is displayed in the viewfinder, the relevant AF points flash red, and the camera beeps.

› Autofocus modes (Viewfinder)

The EOS Rebel T6s/760D and EOS Rebel T6i/750D have three AF modes to choose from when you use the viewfinder. To choose the AF mode, set the lens to AF and press ▶, or press Q to select the required AF mode from the Q screen.

Warning!

Ring-type USM lenses can be adjusted manually, even when the focus switch on the lens is set to AF. However, do not turn the focusing ring on a non-USM lens when the focus switch is set to AF, as this may damage the AF motor in the lens.

SWITCH TO MF ⌃
If you use autofocus, and want the focus to stay locked when you press down on the shutter-release button, simply switch to MF once the focus has been set.

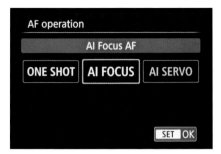

One Shot AF

One Shot AF is designed for shooting static subjects. After you've pressed down halfway on the shutter-release button, the focus and exposure will be locked and confirmed by ● lighting green in the viewfinder. If you keep the shutter-release button held down halfway, it is possible to recompose your shot without the focus or exposure altering. If focus cannot be confirmed, ● will blink and you will not be able to fire the shutter. Pressing the shutter-release button down fully makes the exposure.

AI Servo AF

AI Servo AF is the AF mode to choose when you are shooting fast-action subjects. If you hold the shutter-release button down halfway, the AF system tracks your subject, keeping it in focus (providing it remains with the diamond shape formed by the AF points). Neither focus nor exposure is set until you press the shutter-release button

down fully. If the AF selection point is set to 19-point automatic selection, the central point is used to begin focusing, but the camera will automatically switch to one of the other points as movement is tracked. ● does not light in AI Servo AF mode.

AI Focus AF

This mode is a cross between One Shot AF and AI Servo AF. AI Focus AF starts in One Shot AF mode, but then switches to AI Servo AF if the subject begins to move— as long as you keep the shutter-release button pressed down halfway.

When focus has switched to AI Servo AF, the beeper will sound very softly (and continuously) as focus is tracked.

Although AI Focus AF sounds like a good compromise between One Shot AF and AI Servo AF, in practice it's marginally slower to start tracking movement, so if you are certain your subject will move, it is better to use AI Servo AF instead.

> ### Notes:
> The AF mode is selected automatically when the camera is set to a Basic Zone mode.
>
> If **Beep** is set to **Enable** (via the □ menu) the camera will also beep to confirm focus In One Shot AF mode.

When you look through the viewfinder you will see a flat diamond shape, within which are 19 squares—these are the camera's focus points. When the camera focuses, at least one of these points is used to determine the camera-to-subject distance and focus the lens accordingly.

All of the AF points are "cross-type," which means they can detect both vertical and horizontal lines when focusing. However, this capability degrades when you fit a lens with a maximum aperture smaller than f/5.6 (or use a teleconverter that effectively reduces the maximum aperture). Then, the outer AF points lose their ability to detect either horizontal or vertical lines depending on the location of the AF sensor. This results in a reduction of focusing speed and accuracy. AF speed and accuracy also degrades in low light, and the problem is compounded when shooting in low light with a lens that has a small maximum aperture.

By far the most effective focus point is the central point. Use a lens with a maximum aperture of f/1.0–f/2.8 and the vertical line detection of the central point becomes even more precise. This is also the AF point to use when shooting with a lens with a small maximum aperture and/or in low light, when the outer AF points may start to struggle.

Notes:
AF point selection is only available when using a Creative Zone mode.

You don't need to set the lens to its maximum aperture to focus—the lens is held open at its maximum aperture setting until you make your exposure.

See chapter 3 for details about custom functions that enable you to configure the AF further.

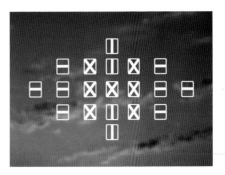

AF/LENS CHOICE ⌃
Use a lens with a maximum aperture smaller than f/5.6 and the outer eight AF points will only be able to detect horizontal lines, while the central top and bottom four AF points will detect vertical lines only.

› Selecting the AF point

When using a Creative Zone mode, your camera can focus using any one (or more) of the AF points. The AF points can be selected individually, as areas referred to as zones, or automatically by your camera. To switch between the three selection options press ⊞ or ⊞ until the desired selection method is highlighted in the viewfinder.

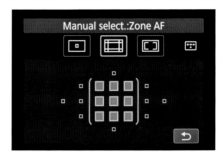

⊞ Manual select.: Zone AF

In this mode, the AF area is divided into five zones, as outlined on the following page.

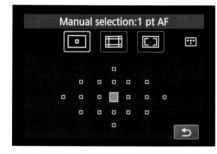

⊡ Manual selection: 1 pt AF

Select ⊡ and you can manually select any one of the 19 AF points, either by turning ⊙ to move the selection horizontally, or by holding down Av⊠ and turning ⊙ to move the selection vertically (turn ⊙ on the EOS Rebel T6s/760D). To quickly select the central AF point press ⊛. This mode is ideal when you need to focus on an off-center subject.

⊡ Auto selection: 19 pt AF

Set to this mode, any or all of the AF points will be used automatically for focusing. When One Shot focus is used, the AF point(s) that achieve focus will light. When AI Servo focus is selected, the first manually selected AF point will be used to begin focusing. Focusing will then automatically switch to the other points as subject movement is tracked.

Manual select.: Zone AF

When you select one of the zones in **Manual select.: Zone AF**, any or all of the AF points in that zone will be used automatically for focusing. Zone AF can be especially useful for shooting action images, when you're confident your subject will enter the selected zone and will also be the closest element in the scene.

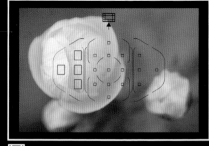

Zone AF: Zone 1

Zone AF: Zone 2

Zone AF: Zone 3

Zone AF: Zone 4

Zone AF: Zone 5

› Live View Autofocus

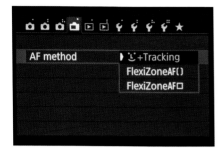

When you switch to Live View, you have the choice of using one of three AF modes. You can choose the mode either by selecting it from the View ◻ menu or by pressing [Q]. Live View AF isn't as quick to focus as using the viewfinder; depending on the subject and its distance to the camera the AF system may take a second or so to lock on to your subject (especially if there's a marked difference between the distance the lens is set and the subject distance). One way to reduce the focusing time is to **Enable** the **Continuous AF** function on the ◻ menu.

ꭎ+Tracking (AF ꭎ ⚏)

AF ꭎ ⚏ is the default Live View AF mode. Its main function is to find and focus on any face within the image frame. The tracking part of the name indicates that if your subject moves, the AF system will track their face (as long as they don't move too fast or out of the frame completely).

When **AF ꭎ ⚏** is activated, your camera will draw a white focus frame ⌐⌐ around the first face it detects. If there are a number of faces in the shot, the focus frame will change to ⟨ ⟩. Move this frame to the target face by pressing ◄ / ► (or tap on the face you want to focus on) and press the shutter-release button down halfway to focus.

Once focus has been achieved, the target box will turn green; press the shutter-release button down fully to take the shot. If a face cannot be detected, the AF system will switch automatically to FlexiZone-Multi.

> **Notes:**
> See pages 116–117 for details of the Live View menu options.
>
> One difference between the EOS Rebel T6s/760D and EOS Rebel T6i/750D is that the latter model has far better AF tracking performance between frames when shooting using ꭎ.
>
> ꭎ+Tracking is shown as **AF ꭎ ⚏** when selecting the AF method using the [Q] menu.

the center of the screen. You can move the AF point around the screen using ✛ (pressing ⓢⓔⓣ will quickly re-center the AF point again).

If **Continuous AF** is set to **Disable**, press down halfway on the shutter-release button to focus. The AF point will turn green when focus is achieved.

FlexiZone–Multi AF()

AF() divides the image space into either 49 AF points that are selected automatically by the camera, or nine larger AF zones that you can select manually. The default option is automatic selection.

If **Continuous AF** is set to **Disable**, press down halfway on the shutter-release button to focus. The automatically selected point (or points) will be shown as green boxes when focus is achieved.

To switch to zone selection, press ⓢⓔⓣ or 🗑. Zone selection allows you to choose which area of the image is focused—to jump between the nine zones press ✛ or touch the LCD screen in the required area.

FlexiZone–Single AF□

AF□ is by far the simplest of the three Live View AF modes. However, it is also the most useful, especially when you need to precisely select a particular area of a scene to focus on.

When you select **AF□**, the AF point (shown as a white box) will initially be at

> **Note:**
> You can touch the screen during Live View to select a focus point and to fire the shutter when **Touch Shutter** (on the 📷 menu) is set to **Enable**, or when 🔲 is shown on screen at the bottom left corner (tap the icon to toggle **Touch Shutter** to 🔲 to avoid accidentally setting focus or firing the shutter).

» SHARPNESS

Although Canon refers to AF "points," the area of focus is actually a plane of sharpness (or focus) parallel to the camera. This is why you sometimes see several AF points lock focus—the AF points are locked onto areas of the scene that are equidistant from the camera on the plane of focus. In this shot, the plane of focus passes through the sundial near the bottom of the image.

Settings
> Focal length: 40mm
> Aperture: f/4
> Shutter speed: 1/125 sec.
> ISO: 200

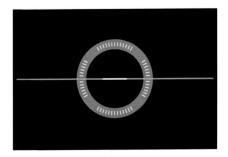

Available on the EOS Rebel T6s/760D only, the electronic level is a useful aid to keeping your camera straight when composing a shot. The electronic level is viewed on the LCD by pressing **INFO.** repeatedly, until it is displayed.

The electronic level shows you how close (or not) your camera is to being level horizontally. The long bar across the screen outside the central circle shows the horizontal angle of the camera. When the bar is red, the camera isn't horizontal; when the camera is perfectly horizontal, the bar turns green.

Whether or not your camera needs to be level depends on the subject matter; some subjects benefit from being shot at unusual angles. However, one subject that definitely requires a level camera is a large body of water, especially when there is a definite horizon line.

> **Note:**
> To display the electronic level, set **Electronic Level** to ✓ on the INFO. button display options menu screen.

LEVEL **«**
Lakes and oceans should be horizontal and not appear to slope up or down toward the side of the image.

➤ EXPOSURE

› Metering modes

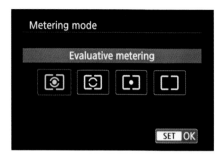

You can choose between four metering modes, either from the Q screen or the 📷 menu. Which you choose will depend on how a scene is lit.

Evaluative metering

Evaluative is the default metering method, which works by splitting the image into 63 zones (or 315 zones when using Live View). Each zone is metered separately and the exposure calculated by averaging these results, taking into account where the focus point is. This system is very accurate and can generally cope even with unusual lighting situations.

Center-weighted average metering

As with Evaluative metering, 63 zones are used to measure the exposure, but the exposure is biased heavily toward the center of the frame. If you are shooting

subjects that are always at the center of your image, filling the frame, will prove very accurate and consistent, but this metering mode has largely been superseded by Evaluative metering.

Partial metering

Rather than assess the entire image, partial metering evaluates the exposure from a 6% area at the center of the viewfinder (10% in Live View). You would use this mode if you wanted to measure a wider area of the image than Spot metering.

Spot metering

 reads the exposure from a 3.5% area at the center of the image frame (2.7% in Live View). Spot metering is used when you want to base the final exposure on a very small area of a scene, rather than the scene as a whole.

> **Notes:**
> The metering mode is set to in the Basic Zone modes.
>
> You can override the exposure using exposure compensation, unless you are in one of the Basic Zone modes or Manual (**M**) mode.

› Exposure compensation

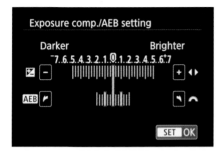

If you shoot in a Creative Zone mode (with the exception of **M**), you can use exposure compensation to override the camera's suggested exposure in ½- or ⅓-stop increments (up to ±5 stops). This means you can correct exposure errors made by the camera or alter the exposure for creative effect. Applying negative exposure compensation will darken the exposure; applying positive exposure compensation lightens the exposure.

The simplest method of setting exposure compensation is to turn ◌ (on the EOS Rebel T6s/760D) or to hold down Av⊠ and turn 🔄 (on the EOS Rebel T6i/750D). The compensation amount can be seen on the exposure bar in the viewfinder or on the LCD. You can also set exposure compensation on the Quick Control screen and by selecting **Expo.comp./AEB** from the ☐ menu.

› Auto exposure bracketing

Bracketing is the term used to describe the process of making two or more images of the same scene at different shooting settings. This is usually exposure (automatic exposure bracketing/AEB), but the EOS Rebel T6s/760D and EOS Rebel T6i/750D also let you bracket the white balance.

In either case, the first shot is usually "correct," the other shots are variations on the settings used for this first shot. When using AEB, the bracketed shots are darker and lighter versions of the first shot. The bracketing sequence can be set to ±2 stops lower or higher than the first image. AEB is set on the main ☒ or ☐ Expo. comp./AEB screen by turning 🔄. Turning to the right will increase the difference in the exposure of the bracketed sequence; to the left will decrease it. Press ⑭ to confirm the new setting.

Notes:
AEB can be used in conjunction with exposure compensation: the bracketing values will be centered on the adjusted exposure value.

To deactivate AEB, turn 🔄 to the left until only the standard exposure bar is shown.

› AE lock

One problem you may face occasionally is setting the exposure for one area of a scene, while framing for another. While it's possible to lock the exposure reading by holding the shutter-release button down halfway, this will prevent you from refocusing. The solution, therefore, is to use AE lock.

A good example of when you may need AE lock is when shooting a subject that is brightly spotlit against a dark background. The dark background will potentially cause the shot to overexpose, so you would ideally want to zoom into the subject and meter from the spotlit area. The exposure could then be locked, allowing you to zoom out to compose your shot correctly.

Activating AE lock

1) Press the shutter-release button down halfway to activate the exposure meter in the camera.

2) Press ✳. ✳ will light in the viewfinder, or if you are using Live View, it will be displayed on the LCD to show that AE lock has been activated.

3) Recompose and press the shutter-release button down fully to take the shot.

4) AE lock is cancelled after you've taken the shot. If you want to keep exposure locked, hold down ✳ as you shoot.

AE LOCK ⌃
The ✳ AE lock button is conveniently positioned for your right thumb.

Metering mode	AF point selection method	
	Automatic	**Manual**
⊡	Exposure is determined and locked at the AF point that achieved focus.	Exposure is determined and locked at the manually selected AF point.
⊡/⊏⊐/⊡	Exposure is determined and locked by the central AF point.	

A histogram is a graph that shows the distribution of tones in an image. Although this graph may initially look like a random series of peaks, once you've learned to read it, it is a very accurate way of assessing an image's exposure. By interpreting a histogram correctly you'll know whether you need to make adjustments to exposure (either immediately in Live View or with a view to reshooting when reviewing an image in playback)

The left half of a histogram shows the range of tones in an image that are darker than mid-gray, with black at the extreme left edge. The right half of the histogram shows the tones in an image that are lighter than mid-gray, with white at the extreme right edge. The vertical axis of the histogram shows the number of pixels in an image of a particular tone.

If a histogram is skewed toward the left, this may be an indication that the image is underexposed; skewed to the right, it may be overexposed. If a histogram is squashed against either the left or right edge, then it has been "clipped." This means that there are pure black or pure white pixels in the image respectively—these pixels contain no usable image data.

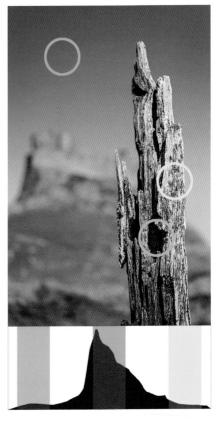

ASSESSMENT

With practice, you can begin to read a histogram and use it as a guide to whether an image is exposed correctly or not. In this image, the yellow circle corresponds to the yellow band in the histogram, and the green and blue circles to the green and blue bands respectively.

» ISO

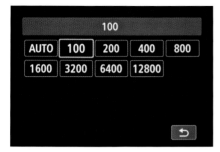

The aperture in the lens can be varied in size and the time the shutter is held open for can be increased or decreased. Together, these two controls allow you to vary the amount of light that reaches the sensor. However, the amount of light needed by the sensor to make a successful image is determined by a third control: ISO.

The higher the ISO value set, the less light the camera needs to make a usable image. Unfortunately, there is a price to pay for increasing the ISO: image noise. Image noise is seen as reduction in fine detail and an increase in "grittiness" in the image: the higher the ISO, the "grittier" the image.

On both the EOS Rebel T6s/760D and EOS Rebel T6i/750D the optimal ISO setting is the lowest: ISO 100. To maximize image quality, this is the option to choose. However, there's no reason not to use higher ISO settings. Although image quality drops, using a higher ISO means you can use a faster shutter speed or smaller aperture than would otherwise be possible. If there's a choice between image noise and having a shot ruined by camera shake, image noise is generally the better option. A certain level of noise can be removed relatively easily during postproduction (although there is usually some loss of fine image detail), but camera shake is far harder to cure.

Noise is most visible on screen when an image is viewed at 100% magnification. However, when you reduce the resolution of an image, noise becomes less visible. Using a higher ISO setting is therefore less of an issue if you know that the image will be reduced in size later.

Notes:

Increasing the ISO reduces the dynamic range that the camera can capture. Therefore, when shooting a scene with bright highlights and dark shadows, you will have a greater chance of capturing the full tonal range by using a lower ISO.

If you're using your camera on a tripod, use ISO 100. You won't need to worry about long shutter speeds to warrant an increase in ISO.

Don't set the ISO to Auto if you are using ND filters.

2

Your camera gives you the option to select a specific ISO value, or let the camera choose the ISO (Auto) based on the lighting conditions. Which you choose will depend on how you use your camera.

A fixed ISO is ideal when shooting in light that is relatively constant in brightness; when using light-sapping filters for effect; or when shooting on a tripod where slow shutter speeds won't cause camera shake.

However, Auto ISO is a good choice when shooting with your camera handheld in low lighting, or when the brightness of the light you shoot under fluctuates and you want to maintain consistent shutter speed and aperture settings.

There are several ways to set the ISO. The simplest method is to press the dedicated ISO button on top of the camera and press ◄ / ► or turn 🎛 to the required value. Alternatively, you can set the ISO via the Q screen.

The standard ISO range on both the EOS Rebel T6s/760D and EOS Rebel T6i/750D runs from ISO 100–12,800 in the Creative Zone modes (and can be set in 1-stop increments), or from ISO 100–6400 in the Basic Zone modes (and is set automatically). You can expand the ISO range to "H" (equivalent to ISO 25,600) using **C.Fn I-2** from the 🛠 menu, but this is not recommended for everyday shooting, as image quality is extremely low.

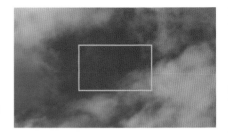

LOSS OF DETAIL ⌃»
Noise increases with each step in ISO. The thumbnails on the page opposite are details of the area in yellow (above) of a sky shot at different ISO settings.

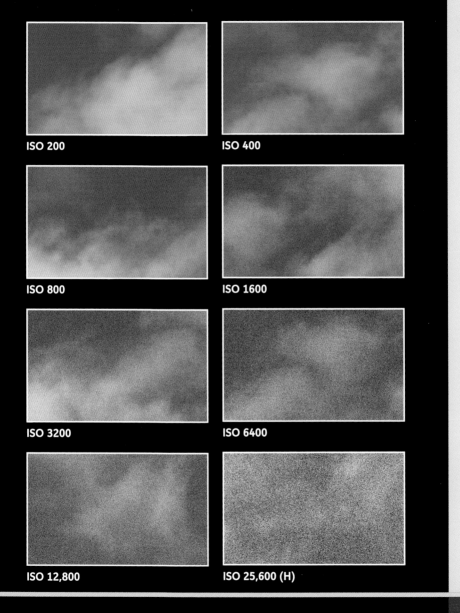

ISO 200

ISO 400

ISO 800

ISO 1600

ISO 3200

ISO 6400

ISO 12,800

ISO 25,600 (H)

White balance settings

AWB	White balance is set automatically
☀	Daylight/5500K (sunny conditions)
⌂	Shade/7000K (shadow conditions)
☁	Cloudy/6000K (overcast light)
☀	Tungsten/3200K (domestic lighting)
※	White fluorescent lighting/4000K
⚡	Flash/5500K
◢	Custom white balance

Most light sources—natural or artificial—have a color bias. This bias is usually either red (resulting in the light being "warm" in color) or blue ("cool"). We usually don't notice this bias as our eyes and brain compensate for it; it's only when the color bias is extreme that it's readily apparent. The variation in the color bias of light, from warm to cool, is known as a variation in "color temperature," which is measured using degrees Kelvin (K).

A digital camera will faithfully record the color bias of light, producing images that appear too warm or too cool, unless you adjust the camera's white balance to compensate for the color temperature. You can set the white balance for a particular light source by using one of the preset values built into the camera or by selecting a specific Kelvin value. For the greatest accuracy, you can also create a custom white balance (see chapter 3).

Setting white balance

1) Press ▲ / WB in shooting mode.

2) Highlight the desired white balance preset and press ⓢⓔⓣ, or touch the required preset on the LCD.

> **Note:**
> White balance is set to AWB in all of the Basic Zone modes and cannot be altered.

» IMAGE PLAYBACK

By default, your camera automatically displays the image you've just shot once you've released the shutter-release button. To view other still images or movies after shooting, press ▶. The last still image or movie viewed will be displayed on the LCD (a movie can be recognized by a 〔SET〕⊥ icon at the top left of the LCD).

You can skip backward or forward through your still images and movies by pressing ◀ / ▶ or by swiping left or right with your finger across the LCD (you can also turn ⌒, which will skip through images using the method set up on **Image jump w/**⌒ on the ▶ menu).

Pressing **INFO.** repeatedly toggles between three different ways of viewing still images and movies. The default is a simple display showing only the still image or the first frame of the movie. The second shows the still image or movie with a restricted amount of shooting information. The third screen shows detailed information initially with a brightness histogram. When this detailed information screen is displayed, pressing ▲ / ▼ switches between a panel showing the Lens/ Histogram information, WB, Picture Style, Color space/Noise reduction, Lens aberration correction, or GPS settings (if GPS was active at the time of shooting).

› Playback Quick Control

Press 〔Q〕 during playback and you can set the following functions: Protect images O⊓ (see page 58), Rotate ⊡, Rating ★, ⊙ Creative filters, ⊟ Resize (JPEG only), ⊕ Cropping, ᵒₒₙ AF point display, ⁽ᵗ⁾ Wi-Fi, or ⌐ᵢ Jump method. Options in gray are not available when viewing movies.

> **Note:**
> The length of time images are displayed for can be changed on the 🖿 menu by altering the **Image review** settings.

You can magnify still images up to 10x in playback. This has many uses, including confirming whether a particular area of an image in correctly focused, or to see if a human (or animal) subject kept their eyes open when the exposure was made. This will allow you to reshoot if necessary.

Magnify images

1) In playback mode, navigate to the image you want to view.

2) To zoom into an image, either press ⊕, or place the tips of two fingers close together on the screen and gently pull them apart. Use ✛ or move a finger around the LCD to move around the zoomed display. A white box within a small gray box, at the bottom right corner of the LCD, will show your position in the image.

3) To zoom back out press ⊖, bring your two fingers together again, or tap ↩.

Image index

Up to 100 images can be shown on screen at any one time to help you quickly scan through the images on your memory cards.

1) In playback mode, press ⊖ or place the tips of two fingers spaced apart on the screen and then gently pull them together.

2) The selected image will be highlighted with a yellow frame. Use ✛ or tap on the relevant thumbnail on the LCD to select another image.

3) When the image you wish to view is highlighted, press (SET) to revert to single image display.

⤼ ERASING IMAGES

After an image has been shot, it can be erased immediately by pressing 🗑 and selecting **Erase**. The same method can be used when reviewing pictures shot previously (unless the image is protected). To erase multiple images in one go, you need to delve into the menu system.

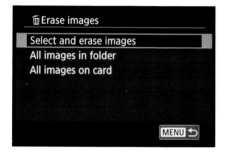

Selecting a range of images for deletion

1) Press MENU and navigate to ▣. Select **Erase images**.

2) Choose **Select and erase images**.

3) Press ◄ / ► (or turn ◎ on the EOS Rebel T6s/760D) to skip through the images on the memory card.

4) When the image you want to delete is displayed, press (SET) to toggle the erase marker. ✓ will be displayed in a box at the top left corner of the LCD to show the image

has been marked for deletion. The number of images marked for deletion is shown at the right of ✓. Mark more images for deletion as necessary.

5) Press 🗑 to erase all the marked images. Select **OK** to erase the selected images, or **Cancel** to return to step 3.

Other deletion options

1) Press MENU and navigate to the ▣ tab. Select **Erase images**.

2) Highlight **All images in folder** and press (SET). Select the folder you wish to erase images from. Choose **OK** to continue, or **Cancel** to return to the folder selection screen without deleting any images.

3) To erase all the images on the memory card (except those that are protected), select **All images on card** at step 1, followed by **OK**. Choose **Cancel** to return to the main **Erase images** menu.

2 » PROTECTING IMAGES

You can protect your images to avoid accidentally erasing them—once an image has been protected, the only way to erase it is to first remove its protection or to format the memory card (which will clear the card of both protected and unprotected images).

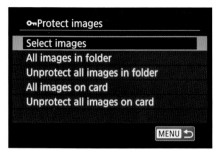

Protecting multiple images
1) Press MENU, navigate to the ▶ menu, and select **Protect images**.

2) Choose **Select images**.

3) Press ◀ / ▶ (or turn ⭕ on the EOS Rebel T6s/760D) to skip through the images on the memory card. Press ⑤ to set protection when the image you want to protect is displayed. **Oₙ** will be displayed at the top of the LCD to show that the image has been protected.

4) Repeat step 3 to protect other images as required.

5) When you're done, press MENU to return to the main **Protect images** menu.

Other protection options
1) Press MENU, navigate to the ▶ tab, and select **Protect images**.

2) Select **All images in folder** and choose the folder you wish to protect. Select **OK** to continue, or **Cancel** to return to the select folder screen. Press MENU to return to the main **Protect images** screen.

3) To protect all of the images on the memory card select **All images on card**. Select **OK** to continue, or **Cancel** to return to the main **Protect images** menu.

4) To remove protection, follow steps 2–3, this time choosing either **Unprotect all images in folder** or **Unprotect all images on card**.

MODE DIAL

The mode dials of both the EOS Rebel T6s/760D and EOS Rebel T6i/750D have 12 settings, each of which is represented by an icon. To choose a setting, turn the dial until the relevant icon is aligned with the white index mark.

Canon groups the settings into two categories: Basic Zone and Creative Zone. The Basic Zone options are automated shooting modes, which are subdivided further by grouping some of them under Special scene (**SCN**). These modes are designed for specific shooting situations, such as when shooting using candlelight.

As the name suggests, you have more creative control over your camera when using one of the Creative Zone modes. This means that using your camera requires more thought (it's possible to make more errors with a Creative Zone mode), but it also makes the entire photographic process more rewarding.

Creative Zone	
Program	P
Shutter priority	Tv
Aperture priority	Av
Manual	M
Basic Zone	
Scene Intelligent Auto	🄰⁺
Flash Off	🚫
Creative Auto	CA
Portrait	👤
Landscape	🏔
Close-up	🌷
Sports	🏃
SCN modes	
Kids	🏃
Food	🍴
Candlelight	🕯
Night portrait	🌃
Handheld night scene	🌆
HDR Backlight control	🔆

LOCKED �')
The mode dial has a "lock" to prevent it moving accidentally. Press and hold the locking button down before you start to turn the mode dial.

The various Basic Zone modes are designed to let you "point and shoot," without worrying too much about the technical requirements of a shot. Although some Basic Zone modes give you limited control of selected camera functions, the number of camera functions you can control is far less than can be found in any of the Creative Zone modes.

› Scene Intelligent Auto A⁺

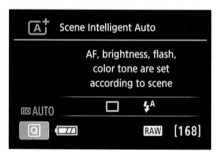

A⁺ is the most automated of all the Basic Zone modes. Virtually all the shooting functions (including exposure, white balance, and Picture Style) are set automatically and cannot be altered. Even the flash is raised if the camera deems it necessary. This leaves you free to compose your images without worrying about technical details, although almost all creative decisions are taken out of your hands (the only functions you can alter

are the drive mode and flash, via the Q screen). However, if you just want to shoot and have a better-than-average chance of success—such as at social or sporting events—A⁺ is ideal.

If you combine A⁺ with Live View, your camera analyzes the scene before shooting and displays an icon on screen. This gives you an indication of how the camera is configuring itself: the grid on the page opposite shows the range of scenes the cameras can detect.

Q **options:**
Drive mode; Flash

› Flash Off

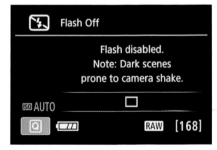

is the same as A⁺, but with one important difference: the flash will not fire, no matter how dark it is. You'd typically use this mode for scenes in which flash would not be creatively appropriate.

Live View Ⓐ＋ icons

	People		Non-people or landscape subjects		
	Normal	Moving	Normal	Moving	Close-up
Bright					
Bright & backlit					
Image includes blue sky					
Blue sky & backlit					
Sunsets	N/A				N/A
Spotlights					
Dark					
Dark with tripod		N/A		N/A	

2

increases the ISO automatically to try and maintain a shutter speed that is fast enough to avoid camera shake. You can help by switching on your lens' image stabilization (if available)—using a wide-angle focal length will also reduce the risk of camera shake compared to a telephoto focal length. If the shutter speed is slow enough that camera shake is a possibility, the shutter speed display in the viewfinder will flash.

Q options:

Drive mode

› Creative Auto CA

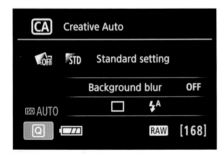

CA is also similar to A⁺. However, three extra shooting functions are available for alteration on the **Q** screen.

The first control is **Ambience Selection**, which is similar to Picture Style (see chapter 3). You can choose from a range of presets that alter the visual character of your images.

The second control allows you to roughly set the depth of field of the image by changing the **Background blur**. When set to ⬛, depth of field will be minimized and the background will be softer, while ⬛ maximizes depth of field, making the image sharper overall.

Finally, you can choose to apply effects to your images, using **Extra Effect Shot**. As well as **Ambience Selection** this option allows you to choose **Picture Style** (see page 104) and **Creative Filters** (see page 120) as well.

Extra Effect Shot sets the camera to record two shots every time you press the shutter button. After shooting, the two shots are shown side-by-side in playback. The first shot shows the image without the applied effect; the second shows the image with the effect applied. To swap between the options, select **Extra Effect Shot** and turn ✲ to find the required effect.

During playback you can also register the effect by selecting either the ★1 or ★2 icon. When you next choose **Extra Effect Shot**, tap the relevant icon to quickly select your registered effect.

Q options:

Ambience-based shots; Background blur; Flash; Drive mode; Extra Effect Shot

Ambience-based options

Setting	Options	Comments
🄢 Standard	None	The standard image setting for the chosen shooting mode.
🄥 Vivid	Low; Standard; Strong	Increases the saturation of the colors in an image. The effect can appear slightly cartoon-like if shooting a scene that is already highly saturated.
🄢 Soft	Low; Standard; Strong	Reduces the contrast to produce a softer effect.
🄦 Warm	Low; Standard; Strong	Adds red to an image to increase the warmth of the image.
🄘 Intense	Low; Standard; Strong	Contrast is increased to add drama to an image.
🄒 Cool	Low; Standard; Strong	Adds blue to an image to cool the image down.
🄑 Brighter	Low; Medium; High	Brightens an image for a "high-key" effect. Lightens shadows, but can lead to burnt-out highlights in high-contrast situations.
🄓 Darker	Low; Medium; High	Darkens an image for a "low-key" effect. Darkens highlights, but can lead to dense, black shadows in high-contrast lighting.
🄜 Monochrome	Blue; B/W; Sepia	Removes the color from your images, turning them black and white (or optional Blue or Sepia tone).

2

Light/scene-based options

Setting	Results	Comments
[STD] Standard	Image stays relatively true to the light source.	The default setting. Good for general-purpose photography.
[☀] Daylight	Image colors are correctly balanced for shooting during the middle of the day under sunlight.	Images will appear overly warm when shooting indoors under artificial lighting.
[⌂] Shade	Image colors are rendered true when shooting in open shade.	Shade light is very blue. [⌂] adds red to the image to compensate.
[☁] Cloudy	Image colors are rendered true when shooting under cloudy conditions.	As with shade, overcast light has a tendency to blueness, though not as dramatically.
[※] Tungsten	Corrects image color when shooting under household lighting.	Tungsten lighting is biased toward red. [※] adds blue to compensate. This option is not available when shooting using ▶▲.
[▒] Fluorescent	Corrects image color when shooting under white fluorescent lighting.	White fluorescent is warmer than daylight, but not as warm as tungsten lighting, so less blue is added to compensate. This option is not available when shooting using ▶▲.
[☀] Sunset	Keeps the warmth of sunlight at sunrise and sunset.	Direct sunlight at either end of the day is very warm in color.

› Portrait 🦰

🦰 is dedicated to helping you create pleasing shots of people's faces. When your camera is set to this mode, the aperture is set to a relatively large size to minimize depth of field. This will tend to make backgrounds softer and more out-of-focus and so be less distracting (the longer the focal length of the lens, the more noticeable the effect).

When depth of field is minimized, focusing needs to be accurate, so it's recommended that you ensure that your subject's face is within the AF focusing area when using the viewfinder.

Q options:
Ambience-based shots; Light/scene-based shots; Drive mode; Flash

› Landscape ⛰

⛰ enhances landscape photographs by increasing the vividness of greens and blues, and boosting the contrast and sharpness. However, the results are often overpowering, particularly when shooting in the summer on a cloudless day.

Landscape photography is typically done at either end of the day, when the raking, warm-orange light helps to bring out the best of a landscape.

However, there are some subjects that benefit from the softer light found on overcast days. Woodland is one of these subjects, as soft light reduces the contrast range, making it easier to record detail in both the shadows and the highlights.

Q options:
Ambience-based shots; Light/scene-based shots; Drive mode

› Close-up ♣

› Sports ⚐

When ♣ is selected, your camera is optimized to shoot close-up images: the aperture and shutter speed are set to minimize depth of field and reduce the risk of camera shake. However, unless you have a macro lens attached to your camera you will not actually be able to shoot really close-up images (see chapter 7). The 18–55mm kit lens commonly sold with both the EOS Rebel T6s/760D and EOS Rebel T6i/750D doesn't have a true macro facility, but with a minimum focusing distance of 10in (25cm) it will allow you to capture reasonably close-up images.

Sports mode gives priority to fast shutter speeds, which often means a wide aperture setting is used (minimizing depth of field). The ISO is also increased, up to a maximum of ISO 6400, which can potentially make images "noisy."

However, capturing fast action successfully isn't just about shooting wildly and hoping that at least one frame works. It takes time to work through and sort hundreds of near-identical images, so the most successful sports photographers understand their subject and can anticipate when the peak of action will occur, and will then be ready to shoot one or two frames at that point. Shooting in this disciplined way is highly recommended to avoid spending your life deleting photos later.

Q options:
Ambience-based shots; Light/scene-based shots; Drive mode; Flash

Q options:
Ambience-based shots; Light/scene-based shots; Drive mode

› Special Scene **SCN**

SCN is six shooting modes in one. Each of the **SCN** modes is designed for a specific shooting situation. To switch between the modes press [Q] and select the mode icon at the top left of the LCD.

Kids

makes the task of photographing children easier by switching to AI Focus and Continuous shooting. However, children are either at ease in front of the camera or they're not. The problem with children who enjoy being photographed is that they often pose for the camera, which can look too contrived and unnatural. Fortunately, children often get bored quickly and wander off to do other things. This is a good opportunity to shoot more candid photos.

[Q] options:
Ambience-based shots; Light/scene-based shots; Drive mode; Flash

Food

Many photographers make a living from shooting food for books and magazines. Skill is needed to make food in a photograph look tasty, and while mode is designed to help you achieve this, a key part of good food photography is lighting.

There is a vogue at the moment for food photography with high-key lighting, in which there are no deep shadows. The positioning of the light is important, and the most flattering way to light food is to use backlight. Supplementary lighting or reflectors can be used in front to reduce the contrast.

[Q] options:
Ambience-based shots; Color tone; Drive mode; Flash

Candlelight

The light from a candle has very romantic connotations. It is by far the warmest light used on a regular basis (it's a far warmer light than a household bulb, for example). mode is designed to help you capture that romantic warmth.

Candlelight by its very nature isn't a bright light, so your camera will adjust the ISO to maintain a reasonable shutter speed. However, there are limits, and you may find a tripod necessary if the light levels are particularly low.

You can't turn the flash on when using , and this is for good reason: flash is very cool in comparison to the light from a candle and mixing light sources with different color temperatures isn't particularly attractive.

Q options:

Ambience-based shots; Color tone; Drive mode

Night Portrait

When shooting in low light (such as at dusk) allows you to use flash to illuminate your subject. However, the camera continues to expose by setting a long shutter speed. This means that the background (which won't be lit by flash) will be exposed correctly.

Because of the slow shutter speed it is a good idea to mount your camera on a tripod (or other support). If the shutter speed drops below 1/4 sec., you will also need to ask your subject to keep as still as possible during the exposure—if they move, they will be recorded as a ghostly double image; the first (sharp) image lit by flash, the second (more blurred) lit by ambient light.

Q options:

Ambience-based shots; Drive mode

Handheld Night Scene

is a clever mode that allows you to shoot reasonably successfully in low light without a tripod—it's not perfect, but when used carefully it enables you to capture otherwise impossible images.

works by temporarily increasing the ISO to reduce the exposure time. The camera then shoots four images in rapid succession and merges them to reduce the appearance of noise.

One drawback is that you need to keep as still as possible as the camera shoots to avoid misalignment of any of the shots. Another drawback is that there is a slight lag while the images are blended, so you can't shoot very quickly.

Q options:

Ambience-based shots; Drive mode; Flash

HDR Backlight Control

The greatest challenge for a camera is to shoot high-contrast backlit scenes. Typically, the choice is to either expose for the background so the subject is in silhouette, or expose for the subject and accept that the background will be overexposed. HDR is the technique of shooting a number of frames at different exposures and then blending the results. This produces images where both the backlit subject and brighter background are exposed correctly.

HDR images are normally created during postproduction, but both the EOS Rebel T6s/760D and EOS Rebel T6i/750D can create HDR images in-camera. As with , several shots are fired (in this case three), with the exposure altered between shots. The results are then combined and saved to the memory card.

Q options:

Drive mode

» THE CREATIVE ZONE

The Creative Zone modes unlock the full potential of your camera. You will need to understand some of the basic concepts of photography, such as how the aperture and shutter speed controls will affect an image, but the Creative Zone modes will hand you full creative control over your photography in return.

AVAILABLE SETTINGS IN THE CREATIVE ZONE MODES

Focus settings
One Shot AF; AI Servo AF; AI Focus AF; AF point selection; AF-assist beam; Manual focus
Live View only: ⛶+Tracking; FlexiZone-Multi; FlexiZone-Single

Image settings
Quality: JPEG (Fine/Normal; Compression levels: L; M; S1; S2; S3); Raw+JPEG; Raw
Other: Aspect ratio; Lens aberration correction

Exposure settings
Metering: Evaluative; Center-weighted average; Partial; Spot
Settings: Program shift (**P** only); Exposure compensation (not **M**); AEB; AE lock (in **M** with Auto ISO you can set a fixed ISO); Depth of field preview; Bulb (**M** only)

Tone settings
White balance (AWB; Preset; Custom; Correction/Bracketing); Auto Lighting Optimizer; Highlight tone priority; Color space (sRGB; Adobe RGB); Picture Style

Drive mode
Single; Continuous; Single silent; Continuous silent; Self-timer (2 seconds; 10 seconds; ⏱c)

ISO settings
ISO Auto; Manual selection (100-12,800); Maximum for Auto; High ISO speed noise reduction; Long exposure noise reduction

Built-in flash settings
Manual firing; Flash off; Red-eye reduction; FE lock; Flash exposure compensation; Wireless control

External flash settings
Function settings; Custom function settings

› Program P

Program AE

Auto setting of shutter speed and aperture. Other settings can be configured manually.

P is the Creative Zone version of [A]. You can use P to shoot without worrying about what shutter speed or aperture is required for the exposure (the camera selects both automatically). However, as befits its place in the Creative Zone modes, you can override the exposure decisions made by your camera, either by applying exposure compensation, changing the ISO, and/or using Program Shift. You're also able to select the full range of shooting functions, such as Picture Style and white balance, which alter the look of your images. P is best seen as a halfway point between [A] and the semi-automatic Tv and Av modes described on the following pages.

Program Shift allows you to alter the combination of shutter speed and aperture initially selected by your camera, without altering the level of exposure. You can shift the combination so that you have a wider aperture/faster shutter speed or a smaller aperture/longer shutter speed than the original settings selected by the camera. To set Program Shift, turn 🔄 once you've pressed the shutter-release button down halfway to activate the camera's exposure meter. Once you've taken your shot, Program Shift will be cancelled.

Note:
P will try to bias the exposure settings to reduce the risk of camera shake. Typically, this means using a shutter speed figure that roughly matches (or is faster than) the focal length of the lens—if you're using a 50mm lens, the camera will try to use a shutter speed that is faster than 1/50 sec., for example.

Using Program P mode
1) Turn the mode dial to P.

2) Press halfway down on the shutter-release button to activate exposure metering and focusing. If *30"* is displayed, and is blinking in the viewfinder or on

the LCD, this indicates underexposure. You will need to increase the ISO or add extra illumination to the scene (potentially by flash). If *4000* is displayed, and is blinking in the viewfinder or on the LCD, this indicates overexposure. You will need to decrease the ISO or reduce the amount of light reaching the sensor. Turn ⚙ to alter the shutter speed and aperture combination if required.

3) When focus has been achieved, the active focus point(s) will flash red, the camera will beep, and the focus confirmation light ● will be displayed in the viewfinder. If you're using Live View

(in FlexiZone–Single mode), the focus box will turn green and the camera will beep to confirm focus lock.

4) Press down fully on the shutter-release button to take the shot. The captured photograph will be displayed on the LCD for 2 seconds, unless the review time has been adjusted.

OUT AND ABOUT ⌄
P is the perfect mode when you're shooting on a whim and don't want to think too technically (but still want the option to step in and adjust the exposure if the need arises).

› Shutter priority **Tv**

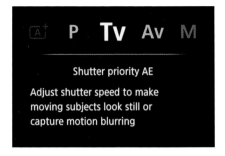

Tv and **Av** are both semi-automatic exposure modes, where you set one aspect of exposure and your camera automatically sets the other. When you shoot using **Tv**, you set the shutter speed and your camera selects the required aperture (with the roles reversed when you shoot with **Av**).

Both shutter speed and aperture affect how an image is recorded visually. However, shutter speed has its greatest impact visually when your subject is moving. You have two choices in how movement is recorded: you can either "freeze" movement or deliberately blur it.

To freeze movement (so that, slightly ironically, your moving subject appears static in the image) means using a fast shutter speed. Shooting at shutter speeds faster than 1/800 sec. on all but the sunniest days may mean using a fast lens (one with a large maximum aperture) set to one of the larger apertures or increasing the ISO.

Conversely, a slow shutter speed blurs movement. This is often a very effective way of conveying movement, and with a sufficiently long shutter speed, a moving subject may even disappear entirely from the image (which is useful if you want to "remove" people from a scene). The slower the shutter speed, the more necessary a tripod or other support will become. Achieving very long shutter speeds may mean shooting when light levels are naturally low or using an ND filter (see chapter 6).

Using Shutter priority **Tv** mode

1) Turn the mode dial to **Tv**.

2) Turn 🎛 to the right to set a faster shutter speed or to the left to set a slower shutter speed. As you change the shutter speed, the aperture will be adjusted automatically to maintain the same level of exposure overall.

If the maximum aperture figure blinks in the viewfinder or in Live View, your image will be underexposed. You will need to use a longer shutter speed, or increase the ISO. If the minimum aperture figure blinks, the image will be overexposed, so you'll need to use a faster shutter speed, or decrease the ISO.

3) Press halfway down on the shutter-release button to focus. If you're using the viewfinder the active focus point(s) will flash red, the camera will beep, and the focus confirmation light ● will be displayed once focus has been achieved. If you're using Live View (in FlexiZone-Single mode), the focus box will turn green and the camera will beep.

4) When focus has been achieved, press down fully on the shutter-release button to take the shot. The captured photograph will be displayed on the LCD screen for 2 seconds, unless the default review time has been adjusted.

SPEED ⌄
The faster your subject moves, and the closer it is to the camera, the faster the shutter speed will need to be. This shot required a shutter speed of 1/800 sec. to "freeze" the movement of the waves crashing against the rock.

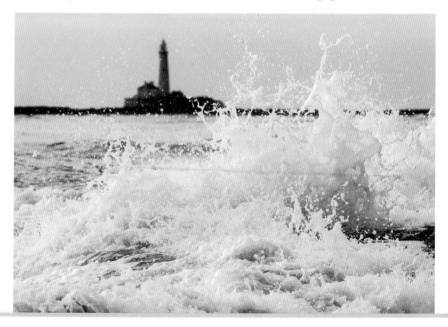

P Tv **Av** M SCN

Aperture priority AE

Adjust aperture to blur backgnd (subjects stand out) or keep foreground and backgnd in focus

The aperture inside every EOS-compatible lens controls the amount of light that passes through the lens. The aperture also controls the amount of acceptable sharpness in an image. By making the aperture smaller, a zone of sharpness extends out from the focus point both toward and away from the camera. Known as depth of field, this zone of sharpness always extends further away from the focus point than toward the camera.

The depth of field is determined by three factors: the aperture setting, the focal length of the lens, and the camera-to-subject distance. Depth of field is increased by a small aperture, short focal length, and long camera-to-subject distance, and decreased by a wide aperture setting, long focal length, and short camera-to-subject distance. Therefore, setting the minimum aperture on a wide-angle lens and photographing a subject that is relatively distant from the camera will achieve a

"deep" depth of field. Conversely, using the widest aperture on a telephoto lens, with a subject that is relatively close to the camera, can minimize the depth of field.

When you look through the viewfinder, or when viewing a Live View image, you see the scene at maximum aperture (and so at minimum depth of field). However, press and hold in the depth of field preview button and the aperture is temporarily closed to the selected "shooting" aperture. This can make the viewfinder go very dark if you've selected a small aperture, but you should see a difference in overall sharpness. In many respects, Live View is a better option for this, as the brightness of the screen remains constant, making it easier to see the increase in depth of field.

Using Aperture priority **Av** mode
1) Turn the mode dial to **Av**.

2) Turn **Av** to the right to decrease the size of the aperture or to the left to increase it. If the shutter speed shows *30"* and this figure blinks in the viewfinder or in Live View, your image will be underexposed, so you will need to use a larger aperture or increase the ISO. If the shutter speed shows *4000*, and the figure blinks, the image will be overexposed, so you will need to use a smaller aperture or decrease the ISO.

3) Press halfway down on the shutter-release button to focus. If you're using the viewfinder, the active focus point(s) will flash red, the camera will beep, and the focus confirmation light ● will be displayed once focus has been achieved. If you're using Live View in FlexiZone–Single mode, focus lock will be confirmed when the focus box turns green and the camera beeps.

4) When focus has been achieved, press down fully on the shutter-release button to take the shot. The captured photograph will be displayed on the LCD screen for 2 seconds, unless the default review time has been adjusted.

SOFT ⌄

Images don't need to be pin-sharp all the way through. We tend to look more intently at the sharpest part of a photograph and pay less attention to blurred areas. This can help to direct the eye in an image, and can be achieved by using a longer focal length lens, a wide aperture, and focusing precisely on the element in the scene that you want to draw attention to.

› Manual **M**

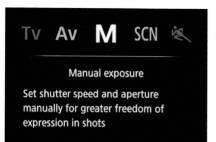

Manual exposure

Set shutter speed and aperture manually for greater freedom of expression in shots

Manual mode puts you fully in control of the exposure, as both the shutter speed and the aperture are adjusted independently. Consequently, if your images are exposed incorrectly there's no one to blame but yourself. Fortunately, you can still use your camera's exposure metering as a guide, or you can also enter the readings from a handheld light meter if you have one.

One good reason to use **M** is that once you've set the exposure, the settings will not change. This means that if you're shooting a sequence of images, the exposure for each shot will be consistent (assuming the light levels don't change as you shoot). This is often desirable if you're shooting to produce a series of images that will later be stitched to produce a high-resolution panoramic image.

Unlike other Creative Zone modes you can extend the shutter speed for periods longer than 30 sec. using "Bulb." When your camera is set to Bulb, the shutter stays open

for as long as the shutter-release button is held down. This could get tiring after a while, so it's recommended that a remote release is used to lock the shutter open.

Bulb is found beyond the 30 sec. mark when you adjust the shutter speed; during the exposure, the elapsed time is displayed on the LCD.

Note:
Manual exposure mode is best used with a definite ISO value rather than Auto ISO.

Using Manual **M** mode
1) Turn the mode dial to **M**.

2) Turn ⚙ to adjust the shutter speed, or hold down Av🔲 and turn ⚙ to set the aperture (turn ◯ on the EOS Rebel T6s/760D). The correct exposure is set when the exposure level mark is centered below the standard exposure index.

If the exposure level mark is at the left of the standard exposure index, this indicates possible underexposure. If the exposure difference is greater than -2 stops (viewfinder) or -3 stops (LCD) then ◀ is shown at the left edge of the exposure scale.

If the exposure level mark is at the right of the standard exposure index, the resulting image may be overexposed. If the exposure difference is greater than +2 stops (viewfinder) or +3 stops (LCD) then ▶ is shown at the right edge of the exposure scale.

3) Press halfway down on the shutter-release button to focus. If you're using the viewfinder the active focus point(s) will flash red, the camera will beep, and the focus confirmation light ● will be displayed once focus has been achieved. If you're using Live View, the focus box will turn green and the camera will beep to confirm focus lock (when you are in FlexiZone–Single mode).

4) When focus has been achieved, press down fully on the shutter-release button to take the shot. The captured photograph will be displayed on the LCD screen for 2 seconds, unless the default review time has been adjusted.

SUNSET ⌄
M isn't ideal when light levels are changeable. At a time such as sunset you need to keep an eye on your exposure settings and be prepared to adjust them as the light levels drop.

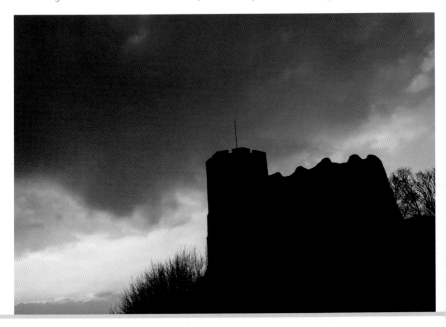

› MAKING MOVIES

As with still images, there are several options that can be chosen that affect the look of movies shot using your EOS Rebel T6s/760D or EOS Rebel T6i/750D. These include Picture Style, as well as movie-specific options, such as the frame rate.

› Movie compression

Creating a movie involves capturing a continuous stream of digital data, which is compressed by your camera as it shoots (this is just as well, otherwise proceedings would quickly grind to a halt as memory cards fill up).

Movies are compressed by comparing individual frames within the movie. If there is little or no difference between two or more successive frames the camera doesn't need to save the data for each frame over and over again—only the changes, if any, need to be recorded. Therefore, the more static a movie clip is, the more easily it can be compressed.

However, the opposite is also true, and the greater the difference between frames, then the more data needs to be captured and the lower the compression rate. This means that a movie with lots of movement will take up more room on a memory card than a static one.

The EOS Rebel T6s/760D and EOS Rebel T6i/750D use MPEG 4 AVC/H.264 compression, which is a compression format used and recognized by many different devices and movie-editing software packages.

› Live View

Movies are only shot using Live View (so you can't use the viewfinder for composing shots). Pressing **INFO.** toggles between screens with different levels of shooting information. The picture displayed before and during recording reflects the following functions that you or the camera have set automatically: white balance, Picture Style, Auto Lighting Optimizer, exposure mode, frame rate, resolution, AF method, Miniature Effect, and Video Snapshot

› Shooting a movie

1) Turn the power switch to '🎥; your camera will switch to Live View.

2) Press the shutter-release button halfway down to focus. Adjust the focal length of your lens too, if necessary. Although your camera can focus during movie recording, it is preferable to start with the lens focused correctly.

3) Press 🎦. A red ● mark will be displayed at the top right of the LCD screen to show that recording has started.

4) Press 🎦 again to stop recording.

› The mode dial

The amount of control you have over the exposure of your movies will depend on how the mode dial is set. If the mode dial is set to a Basic Zone mode, your camera will detect the type of scene being shot and adjust the exposure settings accordingly, including the ISO.

Movies shot with the mode dial set to **P**, **Tv**, and **Av** also benefit from automatic exposure, but you can lock and unlock the exposure by pressing ✳ and then ⊡ respectively. You can also apply exposure compensation by holding down Av☑ and turning 🎛 (or turning ○ on the EOS Rebel T6s/760D). Pressing the shutter-release button down halfway displays the current exposure settings, while pressing it down fully takes a still image using those settings (temporarily pausing movie recording).

For the greatest control over the exposure, the mode dial needs to be set to **M**. In this mode you can alter the ISO, aperture, and shutter speed, although the slowest shutter speed available is dependant on the frame rate selected from the 🎥 menu.

Notes:
When shooting movies, the ISO Auto range is 100–6400.

When the mode dial is set to 🅰, scene icons will be displayed on the LCD. See page 61.

Pressing the shutter-release button during movie recording will temporarily pause movie record to shoot a still image. The pause is approximately 1 second in length.

MOVIE SHOOTING OPTIONS

› Frame rate

The EOS Rebel T6s/760D and EOS Rebel T6i/750D can shoot using the following frame rates: **23.98P**, **25.00P**, **29.97P**, **50.00P**, and **59.94P**. However, the frame rates available will depend on the resolution of the movie you shoot and whether **Video system** is set to **NTSC** or **PAL**.

Each individual frame in a movie is shot at a particular shutter speed. If you shoot in **M** mode you can control the shutter speed, which doesn't need to match the selected frame rate. You could, for instance, use a shutter speed of 1/200 sec., and if the movie frame rate is **59.94P**, this would mean that a frame is exposed for 1/200 sec. approximately every sixtieth of a second. However, using such a fast shutter speed will produce very staccato movie footage. This will be effective visually when shooting short action sequences, but isn't comfortable to watch for long periods.

Instead, a slight amount of blurring between frames will produce footage that is more comfortable to watch, and this means shooting with a slightly slower shutter speed. The general rule is to use a shutter speed that is twice the chosen frame rate, so a shutter speed of 1/50 sec. when shooting at 25fps, or 1/60 sec. when shooting at **29.97P**, for example. Avoid shooting at the lowest possible shutter speed of 1/30 sec., as this can result in smeary footage, particularly if there is a lot of movement in the scene being filmed.

> **Note:**
> You can use ⓠ to call up a Quick Control movie, just as you can when shooting still images.

The Miniature Effect Movies mode on your camera blurs out large areas of an image so that even large vistas start to look like small-scale models. The effect isn't achieved by altering the aperture, but by selectively blurring parts of the image as a processed effect. Simple compositions work best when using Miniature Effect Movies and you also need to keep your main subject precisely in the area of sharp focus.

Miniature Effect Movies differs from the other movie modes in that you cannot shoot at the standard frame rate. Instead, you must choose between 5x, 10x, or 20x speed. This will cause any motion in the movie to be sped up, so a 1-minute clip will last just 3 seconds at 20x speed.

Setting Miniature Effects Movie mode
1) Press Q and then select ⚙OFF.

2) Press ◀ / ▶ to highlight **5x**, **10x**, or **20x**, and then press SET.

3) The area of the image that will be sharp and in focus is shown within a white frame. Press ▲ / ▼ to move the frame up and down, or press 🔍 (or tap on the LCD screen) to change the frame's orientation.

4) Press 📷 to start recording.

Notes:
Sound is not recorded in Miniature Effects Movie mode.

You can't use Miniature Effects Movie mode if **Video Snapshot** is set to **Enable**; if Raw or Raw+JPEG is selected; or if white balance bracketing is in use. You also can't shoot still images while recording.

› HDR Movie Shooting

Unlike shooting still images, there is no Raw option for shooting movies. This means that less adjustment can generally be made to correct for exposure errors in movie footage. **HDR Movie Shooting** (only available on the EOS Rebel T6s/760D) is Canon's solution to keeping contrast under control, so that highlights are less likely to be lost ("burnt out").

HDR Movie Shooting works by merging multiple frames, shot at subtly difference exposures, to expand the tonal range of the footage. This means that movement (particularly of the camera) should be kept to a minimum, so shooting on a tripod is highly recommended.

However, it is not perfect. When contrast is high, you may still need to use additional lighting to reduce the contrast or add filters (see chapter 6). Another drawback to HDR Movie Shooting is that it's only available when the mode dial is set to a Basic Zone mode.

Setting HDR Movie Shooting mode

1) Set the mode dial to one of the Basic Zone modes.

2) Press Q and select ▤HDR▤OFF.

3) Select ▤HDR▤ to turn **HDR Movie Shooting** on.

> **Notes:**
> Using video-editing software to adjust aspects such as contrast and color is known as "grading." If you want to adjust footage during postproduction, shoot using a Picture Style such as ⒮N—it is easier to add contrast and increase saturation than it is to remove it.
>
> HDR movie shooting is limited to shooting at 1280 x 720 pixels at 29.37/25.00fps.
>
> You cannot use HDR Movie Shooting in conjunction with Miniature Effect Movies, Digital zoom, or Video snapshot.

You can view and make simple trimming edits to your movies in-camera. For greater control over the editing process (such as cutting your movie footage into separate clips and rearranging the clips in a different order) you need to use video-editing software on your computer. There is a good range of relatively inexpensive software that is readily available and easy to use—Adobe Premiere Elements and iMovie, for example.

Playing back a movie

1) Press ▶. Navigate to the movie you wish to view by pressing ◀ / ▶ (or turn ⟳ on the EOS Rebel T6s/760D). Movie files are distinguished from still images by **SET** 🎬 appearing at the top left corner of the LCD.

2) When you've found the movie you want to view, press ⟮SET⟯ to display the movie playback panel.

3) The play symbol (▶) is highlighted by default when you first view the Playback panel. Press ⟮SET⟯ to play the movie or tap ▶ on the LCD.

4) When the movie finishes you will be returned to the first frame.

› Other playback options

As well as ▶, there are other options on the Playback control panel, as outlined in the grid opposite.

1) Follow steps 1 and 2 in *Playing back a movie*.

2) Press ◀ / ▶ to highlight the desired option on the Playback control panel and select or touch the required option on the rear LCD screen.

Movie playback panel

▶	Movie playback.
I▶	Slow motion: press ◀ / ▶ to decrease/increase speed.
I◀◀	Jump back to the first frame of the movie.
◀II	Moves back one frame every time ⑤ⓔⓣ is pressed. Hold down ⑤ⓔⓣ to skip backward.
II▶	Move forward one frame every time the ⑤ⓔⓣ button is pressed. Hold down ⑤ⓔⓣ to skip forward.
▶▶I	Jump forward to the last frame of the movie.
♫	Plays movie accompanied by music copied to the memory card using EOS Utility software.
✂	Edit movie.

› The editing suite

The EOS Rebel T6s/760D and EOS Rebel T6i/750D have a built-in editing facility that allows you to trim either end of a movie clip if you feel that it's overly long.

Editing movies

1) Follow step 1 in *Playing back a movie.*

2) Highlight ✂ on the Playback control panel and press ⑤ⓔⓣ.

3) To cut the beginning of the movie, highlight ✂Ⅶ, or highlight Ⅶ✂ to cut the end. Press ⑤ⓔⓣ, and then use ◀ / ▶ to set the trimming point backward and forward a frame respectively. The white portion of the time bar at the top of the LCD shows you how much of the movie will be left once it has been edited. Press ⑤ⓔⓣ when you have set the edit point.

4) Highlight ▶ and press ⑤ⓔⓣ to view your edited movie. If you're happy with the movie, highlight 🖫 to save it to the memory card. Select **New File** if you want to create a new movie file with the edit applied, **Overwrite** if you want to save it over the original footage, or **Cancel** to return to the editing screen.

5) At any point in the editing process, pressing MENU or touching ↩ on the LCD screen will take you back to the movie playback control panel. Select **OK** to exit without saving your changes, or **Cancel** to return to the editing screen.

To take complete control of your camera involves mastering (or at least having a working knowledge of) the menu system. Although the menus may look daunting initially, they are logically laid out, so it is easy to find the required functions quickly.

The various menu screens are divided into color-coded sections, each with its own symbol: Shooting ◘ (including Live View Shooting ◘ and Movie ◘), Playback ▶, Set Up ✿, and My Menu ★. Each section is then subdivided into a number of separate screens, with the number of small squares above the section icon showing you the particular sub-section currently displayed.

The number of menu screens available is dependant on the mode, with fewer screens shown when the mode dial is set to a Basic Zone mode. It is only when you select a Creative Zone mode that you have full access to the various options.

One of the keys to using a camera well is understanding exactly what it's doing as you use it. It's therefore a good idea to work your way through the various menu options, making sure you understand what they do and that they're set correctly for your needs.

MENU ⌃
Press the menu button to begin to configure your camera to suit your personal needs.

BLOSSOM »
Photography is a creative pursuit in which personal interests will play a big part in what you want to shoot. However, this creativity has to be backed up with a command of your camera.

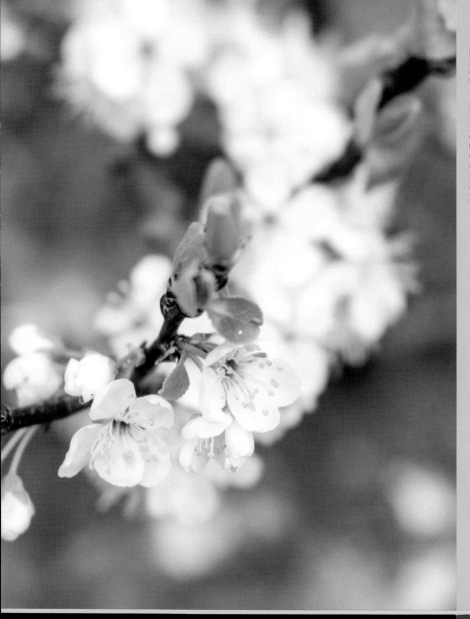

3

Changing menu options

1) Press MENU.

2) Press ◄ / ►, turn ⚙, or slide your finger along the top of the LCD screen to jump left or right between the main menu sections and their various sub-sections. As you move between the various menus, the relevant icon will be highlighted on a tab at the top of the LCD.

3) When you reach the required menu screen, press ▲ / ▼ to move up or down the options, and press ⑤ when the function you want to adjust is highlighted.

4) To highlight one of the options for your chosen function, press ▲ / ▼ for simple menu options or ✛ when there is a series of options. Press ⑤ once more to make your choice. If you press MENU before making your choice, you will jump back up a level to the previous menu screen without altering the option.

5) When viewing a main menu screen, you can press MENU or lightly down on the shutter-release button to return directly to shooting mode.

> **Note:**
> Some options need you to confirm your choice before proceeding. This is done by selecting **OK** to continue or **Cancel** to reject the choice; highlight the required option and press ⑤.

» MENU SUMMARY

Menu settings shown in gray are not
available in the Basic Zone modes.

Shooting 1 ◘ (Red)	Options
Image quality	JPEG: ◢L Large Fine; ◢L Large Normal; ◢M Medium Fine; ◢M Medium Normal; ◢S1 Small 1 Fine; ◢S1 Small 1 Normal; S2 Small 2; S3 Small 3 Raw: Raw RAW[1]; Raw + JPEG ◢L[1]
Beep	Enable; Touch to ♩; Disable
Release shutter without card	Enable; Disable
Image review	Off; 2 sec.; 4 sec.; 8 sec.; Hold
Lens aberration correction	Peripheral illumination, Chromatic aberration, and Distortion (Enable [with compatible lenses]; Disable)
Red-eye reduction	Enable; Disable
Flash Control	Flash firing (Enable; Disable); E-TTL II metering (Evaluative; Average); Flash sync. speed in Av mode (Auto; 1/200–1/60sec. auto; 1/200 sec. fixed); Built-in flash settings; External Flash C.Fn settings; Clear settings

Shooting 2 ◘ (Red)	Options
Expo. comp./AEB	Exposure compensation (±5 stops in ⅓- or ½-stop increments); AEB (±2 stops)
Auto Lighting Optimizer	Disable; Low; Standard; High; Disabled in Manual exposure
Custom White Balance	Manual setting of white balance

[1] Not available in 🖼 or 🎨 modes

WB Shift/BKT	White balance correction; White balance bracketing
Color space	sRGB; Adobe RGB
Picture Style	〔≡A〕 Auto; 〔≡S〕 Standard; 〔≡P〕 Portrait; 〔≡L〕 Landscape; 〔≡N〕 Neutral; 〔≡F〕 Faithful; 〔≡M〕 Monochrome; User Def. 1; User Def. 2; User Def. 3
Metering mode	〔⊙〕 Evaluative; 〔⊙〕 Partial; 〔•〕 Spot; 〔▭〕 Center-weighted average

Shooting 3 ▢ (Red)	**Options**
Dust Delete Data	Image capture for automatic dust removal in Digital Photo Professional
ISO Auto	Max.: 400; Max.: 800; Max.: 1600; Max.: 3200; Max.: 6400
Long exposure noise reduction	Enable; Auto; Disable
High ISO speed noise reduction	High; Standard; Low; Disable; Multi shot noise reduction
Aspect ratio	3:2; 4:3; 16:9; 1:1
Anti-flicker shooting	Enable; Disable

Live View ▢ (Red)	**Options**
Live View shooting	Enable; Disable
AF method	ⵑ+Tracking; FlexiZone-Multi; FlexiZone-Single
Continuous AF	Enable; Disable
Touch Shutter	Enable; Disable
Grid display	Off; Grid 1 ⧉; Grid 2 ⧉
Metering timer	4 sec.; 16 sec.; 30 sec.; 1 min.; 10 min.; 30 min.

Playback 1 ▶ (Blue)	Options
Protect images	Select images; All images in folder; Unprotect all images in folder; All images on card; Unprotect all images on card
Rotate	Rotate images 90–270° clockwise
Erase images	Select and erase images; All images in folder; All images on card
Print order	Selection of images for printing
Photobook Set-up	Select images; All images in folder; Clear all images in folder; All images on card; Clear all images on card
Creative Filters	Grainy B/W; Soft focus; Fish-eye effect; Art bold effect; Water painting effect; Toy camera effect; Miniature effect
Resize	Reduce the resolution of compatible images

Playback 2 ▶ (Blue)	Options
Cropping	Allows the cropping of JPEG images
Rating	Rate images (Off; 1–5 ★)
Slide show	Select images for automatic slide show
Image jump w/🖬	Jump by 1; 10; 100 images; Display by Date; Folder; Movies; Stills; Rating
AF point display	Enable; Disable
Histogram display	Brightness; RGB
Ctrl over HDMI	Enable; Disable

Set Up 1 ☻ (Yellow)	Options
Select folder	Create and select a folder
File numbering	Continuous; Auto reset; Manual reset
Auto rotate	On📷🖥; On🖥; Off
Format	Format memory card
Wi-Fi/NFC	Enable; Disable; Set up NFC functions
Wi-Fi function	Configure Wi-Fi settings
Eye-Fi settings	Settings for Eye-Fi card use (only visible when an Eye-Fi card is used)

Set Up 2 ☻ (Yellow)	Options
Auto power off	30 sec.; 1 min.; 2 min.; 4 min.; 8 min.; 15 min.; Disable
LCD brightness	Seven levels of brightness
LCD off/on button[1]	Shutter-release button; Shutter/**DISP.**; Remains on
LCD auto off[2]	Enable; Disable
Date/Time/Zone	Sets date and time; Daylight saving; Time zone
Language	English; German; French; Dutch; Danish; Portuguese; Finnish; Italian; Ukrainian; Norwegian; Swedish; Spanish; Greek; Russian; Polish; Czech; Hungarian; Romanian; Turkish; Arabic; Thai; Simplified Chinese; Chinese (traditional); Korean; Japanese
Viewfinder display	Electronic level (Hide; Show)[2]; Grid display (Hide; Show); Flicker detection (Hide; Show)
GPS device settings	Settings available when GPS unit GP-E2 is fitted

[1] EOS Rebel T6i/750D only
[2] EOS Rebel T6s/760D only

Set Up 3 ♀ (Yellow)	Options
Screen color	1 black / 2 light gray / 3 brown / 4 blue / 5 red
Feature guide	Enable; Disable
Touch control	Standard; Sensitive; Disable
Battery information	Remaining capacity; Recharge performance
Sensor cleaning	Auto cleaning (Enable; Disable); Clean now; Clean manually
INFO. button display options[1]	Displays camera settings; Electronic level; Displays shooting functions
Video system	PAL; NTSC

Set Up 4 ♀ (Yellow)	Options
Certification logo display	Displays the logos of the camera's certifications
Custom functions	C.Fn I: Exposure; C.Fn: II Image; C.Fn III: Autofocus/Drive; C.Fn IV: Operation/Others
Copyright information	Display copyright info.; Enter author's name; Enter copyright details; Delete copyright information
Clear settings	Clear all camera settings; Clear all Custom Func. (C.Fn)
Firmware ver.	Currently installed camera firmware version number; Install new camera firmware

My Menu ★ (Green)	Options
My Menu Settings	Choose your most commonly used menu options for easy accessibility

[1] EOS Rebel T6s/760D only

Movie 1 🎥 (Red)	Options
AF method	⛶+Tracking; FlexiZone-Multi; FlexiZone-Single
Movie Servo AF	Enable; Disable
AF with shutter-release button during 🎥	One Shot AF; Disable
Grid display	Off; Grid 1 ╫; Grid 2 ╫╫
Metering timer	4 sec.; 16 sec.; 30 sec.; 1 min.; 10 min.; 30 min.

Movie 2 🎥 (Red)	Options
Movie rec. size[1]	**FHD** 1920 x 1080 (**29.97P**; **23.98P**; **25.00P**); **HD** 1280 x 720 (**59.94P**; **50.00P**; **29.97P**; **25.00P**); 640 x 480 (**29.97P**; **25.00P**); Compression method (Standard; Light)
Digital zoom[2]	Disable; Approximately 3–10x zoom
Sound recording[3]	Sound recording (Auto; Manual; Disable); Recording level; Wind filter/Attenuator (Enable; Disable)
Video snapshot	Video snapshot (Enable; Disable); Album settings (Create new album; Add to existing album); Show confirm message (Enable; Disable)

[1] Options available dependent on 🔧 **Video system** settings
[2] EOS Rebel T6s/760D only
[3] When mode dial is set to a Basic Zone mode, **Sound Recording** can only be switched **On** or **Off**

☞ SHOOTING 1 ☐

› Image quality

Image quality lets you set how your still images are saved. There are two basic choices: Raw or JPEG. Which you choose will depend on your style of shooting and attitude to postproduction.

The simplest option is JPEG. JPEG files are processed in-camera using the currently selected image settings for white balance, Picture Style, and options such as Lens aberration correction. This means the image is ready for immediate use, without further adjustment. The downside is that it requires you to make decisions about the look of a shot prior to making the exposure. If you get it wrong, it can be difficult to adjust your shot in postproduction (it's not impossible, but extreme adjustments can lead to a significant drop in image quality).

JPEG is the standard file format used on web pages and by social media sites such

as Flickr and Facebook. JPEGs can also be used in software such as word processors. Another advantage of JPEG is that images are compressed, so they occupy far less space on a memory card than an equivalent Raw file.

However, JPEGs are compressed using a system that simplifies fine detail—the greater the compression, the greater the loss of detail will be. There are two different JPEG quality settings available on the EOS Rebel T6s/760D and EOS Rebel T6i/750D: Fine and Normal, with Fine giving higher image quality than Normal. You can also shoot five different sizes of JPEG—Large, Medium, Small 1, Small 2, and Small 3.

By comparison, a Raw file is a "packet" that contains all of the image information captured by the sensor at the moment of exposure. Although the Raw file initially uses the image settings selected at the time of shooting, these aren't fixed, so can be "unpicked" in postproduction and altered over and over again without any loss of quality. This makes Raw the ideal option if you want to experiment with the look of your images.

Raw files require suitable conversion software, and your camera is supplied with Digital Photo Professional, which is a very

3

comprehensive and useful tool. However, other options include third-party products such as Adobe Lightroom and Phase One's Capture One. Once you've processed your Raw file, you would then export the image to a more useful file format such as JPEG or TIFF. As processing Raw files takes time, this is something that needs to be taken into account before you start to shoot—if you shoot too enthusiastically, you may end up never having the time to process and polish your images.

Notes:
Image quality can also be set via the Quick Control screen when the mode dial is set to one of the Creative Zone modes.

If you're not sure whether a JPEG or Raw file is most suitable for your needs, you can choose to shoot Raw+JPEG (although this means that memory card space will be used more quickly).

Quality		Resolution (pixels)	Possible number of shots[1]	Printable size (cm)[2]	Printable size (in)[3]
JPEG	▲L	6000 x 4000	1880	60 x 40	20 x 13.3
	▟L		3620		
	▲M	3984 x 2656	3540	39.8 x 26.5	13.3 x 8.8
	▟M		7000		
	▲S1	2976 x 1984	5660	29.7 x 19.8	9 x 6.6
	▟S1		10,640		
	S2	1920 x 1280	10,640	19 x 12.8	6.4 x 4.2
	S3	720 x 480	40,360	7.2 x 4.8	2.4 x 1.6
Raw	RAW	6000 x 4000	480	60 x 40	20 x 13.3
Raw+JPEG	–	6000 x 4000	380		

[1] With a 16Gb memory card installed
[2] Approximate size when printed at 100ppcm (pixels per centimeter)
[3] Approximate size when printed at 300ppi (pixels per inch)

› Beep

› Release shutter without card

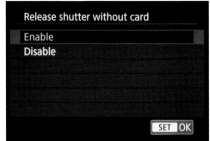

Many of the menu options will be set according to personal preference (which means that there's no right or wrong way to configure your camera). When **Enable** is selected, **Beep** sets your camera to provide an audible confirmation that the focus has got a lock; make a sound whenever you touch the LCD to change an option; and beep when the self-timer is activated. For some this is incredibly distracting, so set **Beep** to **Disable** for blissfully silent photography. As a compromise, you can also set **Touch to** 🔇, which mutes the noise made when touching the LCD.

When **Release shutter without card** is set to **Enable** you can fire the shutter even if no memory card is installed in your camera; the image shot will be displayed briefly on the rear LCD screen, but will not be saved.

Initially, **Release shutter without card** may seem to be a slightly eccentric option. However, your camera can be connected to a computer using a USB cable, which enables "tethered shooting." When your camera is "tethered," images are automatically transferred to the computer and saved to its hard drive. Tethered shooting requires Canon's EOS Utility software to be installed, as well as image-editing software such as DPP or Adobe Lightroom to view and process the captured images.

When **Release shutter without card** is set to **Disable**, a warning will be displayed on the rear LCD screen about the lack of memory card and the shutter will not fire.

> ## Image review

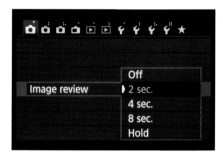

After you've made an exposure, the image will be displayed on the rear LCD screen for a set period of time. The default is **2 sec.**, but this can be changed to **Off**, **4 sec.**, or **8 sec.**. When set to **Hold**, the image will remain on screen until you press any of the controls, or until the camera automatically powers down.

> ## Lens aberration correction

All lenses suffer from optical flaws to a greater or lesser degree. Fortunately, the flaws of a particular lens design are consistent and can be measured and profiled. **Lens aberration correction** uses this information to automatically correct the flaws in a JPEG image at the time of shooting (lens correction is applied in postproduction when shooting Raw). There are three flaws you can correct for: **Peripheral illumin.**, **Chromatic aberration**, and **Distortion**.

Lens aberration correction requires the profile for a particular lens to be installed on your camera, and as standard there are profiles for 28 Canon lenses ready for use. You can add or delete a lens profile using the supplied EOS Utility software (see chapter 8) when your camera is connected to your computer via the USB cable. Note that only Canon lenses are supported and it is unlikely that third-party lenses will ever be included.

Vignetting, the flaw corrected by **Peripheral illumin.**, is seen as a visible darkening at the corners of an image. Most lenses will display a certain amount of vignetting at maximum aperture, but this is usually reduced as the lens is stopped down. Wide-angle lenses are typically more prone to the effects of vignetting than telephotos. One downside to using **Peripheral illumin.** is the potential for an increase in noise at the corners of your images. For this reason, the amount of correction applied is reduced the higher the ISO value you use.

Chromatic aberration (or achromatism) is caused when a lens is unable to focus the various wavelengths of colored light at exactly the same point. This results in colored fringing along the boundaries of light and dark areas of an image. There are two types of chromatic aberration: axial and transverse.

Axial chromatic aberration is visible across the whole of an image when a lens is used at maximum aperture. The effects are reduced by making the aperture smaller and usually disappear by the mid-range aperture settings. Axial chromatic aberration cannot be corrected in-camera (other than by stopping the lens down), although some software packages offer tools that can mitigate its effects.

Transverse chromatic aberration is seen only at the edges of an image and is not reduced by stopping the aperture down: it is this type of chromatic aberration that is corrected when you set **Chromatic aberration** to **Enable**.

Distortion describes the way that lenses appear to warp straight lines in an image. There are two types of distortion: pincushion and barrel. Pincushion distortion is most often associated with telephoto focal lengths and results in straight lines appearing to bow inward, toward the center of the image. Barrel distortion more commonly affects wide-angle focal lengths, and results in straight lines bowing outward. Zoom lenses

covering wide-angle and telephoto focal lengths can display both types of distortion, one at either end of the zoom range, with the mid focal length typically being distortion free.

> ### Tip
>
> *Vignetting is not necessarily a bad thing. Some darkening at the corners of the frame can help focus attention at the center of an image, which is ideal if this is where your subject is placed.*

DISTORTED ⌃
Distortion is generally more noticeable when you have what should be straight lines in an image, such as the horizon on a seascape.

› Red-eye reduction/Flash Control

See chapter 5 for more detail.

› Expo. comp./AEB

Exposure compensation allows you to override the suggested exposure of an image, as well as shoot a bracketed sequence of images (see page 48).

› Auto Lighting Optimizer

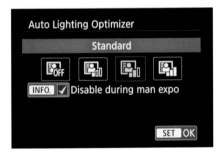

High contrast can easily result in images where the highlights are too bright and/ or the shadows are too dark. If you shoot Raw, this can often be rectified during postproduction, but choose JPEG and your options are more limited.

Auto Lighting Optimizer is Canon's solution to the problem of contrast. When it is activated, Auto Lighting Optimizer analyzes your images as you shoot, and if necessary, the shadows are lightened and highlights darkened. Theoretically, this should lead to a more tonally balanced image. You can control the strength of the effect by choosing 📷 Low, 📷 Standard, or 📷 Strong.

Unfortunately, Auto Lighting Optimizer isn't perfect. Lightening the shadows can make them gritty through the introduction of noise (particularly when using 📷 Strong). If the scene you're shooting is relatively low in contrast, Auto Lighting Optimizer can also make your images appear flatter still. It can also undo slight changes to the exposure that you make with exposure compensation, so you may find that you need to dial in a higher exposure compensation value than you would normally. It is also not recommended if you want your subject to be in silhouette when backlit.

Notes:
Auto Lighting Optimizer cannot be used at the same time as Highlight tone priority.

Press INFO. when setting Auto Lighting Optimizer to allow its use when shooting in M mode (when Disable is unchecked).

Auto Lighting Optimizer is automatically set to 📷 Standard when you use one of the Basic Zone modes.

› Custom White Balance

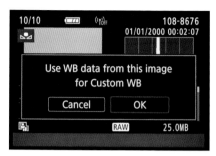

Auto white balance (AWB) is like a lot of automatic camera functions—most of the time it works well, but it can also be fooled into making an incorrect adjustment, leaving images with an unwanted color cast. A common problem with AWB occurs on overcast days, when it doesn't always correct the slight coolness of the overcast light fully, resulting in shots that appear slightly too blue.

Another problem with AWB occurs when there is one predominant color in a scene, as this can fool the camera into overcompensating. For example, if there is naturally a lot of red in a shot this can make the camera try to cool the shot down.

In situations where the camera's AWB struggles, you might find that a custom white balance helps. To set a custom white balance, you must first take a photograph of a neutral white surface under the same light

as the scene you're shooting. Position the white surface within the central area of the viewfinder, switch your lens to MF (it doesn't matter whether the white surface is in focus or not), and adjust the exposure so that the white surface is almost (but not quite) clipping the right edge of the histogram. Then take a shot of the white surface.

Setting a Custom White Balance
1) Select **Custom White Balance** from the 📷 menu.

2) The image you've just shot should be displayed (turn 🎛 if it is not, or if you want to use a different image to create the custom WB). Press (SET).

3) Select **OK** to create the custom WB, or **Cancel** to return to step 2.

4) Press MENU or lightly down on the shutter-release button to return to shooting mode. Press the ▲ WB button and select the 🖎 custom WB preset.

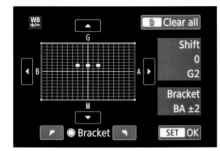

The various WB presets are generally a good starting point to achieving accurate colors, but they can be blunt instruments, especially if the color temperature of a scene falls somewhere between two presets. If you find that a particular preset is almost—but not quite—accurate for a particular scene, you can modify it by selecting **WB Shift/BKT**. This option allows you to add more **G** (green), **M** (magenta), **B** (blue), or **A** (amber/red) to the preset. For extra peace of mind you can also bracket the WB, so three shots are taken using different WB settings.

Setting WB Shift
1) Select **WB Shift/BKT**.

2) Use ✛ to move the square WB adjustment point around the grid. Moving the point to the right increases the amber bias (making the image warmer), while moving it to the left adds blue (making

it cooler). Moving the point up and down adds more green and magenta respectively. These latter two adjustments are most useful when shooting under fluorescent lighting, which often has a green bias.

3) To set WB bracketing, turn 🔄. Turning 🔄 to the left sets the G/M bracketing, while turning to the right sets the B/A bracketing. If you choose to bracket WB, the next three shots that you take will first use the preset WB, followed by a shot with a blue bias, and then a shot with an amber bias (or the WB of the preset, followed by a magenta bias, and then a green bias). The cycle will repeat until WB bracketing is cancelled.

4) Press 🔘 to set the WB adjustment and return to the main 🎥 menu screen or press 🗑 to clear the WB adjustments and return to step 2.

> **Note:**
> When **WB Shift** has been set, WB will be displayed in the viewfinder and on the rear LCD screen.

› Color space

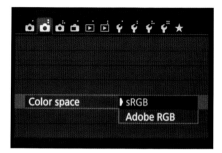

Notes:
The first character of file names of images captured using **Adobe RGB** is an underscore: _.

sRGB is used automatically when the mode dial is set to one of the Basic Zone modes.

A color space is a mathematical model that allows colors to be represented using numbers. An RGB color space uses a mixture of red, green, and blue to define colors (a fully saturated red and blue combined would give you magenta, for example). Your camera allows you to record your images using either the **Adobe RGB** or **sRGB** color space.

The **Adobe RGB** is a larger color space, which encompasses a greater and richer range of colors than **sRGB**. **Adobe RGB** is therefore the better option to choose if you plan to adjust your images in postproduction.

However, if you plan to print your images or upload them to the Internet without adjustment, **sRGB** is the better choice. Which you choose is particularly important if you use JPEG; if you shoot Raw, you can set the color space when you process your images.

COLOR ⌃
sRGB is the standard color space used in web browsers for JPEG images. Photographs that use the Adobe RGB color space often look too flat when viewed online.

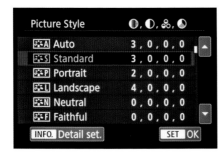

Picture Style lets you set the visual character of your images. This includes aspects such as color saturation (how vivid or not colors are) and contrast. You can either choose one of a number of presets or define your own personal Picture Style (you can do this in-camera or by using

Canon's Picture Style Editor and then applying the new style to your Raw files or uploading the Picture Style to your camera using EOS Utility).

If you shoot using a Basic Zone mode, the Picture Style is selected automatically, but in the Creative Zone modes you have full control over the Picture Style applied to your images.

> **Note:**
> Picture Style can also be set via the Quick Control screen when using a Creative Zone mode.

Presets	Description
Automatic	Picture Style is automatically modified depending on the shooting situation.
Standard	Suitable for general photography.
Portrait	Sharpness is set lower than Standard.
Landscape	Greens and blues are more saturated.
Neutral	Natural colors with lower saturation.
Faithful	Lower saturation still.
Monochrome	Converts images to black and white.
User Defined 1–3	–

 Standard

 Portrait

 Landscape

 Neutral

 Faithful

 Monochrome

Detail settings

Each Picture Style can be modified by the adjustment of one or all of four detail settings: ◑ **Sharpness**, ◐ **Contrast**, ◔ **Saturation**, and ◕ **Color tone** (with the exception of ⬛**M**).

Highlight the required Picture Style and press **INFO.** Select the required detail setting, then press ◄ to decrease the effect of the setting, or ► to the right to increase it. Press ⓈⒺⓉ when you've finished.

Adjust the other settings as necessary, then press MENU to return to the main Picture Style screen. To clear the settings, select **Default set.** from the bottom of the **Detail set.** screen.

Monochrome

When you modify ⬛**M**, the ◔ **Saturation** and ◕ **Color** parameters are replaced by ● **Filter effect** and ⊘ **Toning effect**. ● mimics the use of colored filters when shooting with black-and-white film, while ⊘ adds a color wash to your monochrome images (the color options are **N: None**, **S: Sepia**, **B: Blue**, **P: Purple**, and **G: Green**).

Presets	Description
◑ Sharpness	0-7 (no sharpening applied—maximum sharpening)
◐ Contrast	- Low contrast / + High contrast
◔ Saturation	- Low color saturation / + High color saturation
◕ Color tone	- Skin tones more red / + Skin tones more yellow

Filter effect	Description
N: None	No filter effect applies
Ye: Yellow	Blues darkened; greens and yellows lightened
Or: Orange	Blues darkened further; yellows and reds lightened
R: Red	Blues very dark; reds and oranges lightened
G: Green	Purples darkened; greens lightened

» FILTERED

Using colored filters when shooting in black and white may sound counterintuitive, but filters help to control the tonal range of a black-and-white photograph. They do this by lightening colors similar to the filter and darkening those on the opposite side of a standard color wheel—in this example, a red filter has darkened the blue of the sky to add drama.

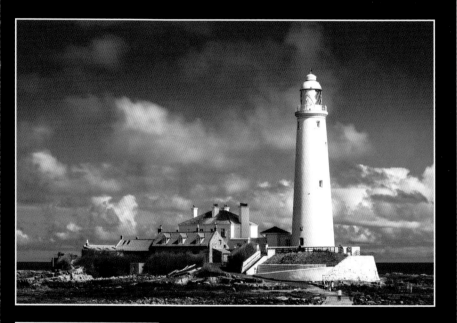

Settings
> Focal length: 160mm
> Aperture: f/16
> Shutter speed: 8 sec.
> ISO: 100

3

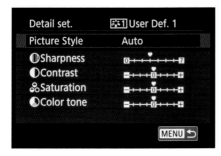

Detail set.	▣ User Def. 1
Picture Style	Auto
◉ Sharpness	
◉ Contrast	
⅋ Saturation	
◉ Color tone	

MENU ⮌

User Defined Picture Style

You can customize up to three Picture Style presets and save them as **User Def. 1**, **2**, and **3**. This allows you to personalize the visual style of your images for creative effect. You could also create a subdued Picture Style, low in contrast and saturation. This is a sensible idea if you're shooting JPEGs and intend to heavily modify your images in postproduction, as it's generally easier to add contrast and saturation, than it is to remove it.

This applies even more to sharpening, which is almost impossible to remove once it's been applied to an image. Therefore, if you think you'll want to increase the resolution of an image later on (to make a large print, for example) set **Sharpening** to **0**. This will mean that you'll have to sharpen your images later, but before then they'll be far easier to resize without a visible drop in quality.

To create a customized Picture Style, highlight **User Def. 1**, **2**, or **3**, followed by **INFO.**. Select **Picture Style** at the top

of the LCD, use ✛ to highlight the Picture Style you wish to modify, and press ⑨. Select and alter the four parameters below Picture Style as described in *Detail settings* on page 106. Press MENU to return to the main Picture Style menu once you are finished.

› Metering mode

This option allows you to set how your camera meters a scene to determine the correct exposure. See page 47 for details.

› Dust Delete Data

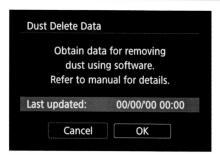

Dust Delete Data

Obtain data for removing
dust using software.
Refer to manual for details.

Last updated: 00/00/'00 00:00

Cancel OK

When your camera is switched on, the
sensor has an electrical charge running
through it that will attract dust toward
it. Once dust lands on the sensor it
may be visible in every still image shot
subsequently (or throughout an entire
movie shot with the camera). Canon uses
a very effective system that shakes dust
off the sensor; every time your camera is
turned on or off, the low-pass filter on the
front of the sensor is vibrated to remove
any dust particles.

 Dust can also be dealt with during
postproduction. **Dust Delete Data** lets
you shoot a reference image that's
analyzed by your camera to create a
"map" that shows the location of dust
on the sensor. This information is then
appended to every subsequent image,
and Canon's DPP software can use it to
remove dust automatically.

Setting Dust Delete Data
1) Attach a lens with a focal length longer
than 50mm to your camera, and set it to
MF with the focus at ∞.

2) Press MENU, navigate to ◙, and select
Dust Delete Data.

3) Select **OK** to continue and let your
camera perform a sensor-cleaning
sequence, or **Cancel** to return to the
◙ menu.

4) Aim your camera at a pristine white
surface—such as a sheet of paper—from
a distance of approximately 12 inches
(30cm). The white surface should fill the
viewfinder entirely. When *Fully press the*
shutter button, when ready is displayed,
press the shutter-release button down.
Once the Dust Delete Data image has been
captured it will be processed. Select **OK**
once it is displayed on screen.

5) If the data is not obtained correctly,
follow the on-screen instructions and
try again.

6) You can now shoot as normal—both
JPEG and Raw files will have Dust Delete
Data added to them.

7) Switch on your computer, import any photographs shot after obtaining Dust Delete Data, and then launch DPP. Select one of your imported images in the main DPP window and click on the **Stamp** button. The photograph will redraw itself and any dust will be removed using the Dust Delete Data. Once this process is finished, click on **Apply Dust Delete Data**.

8) Click **OK** to be taken back to the main DPP window.

Notes:
If you don't use a clean white surface for your Dust Delete Data reference image, any blemishes on its surface may be mistaken for dust.

Dust Delete Data will slowly become out of date as you use your camera. Reshoot periodically, particularly if you're working in a dusty environment.

Dust Delete Data is not foolproof—you may find important details in your images are removed at the same time.

› **ISO Auto**

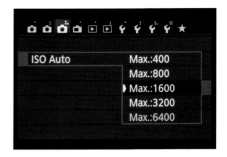

If you set the ISO to **Auto** in a Creative Zone mode, the ISO value will change to suit the lighting conditions (the lower the light levels, the higher the ISO). The chosen ISO will be in the range of ISO 100–6400 (ISO 12,800 is not available for automatic selection), but you can constrain your camera to use a lower maximum value to maintain image quality if you prefer—choose between **Max.:400**, **Max.:800**, **Max.:1600**, **Max.:3200** or **Max.: 6400**. However, you need to be aware that this may increase the risk of camera shake if you're handholding the camera.

› Long exposure noise reduction

Sensors generate heat, and the longer they're active, the hotter they get. Heat corrupts the image data generated by the sensor, resulting in the appearance of noise in the final image. The longer the exposure you use, the greater the risk that your image will lose detail because of noise. The good news is that long exposure noise is consistent over a set period of time, so multiple shots taken using the same exposure will exhibit the same (or very similar) level of noise. This means that it can be tackled using a technique called "dark frame subtraction."

You start by making the long exposure that will create your image. Once this is complete, the camera then makes a second exposure of exactly the same length. However, this time the shutter doesn't open, so this second exposure should be completely black. However, noise—if present—will still affect this second image slightly, lightening areas of the dark frame. The camera can use this tonal variation to calculate where noise is occurring and then subtract it from the original exposure (hence "dark frame subtraction").

This is the process used by your camera's **Long exp. noise reduction** feature. If you set **Long exp. noise reduction** to **Auto**, your camera will perform noise reduction to exposures lasting 1 sec. or more, but only if it is necessary; set to **On**, noise reduction will be applied to every exposure lasting 1 sec. or more.

The drawback to using **Long exp. noise reduction** is that your long exposures will always be twice the duration of the exposure setting shown on the camera. This can make using **Long exp. noise reduction** a drawn-out exercise, as you cannot shoot more images until the camera is finished. **Long exp. noise reduction** also increases the risk that the batteries in your camera will deplete before the exposure ends.

Set to **Off**, no noise reduction will be performed when shooting long exposures. This means that your long exposures will be the expected length, but you may be forced to apply extensive noise reduction during postproduction.

3

› High ISO speed NR

Noise is also an issue when you use high ISO settings; the higher the ISO setting, the noisier images will be. **High ISO speed NR** (noise reduction) lets you choose whether your camera tackles high ISO noise or not.

The most significant problem with noise reduction is that it can smother fine detail in a shot just as readily as noise. This can be a particular problem when **High ISO speed NR** is set to **High**—choosing the **Standard** or **Low** setting offers a better compromise between noise and loss of detail. When **High ISO speed NR** is set to **Disable**, no noise reduction is applied, so any noise in your images will need to be tackled during postproduction.

The final option is **Multi shot noise reduction**. When activated, your camera will shoot four shots in quick succession and then merge them to produce the final image. The disadvantage of **Multi shot noise reduction** is that it will slow your

camera down and restrict the use of other functions such as flash. As the camera needs to shoot four identical images, it's worth using a tripod so that there's no camera movement between each shot.

› Aspect ratio

The aspect ratio of an image is the ratio of its width to its height. Both the EOS Rebel T6s/760D and EOS Rebel T6i/750D offer the option of creating JPEG images with an aspect ratio of **3:2**, **4:3**, **16:9**, or **1:1**.

The default setting is **3:2**, which matches the shape of the sensor inside the camera. The **16:9** aspect ratio is more "panoramic" and is the standard aspect ratio used for HD video. **4:3** is the standard shape of an analog television and the Micro Four Thirds camera system. Finally, **1:1** is square—a strangely difficult shape to compose for, but a common shape used in medium-format film photography.

When shooting in any aspect ratio other than **3:2**, the full resolution of the sensor is not used. Indeed, shooting at **3:2** and cropping using the desired aspect ratio in postproduction is a less permanent and far more flexible way of working.

Image quality	Aspect ratio and resolution (pixels)			
	3:2	4:3	16:9	1:1
L/RAW	6000 x 4000	5328 x 4000	6000 x 3368	4000 x 4000
M	3984 x 2656	3552 x 2664	3984 x 2240	2656 x 2656
S1	2976 x 1984	2656 x 1992	2976 x 1680	1984 x 1984
S2	1920 x 1280	1696 x 1280	1920 x 1080	1280 x 1280
S3	720 x 480	640 x 480	720 x 408	480 x 480

› Anti-flicker shoot.

Fluorescent lighting flickers on and off, usually imperceptibly to the human eye. Therefore, if you take a photograph under fluorescent lighting at a fast shutter speed, it is possible that you'll catch a moment when the light levels are lower due to this flickering. This will cause underexposure and unusual color casts.

If you set **Anti-flicker shoot.** to **Enable**, your camera will automatically sense the rate of flicker and only fire the shutter when the fluorescent lighting is at maximum intensity.

Because the shutter doesn't fire instantly, this might not sound ideal, but in practice, fluorescent lighting flickers so rapidly that you will not notice the delay. If you don't regularly shoot under fluorescent lighting you can set **Anti-flicker shoot.** to **Disable**.

High ISO settings are often necessary when you need to handhold a camera in a dimly lit interior. However, it's often more fun to stick to a low ISO setting and experiment with slow shutter speeds to accentuate the effects of movement. This shot was created by balancing the camera on the rail of an escalator and using an 8 sec. shutter speed.

Settings
> Focal length: 28mm
> Aperture: f/16
> Shutter speed: 8 sec.
> ISO: 200

» SHAPE

Shooting at a different aspect ratio to 3:2 can help to refine a composition by excluding unwanted elements around the edge of the picture. This image, shot at a 4:3 aspect ratio, benefited from the exclusion of ugly and distracting details above the subject that were visible when shooting in 3:2.

Settings
> Focal length: 50mm
> Aperture: f/1.4
> Shutter speed: 1/125 sec.
> ISO: 100

› Live View shooting

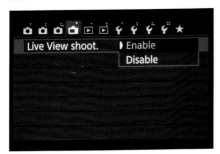

› Continuous AF

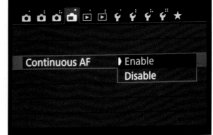

In order to use Live View, you need to have **Live View shooting** set to **Enable**. When **Disable** is selected, you cannot use Live View, so the only way to compose a shot will be to look through the viewfinder. There is no real advantage to having Live View set to **Disable**, other than it will stop Live View being activated accidentally.

› AF method

Sets the AF method when using Live View. See pages 43–44 for details.

When **Continuous AF** is set to **Enable**, your camera will constantly adjust the focus in Live View. This has the advantage that when you take a shot, the focus will either be correct or will only need a minor—and therefore rapid—adjustment.

While this reduces any potential lag in focusing before the shutter can be fired, constantly driving the AF motor in the lens will drain the camera's battery more quickly. If you're shooting still subjects, switch this function to **Disable** to conserve battery power.

> **Note:**
> Set **Continuous AF** to **Disable** or leave Live View before setting a lens to MF.

› Touch Shutter

› Grid display

In Live View (and with **Touch Shutter** set to **Enable**), your camera's touchscreen can take over the role of the shutter-release button. This allows you to focus and fire the shutter by gently tapping the rear LCD screen.

If you just want the camera to focus when you tap the LCD (and not fire the shutter) set **Touch Shutter** to **Disable**. To take a shot, the shutter-release button must then be pressed down.

The problem with using the touch shutter is that it's possible to knock the camera, increasing the risk of camera shake. It's also not a good idea to use touch shutter when the LCD is folded out fully as this causes maximum instability.

Grid display allows you to choose between two grid overlays that can be displayed on the rear LCD screen during Live View. These grids can be used as an aid to composition, or as a visual check that elements in the scene are straight relative to the camera.

Grid 1 divides the screen into nine equal rectangles, using two equally spaced vertical and two equally spaced horizontal lines. This is useful if you want to compose a shot using the "rule of thirds."

Grid 2 divides the screen into 24 squares. This is useful when shooting architectural subjects that need to be square to the camera.

Off turns the grid function off entirely.

› Metering timer

This function sets the length of time that an exposure reading is displayed after you've pressed halfway down on the shutter-release button. It also sets the length of time AE lock is held after it has been selected. The options are **4**, **8**, **16**, and **30 sec.**, and **1**, **10**, and **30 min.** When you are using a Basic Zone mode, **Metering timer** is set to **16 sec.**.

› Protect images

This mode allows you to set or unset protection on images to avoid accidental erasure. See page 58 for more information.

› Rotate image

Occasionally, you may feel the need to rotate an image stored on your camera's memory card. This is often necessary if your camera was confused about the orientation it was held when you took a shot. Once **Rotate** has been selected, press ◀ / ▶ to find the image you want to adjust, and then press (SET) to rotate the image 90° clockwise. Press (SET) a second time to rotate it a further 180° (effectively turning it 90° *counterclockwise*) and press (SET) a third time to restore the image to its original orientation. Press ◀ / ▶ to rotate further images.

Tip

A very effective method of assessing whether the composition of an image has worked is to view it upside-down. If the image still looks right the wrong way up then the composition has worked. If it doesn't, the reason why not is often easier to work out.

› Erase images

Select and erase unprotected single images, or all images in a folder or on a memory card. See page 57 for details.

› Print order

Sets the print order for your images, to control how they are printed when your camera is connected to a PictBridge printer or when the memory card is taken to a photo lab for image printing. This is explained fully in chapter 8.

› Photobook Set-up

Photobook Set-up allows you to tag up to 998 images ready for publication in a print-on-demand photobook. If you use EOS Utility, you can then transfer the selection to your computer, where they will be saved into a dedicated folder. The procedure for choosing images is similar to choosing images for protection (see page 58). You can: **Select images; All images in folder; Clear all images in folder; All images on card; Clear all images on card**. Note that Raw files cannot be added to a photobook selection, only JPEGs.

The key to creating a satisfying photobook is choosing your selection wisely. The impact of a photobook will be reduced if you include images that don't make the grade, either esthetically or technically, so you need to be ruthless when you select your images. Don't be tempted to add images purely for the purpose of filling out pages.

and EOS Rebel T6i/750D can apply a variety of effects to your images in-camera. These effects include: **Grainy B/W**; **Soft focus**; **Fish-eye effect**; **Art bold effect**; **Water painting effect**; **Toy camera effect**; **Miniature effect**.

The effects can be applied after shooting and the results saved as a new file, so your original always remains safe. If you're shooting Raw, you can also apply effects, but the results will be saved as JPEG files.

There's a lot of fun to be had by playing around with images later in postproduction, but why wait? Both the EOS Rebel T6s/760D

Effect name	Result	Options
Grainy B/W	Creates a high-contrast, grainy, black-and-white image.	Low; Standard; High
Soft focus	Adds a soft-focus glow to an image, to give it a more romantic feel.	Low; Standard; High
Fish-eye effect	Distorts the image so that it looks as if it were shot with a fish-eye lens.	Low; Standard; Strong
Art bold effect	Increases the saturation of colors in the image.	Low; Standard; High
Water painting effect	Alters the image so that it looks less like a photograph and more like an artist's sketch.	Low; Standard; Deep
Toy camera effect	Adds a vignette around the image, as well as altering the color palette.	Color tone: Cool tone; Standard; Warm tone
Miniature effect	Makes the image look like a miniature model by restricting the apparent zone of focus.	Move the bar up and down, or left and right, to set the focus point

› Resize

Resize allows you to shrink your JPEG images, saving the smaller image as a new file. Unfortunately you cannot increase an image's size (although this can be done in postproduction if necessary). The main restriction to **Resize** is that the smaller the original image, the fewer options you have to make it smaller still.

Original size	Sizes available for resizing			
	M	S1	S2	S3
L	Yes	Yes	Yes	Yes
M	–	Yes	Yes	Yes
S1	–	–	Yes	Yes
S2	–	–	–	Yes

› Cropping

Cropping allows you to alter the size and shape of your images. This is usually done to improve a composition, either to remove extraneous elements from the edges of the frame, or to reshape the image to a more sympathetic aspect ratio. When you crop an image, a new file is created, leaving the original intact.

There are a couple of limitations, though. For a start, you can't crop JPEG **S3** or Raw files (although you can crop the JPEG if you've shot Raw+JPEG). You can also only crop to one of four aspect ratios: **3:2**, **16:9**, **4:3**, or **1:1**, so you don't have the same level of control over the crop that you would have using image-editing software in postproduction. Finally, you can't crop the cropped version of an image once it's been saved to the camera's memory card—you can only crop an image once.

Cropping an image

1) Select **Cropping** from the ⬛ menu and navigate to the photograph you want to crop by pressing ◄ / ► or turning 🔄. Press ⑤⑤ to select your image.

2) A green box will be overlaid on the image. Initially the box will be in the same orientation as the image. If required, press **INFO.** to rotate the orientation of the box by 90°.

3) Turn 🔄 (EOS Rebel T6i/750D) or ⭕ (EOS Rebel T6s/760D) to change the aspect ratio of the cropping box, or press 🔍 / 🔍 to increase or decrease the size of the cropping box respectively.

4) Press ✛ to move the cropping box around the image (you can also touch the cropping box on the LCD screen and drag it by moving your finger).

5) Press ⓠ to toggle the display between a standard and a cropped view. When you're happy with the crop, press ⑤⑤ and select **OK** to save a new image to the memory card. Alternatively, select **Cancel** to go back to step 3, or press MENU to return to the ⬛ menu without saving the cropped image.

› Rating

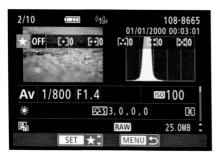

Rating lets you tag your photographs with 1–5 stars (★), which is embedded in the image's metadata. You can use the rating to filter your images when viewing them using **Image jump w/**, **Slide show**, or when the images are on your computer and you're viewing them in DPP.

The obvious way to use **Rating** is to rank your images depending on how successful you think they are, but **Rating** can be used more subtly than that. For example, you could use it to sort images into categories: 1 ★ for portraits, 2 ★ for landscapes, and so on. By default, every image you shoot has no rating stars added (**Off**).

Changing the rating

1) Select **Rating** and Press ◄ / ► (or turn ◌ on the EOS Rebel T6s/760D) to move through the images on the memory card. To view three images on screen at once

press ▦ / ◌; to view a single image on screen press ◌.

2) When you reach an image that you want to "rate," press ▲ / ▼ to decrease or increase the rating respectively.

3) When you're finished, press MENU to return to the ▶ menu screen.

› Slide show

Slide show allows you to view a sequence of images on the memory card. The slide show can either be viewed on the rear LCD screen, or at a larger size on a television. Raw and JPEG images, as well as movies, can be added to a slide show.

Setting up a slide show

1) Select **Slide show**.

2) Choose 🖵 **All images**. Press ▲ / ▼ to change this to 🖩 **Date**, ■ **Folder**, 🎬 **Movies**, 📷 **Stills**, 🔒 **Protect**, or ★ **Rating** as required. When 🖩 **Date**, ■ **Folder**, or ★ **Rating** is selected you can view and alter the options for these functions by pressing **INFO.**. The images that are displayed during the slide show are filtered according to the choices you make at this stage. Press ⚙ when you're finished.

3) Select **Set up**. Highlight **Display time** to choose how long each image will remain on screen. Set **Repeat** to either **Enable** or **Disable** depending on whether you want your slide show to repeat once it's run through the selected images. **Transition effect** lets you set how one image replaces another during the slide show, while **Background music** allows you to choose what music to play during the slide show (the music must be copied to the memory card installed in your camera using the supplied EOS Utility software). Press ⚙ once you have set all the required options.

4) Select **Start** to begin the slide show.

5) To pause and restart the slide show press ⚙. Press MENU to stop the slide show and return to the main **Slide show** screen.

Note:
The images in a slide show will be displayed according to how you have playback set up. Press **INFO.** to change the display mode during the slide show if required.

› Image jump w/🔅

Image jump w/🔅 lets you choose how your camera skips through images as you turn 🔅 in single image playback—this becomes more important the greater the number of images you have on the memory card.

Symbol	Description
🔂	Display one image at a time.
🔟	Jump 10 images at a time.
💯	Jump 100 images at a time.
📅	Display images by date.
📁	Display images by folder.
🎬	Display movies only.
📷	Display still images only.
★	Display by rating.

Note:
If you have not rated any of your images, you cannot use 🔅 to jump through them.

› AF point disp.

When **AF point disp.** is set to **Enable**, the AF point(s) that were used to achieve focus are displayed over your still images. This is a useful (but crude) way to check that the focus is where you intended it to be. However, as **AF point disp.** obscures part of your image, it can prove distracting—to see "clean" versions of your shots set this option to **Disable**.

› Histogram display

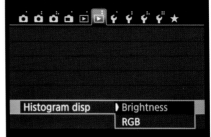

Both the EOS Rebel T6s/760D and EOS Rebel T6i/750D can display a **Brightness** or **RGB** histogram when showing detailed shooting information in playback mode (and both together, with the loss of some useful shooting information). Choose which histogram you'd prefer to see with detailed shooting information.

› Ctrl over HDMI

When your camera is connected to a CEC HDMI compatible television, setting **Ctrl over HDMI** to **Enable** allows you to use the TV's remote control to control certain aspects of the camera's playback functions. If your television is not compatible, set this option to **Disable**.

› Select folder

Every still image or movie that you shoot is stored in a folder on the memory card. When you format a memory card, a new folder is automatically created. However, you can create new folders at any time and use these instead. There are various reasons for doing this. You could, for example, create a new folder for a particular shooting session. This will keep those images separate from all the others on the memory card, so when it comes to copying your images to a computer you would only need to find and copy the images in that folder, rather than sorting through irrelevant images.

To create a new folder, choose **Select Folder**, followed by **Create Folder**, and **OK**. Folders use a three-number system, starting with 100 and continuing up to 999. The numbers are followed by the word CANON. The new folder number

will automatically be one number more than the highest folder number already on the memory card.

To switch to a specific folder, highlight the required folder on the **Select folder** screen and press ⑨. Until you choose or create a new folder, all subsequent images and movies will be saved in this folder.

› File numbering

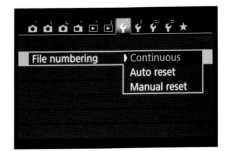

Every time a file is written to the memory card it is assigned a file name. The last four characters before the file type suffix are numbers—a count of the number of images you've created starting from 0001. If you set **File numbering** to **Continuous**, the count continues up to 9999 before reverting to 0001, even if you use multiple folders and memory cards. However, select **Auto reset** and the count will be reset to

0001 every time an empty memory card is used. Alternatively, you can select **Manual reset** to create a new folder on the memory card and reset the count to 0001.

> **Notes:**
> The first four characters of a still image are IMG_. Movie files start with MVI_.
>
> If you create a folder on the memory card when it is connected to your computer, it must use the same naming convention. The five-letter word can only use alphanumeric characters (a–z, A–Z, or 0–9) or an underscore "_." No other characters (including "space") are allowed.

› Auto rotate

This option allows you to choose whether vertical images are rotated after shooting. If an image is rotated, it will be in the correct orientation on the LCD screen during playback; the downside is that the image will not fill the screen entirely.

If an image isn't rotated, it will fill the camera's LCD screen on playback, but you will need to turn your camera 90° to view

images that have been shot in an upright ("portrait") format.

Selecting **On** ☐ 🖵 rotates the images so they remain vertical on the LCD screen and your computer (once they've been copied there from your memory card).

On 🖵 does not rotate the images when you view them on the LCD screen, but it does rotate them so they're in the correct orientation on your computer.

Off does not rotate the images on either your camera or your computer, so you will need to use image-editing software to rotate your pictures.

› Format

Allows you to format your SD memory card (see page 31 for more details).

› Wi-Fi/NFC/Wi-Fi function

Lets you configure your camera's Wi-Fi settings, as outlined on pages 231–232.

› Eye-Fi settings

Used for Eye-Fi memory card control (and is only visible when an Eye-Fi card is being used in the camera). See page 233 for more on Eye-Fi memory cards.

› Auto power off

› LCD brightness

If you leave the controls of your camera untouched, it will eventually go to "sleep" to conserve power. **Auto power off** allows you to choose how long this takes. There are seven options: **30 sec., 1, 2, 4, 8,** or **15 min.**, or you can **Disable** this function.

When the camera is asleep, it can be woken by lightly pressing the shutter-release button, MENU, **INFO.**, ▶, or ▣. When set to **Disable**, the camera will not power down, although the LCD screen will switch off after 30 minutes of inactivity (or if you press **INFO.**).

Allowing your camera to enter sleep mode uses less power than continually switching the camera on and off (powering your camera up and down activates sensor cleaning, which is a drain on the battery). Sleep mode also has the benefit that your camera is ready to use with a simple press of a button.

The camera's rear LCD screen can be difficult to see in bright light, but you can alter the brightness of the screen on both the EOS Rebel T6s/760D and EOS Rebel T6i/750D to compensate. Open the **LCD brightness** screen and press ◀ to darken the display or ▶ to brighten it. Ideally, you should be able to distinguish all eight of the gray bars at the right of the screen. When you're finished, press ⑤ to exit **LCD brightness**.

Note:
No matter how dark or bright the LCD screen is, do not be tempted to use the image displayed in Live View or on playback as a way of assessing exposure. A far more objective method is using the Live View or playback histogram.

› LCD off/on btn.

When **LCD off/on btn.** is set to **Shutter btn.** on the EOS Rebel T6i/750D, the rear LCD screen turns off automatically when you press the shutter-release button down halfway, and reactivates when you release the shutter-release button. This is the recommended option, as it can be very distracting to have the LCD on when you look through the viewfinder.

A variation of this is **Shutter/DISP.** When this option is selected, the LCD screen won't turn back on until you press **DISP.** after releasing the shutter-release button.

You can also leave the LCD screen on permanently (even when you press down halfway on the shutter-release button) by selecting **Remains on**. Although this may be distracting when you look through the viewfinder, it does mean that you'll always know what settings have been selected, even when the shutter-release button is held down.

LCD off/on btn is only available on the EOS Rebel T6i/750D.

› LCD auto off

Above the viewfinder of the EOS Rebel T6s/760D is a sensor that detects when something (typically your face) is in close proximity to the viewfinder. If **LCD auto off** is set to **Enable**, the LCD screen will automatically switch off when it detects something nearby.

To stop this happening, so the LCD stays on regardless, set **LCD auto off** to **Disable**. This is particularly useful if you fit an angle finder accessory to the viewfinder, as this is likely to cover the sensor, therefore switching off the LCD screen.

LCD auto off is only available on the EOS Rebel T6s/760D.

› Date/Time/Zone

Allows you to set the correct date, time, and time zone, as detailed on pages 28–29.

3

› Language

› Viewfinder display

Both the EOS Rebel T6s/760D and EOS Rebel T6i/750D can display the menu and shooting options in the following languages: English, German, French, Dutch, Danish, Portuguese, Finnish, Italian, Ukrainian, Norwegian, Swedish, Spanish, Greek, Russian, Polish, Czech, Hungarian, Romanian, Turkish, Arabic, Thai, Simplified Chinese, Chinese (traditional), Korean, and Japanese. Although it can be fun to set the language to one other than your own, be careful that you can find this option again to restore the menu system to a more familiar language.

The viewfinder of the EOS Rebel T6s/760D and EOS Rebel T6i/750D has a transparent LCD panel built into it. This means that you can **Show** or **Hide** three useful pieces of information as needed:

Viewfinder level adds a spirit level that shows how level (or not) the camera is (EOS Rebel T6s/760D only).

Grid display adds a 3 x 3 grid to the viewfinder.

Flicker detection sets whether **Flicker!** is displayed in the viewfinder if the camera detects that it is shooting under a light source with rapidly altering levels of brightness (see **Anti-flicker shoot.** on page 114).

› GPS device settings

Accesses settings that are only available when the GP-E2 GPS unit is fitted (see page 210).

» COLOR

Fluorescent lighting isn't ideal for shooting under, as it often has a green color cast that makes skin tones look unnatural. This shot required a heavy increase in the magenta color balance in order to counter this green tendency.

Settings
> Focal length: 50mm
> Aperture: f/2.8
> Shutter speed: 1/60 sec.
> ISO: 800

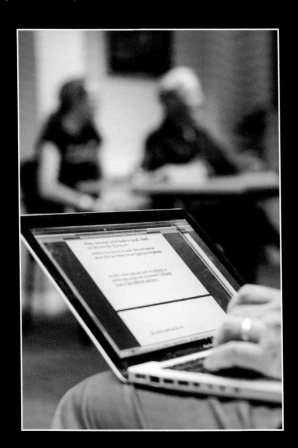

› Screen color

› Feature guide

Screen color allows you to change the background color of your camera's menu screens. You can choose between **1** (black—the default setting), **2** (light gray), **3** (brown), **4** (blue), or **5** (red).

The color you choose is a personal decision, but **5** is a good option if you like to shoot in low light, as it's relatively subdued and won't affect your night vision as much as the others.

When **Feature guide** is set to **Enable**, your camera will display handy notes when you are changing options on the menu system, Quick Control menu, or when selecting a different shooting mode. These notes are simple explanations of the option or mode as it's selected.

Once you feel confident about using your camera, selecting **Disable** will turn these notes off. This will marginally speed up the operation of your camera and make the LCD screen feel less cluttered.

› Touch control

› Battery info.

There are many reasons to **Disable** the LCD screen's touch control, one of which is to prevent the accidental setting of functions without realizing it. You may even not like the touchscreen feature, as using the touchscreen invariably adds smears to the LCD from your fingers.

Select **Standard** or **Sensitive** (for more responsive selection when touching) if you want to switch touchscreen functionality back on again.

Batteries don't last indefinitely; the more you use and recharge them, the less efficient they will become at holding a charge. **Battery info.** allows you to check the condition of your battery so you can assess its performance. If you find your battery doesn't hold power, it is likely that it is coming to the end of its useful life. When the **Recharge performance** bar shows a single red bar, the battery should be replaced.

Battery info. also displays the **Remaining cap.** (the amount of charge left) of the battery, using the battery icons described on page 24.

The default setting for **Auto cleaning** is **Enable**. This means that every time you switch your camera on or off the sensor is cleaned, which is a process that takes a second or two.

If you set **Auto cleaning** to **Disable**, the sensor will not be cleaned, which will gain you a few seconds each time you switch the camera on (or off). However, it will also increase the likelihood that you'll lose that time—and more—cloning out specks of dust from your images in postproduction.

If you start to notice specks of dust in your images as you shoot, you can force the camera to **Clean now**. However, the camera's sensor-cleaning system only works with dry particles of dust—it can't remove specks and marks caused by moisture or lubricants.

Instead, this type of "wet" mark needs to be cleaned off using a commercial sensor cleaning system, such as a swab and cleaning fluid. To do this, select

Clean manually to raise the mirror and expose the sensor. Note that manual cleaning should only be attempted with a freshly charged battery, and only if you're confident that you know what you're doing—if you get it wrong you could scratch the surface of the low pass filter, resulting in an expensive repair bill.

> **Note:**
> Dust becomes more prominent at smaller aperture settings, so it is a good idea to try and use the largest aperture you can and focus precisely, rather than using a small aperture and relying entirely on depth of field for image sharpness.

› INFO. button display options

This option determines what information is displayed on the LCD as you repeatedly press **INFO.** in shooting mode. You can choose between: **Displays camera settings**, **Electronic level**, and **Displays shooting functions**.

INFO. button display options is only available on the EOS Rebel T6s/760D.

› Video system

There are two main television standards in use around the world. If you want to connect your camera to a TV, you should use **Video system** to select the standard relevant for your location: the **NTSC** standard is used in North America and Japan, while the **PAL** standard is mainly used in Europe, Russia, and Australia. The choice you make will affect the options available in **Movie rec. size**.

› Certification Logo Display

This option is one that you may look at once (if at all) and then never again. When selected, it allows you to view the logos of organizations that have certified that aspects of the EOS Rebel T6s/760D or EOS Rebel T6i/750D have met or passed a particular standard or requirement.

› Custom Functions (C.Fn)

Custom Functions (C.Fn) let you fine tune the operation of your camera to suit your personal way of working. There are 13 common custom functions, plus an additional one on the EOS 760D/Rebel T6s. These functions are divided into four groups, based on type: C.Fn I: Exposure, C.Fn II: Image, C.Fn III: Autofocus/Drive, and C.Fn IV: Operation/Others.

Custom functions can only be altered when using Creative Zone modes.

Setting custom functions
1) Select **Custom Functions (C.Fn)**.

2) Press ◄ / ► to skip between the 13 custom function screens. Press ⓈⒺⓉ when you reach the custom function that you want to alter. At the bottom of the LCD the current custom functions' settings are displayed below their respective numbers.

3) Press ▲ / ▼ to highlight the desired option and press ⓈⒺⓉ to select that option.

4) Repeat steps 2 and 3 if there are other functions you wish to alter. If not, press MENU to return to the main 📷 screen.

C.Fn I: Exposure		📷 shooting	🎥 shooting
1	Exposure level increments	Yes	Yes
2	ISO expansion	Yes	In **M**
C.Fn II: Image			
3	Highlight tone priority	Yes	Yes
C.Fn III: Autofocus/Drive			
4	AF-assist beam firing	Yes[1]	No
5	AF area selection method	Yes[2]	No
6	Auto AF point selection: Color tracking	Yes[2]	No
7	AF point display during focus	Yes[2]	No
8	VF display illumination	Yes[2]	No
9	Mirror lockup	Yes[2]	No
C.Fn IV: Operation/Others			
10	Shutter/AE lock button	Yes	Yes
11	Assign ⑤ button	Yes (except option 3)	Yes (except option 2 and 3)[3]
12	LCD display when power ON	Yes	No
13	Multi function lock[4]	Yes	Yes
14[5]	Retract lens on power off	Yes	Yes

[1] Settings 1 and 4 do not apply when shooting movies
[2] Not available during Live View shooting
[3] Option **5: ISO Speed** is only available when using Manual exposure shooting
[4] EOS Rebel T6s/760D only
[5] C.Fn 13 on EOS Rebel T6i/750D

› C.Fn I-1 Exposure level increments

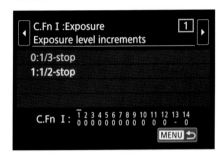

This option allows you to set either **1/3-stop** or **1/2-stop** increments for exposure operations such as shutter speed, exposure compensation, and so on. When set to **1/2-stop**, the exposure controls will be coarser, making it less easy to set the precise exposure. However, selection will be speeded up slightly, as there is a smaller range of options to choose from.

› C.Fn I-2 ISO expansion

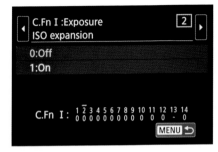

An extra ISO option—"H"—is added when **ISO expansion** is set to **On**. This is equivalent to ISO 25,600 when shooting still images, and ISO 12,800 when shooting movies. The downside to this extra option is a noticeable increase in noise, so while it is useful if you need to maintain a certain exposure setting in low light, it is best avoided if not (set **ISO expansion** to **Off** to avoid accidentally setting H).

> **Note:**
> The H setting cannot be used when Highlight tone priority is enabled.

› C.Fn II-3 Highlight tone priority

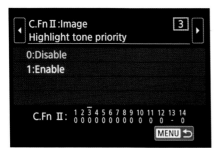

High-contrast lighting is often problematic, and can require a compromise to be made between retaining detail in the highlights or in the shadows.

When **Highlight tone priority** is set to **Enable**, your camera will attempt to prevent highlight areas from overexposing. If you're a wedding photographer, this can prove invaluable, as the contrast range at weddings—from the white of the bride's dress to the black of the groom's suit—is often considerable.

The downside is a risk of increased noise in shadow areas. **Highlight tone priority** also restricts the ISO range to ISO 200–12,800 (ISO 200–6400 for movies).

Highlight tone priority can be used when shooting JPEG or Raw, but is better suited to JPEG, as there is less leeway for reclaiming highlight detail when shooting JPEGs. When shooting Raw, **Highlight tone priority** can be removed in postproduction, or you can achieve the same effect as

Highlight tone priority by underexposing your images by 1 stop and then adjusting the tone curve in postproduction to increase the overall exposure without losing highlight detail.

When set to **Enable, D+** will be displayed in the viewfinder and on the rear LCD screen.

> **Note:**
> Auto Lighting Optimizer cannot be used at the same time as Highlight tone priority.

› C.Fn III-4 AF-assist beam firing

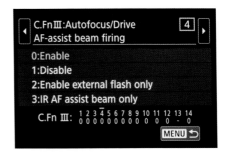

When the light levels are low, and **AF-assist beam firing** is set to **Enable**, the built-in flash or an attached Speedlite will pulse light to help the camera's AF system.

Disable turns this function off, while **Enable external flash only** will only use an attached Speedlite. Selecting **IR AF assist beam only** uses the infra-beam available on certain Speedlites to assist the autofocus.

› C.Fn III-5 AF area selection method

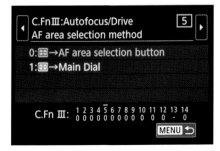

This option allows you to alter the way that you switch between the AF area selection modes. The default setting is ⊞ **AF area selection button**, which allows you to switch between the three AF area selection modes by repeatedly pressing ⊞.

When set to ⊞ **Main Dial**, you turn ⚙ to set the AF area selection modes, after pressing either ⊞ or ⊞. Which option you choose depends entirely on personal preference.

› C.Fn III-6 Auto AF point selection: Color tracking

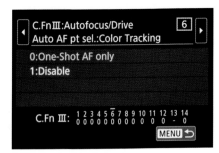

Auto AF pt sel.: Color tracking is designed for shooting portraits when you are using the viewfinder (so don't have the useful Live View facial recognition of 🔲+Tracking).

In this instance, **Auto AF pt sel.: Color tracking** looks for tones in a scene that are similar to skin tones and focuses on these areas. The main restriction is that you can only use color tracking when the AF is set to One Shot AF and you are using Zone AF area selection.

Select **One-Shot AF only** to activate color tracking, or **Disable** to turn it off. Due to the extra processing of information, focusing will always be marginally slower when **One-Shot AF only** is selected.

› C.Fn III-7 AF point display during focus

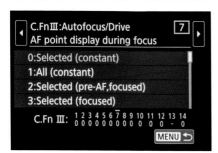

› C.Fn III-8 VF display illumination

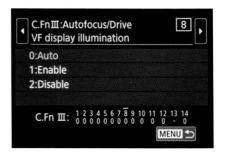

AF point display during focus allows you to set how and when AF points are displayed. **Selected (constant)** displays the selected AF point(s) or zones both before and after focusing; **All (constant)** displays all of the AF points, regardless of whether they are selected or not; **Selected (pre-AF, focused)** displays the AF points when you select them, before you begin to focus and when focus is locked; **Selected (focused)** only displays the AF points when you select them, and the camera locks focus; **Disable display** will only display the AF points when you choose them (after that, they will not be displayed, even when focus is locked).

VF display illumination is another option that should be set according to personal preference. You can **Enable** the AF points to light red when focus is achieved, or **Disable** this facility. Set to **Auto**, the AF points only light when focus is achieved and the ambient light level is low.

Set **Mirror lockup** to **Disable** to return to normal shooting.

> ***Notes:***
> The mirror is always in the up position during Live View, so switching to Live View effectively achieves the same thing as activating **Mirror lockup**.
>
> If the shutter-release button isn't pressed within 30 seconds of you flipping the mirror up, the mirror will return to the down position automatically.

There are many causes of camera shake, but one that is often overlooked is the camera itself. The mirror inside a DSLR camera can cause significant vibrations through the body when it is swung upward during an exposure.

The solution is **Mirror lockup**. When set to **Enable**, pressing the shutter-release button once will lock the mirror in the "up" position, but without taking a shot. You have to press the shutter-release button a second time to make the final exposure, and as the mirror is already raised, any vibrations are minimized. After the exposure has been made, the mirror will return to the down position as normal.

The main drawback to **Mirror lockup** is that the view through the viewfinder is blocked when the mirror flips up. Therefore, **Mirror lockup** is only really suitable when you're using a tripod and there's no chance that your composition will change accidentally.

› C.Fn IV-10 Shutter/AE lock button

This option sets how focus and exposure are activated or locked using the shutter-release button and the ✱ button.

AF/AE lock activates both metering and autofocus when the shutter-release button is pressed down halfway; pressing ✱ locks the exposure.

Choose **AE lock/AF** and ✱ activates autofocus; pressing the shutter-release button down halfway activates and locks the exposure.

With **AF/AF lock, no AE lock**, AF is temporarily locked for as long as ✱ is pressed, provided that AF is set to AI Servo AF mode. The exposure is not set until the shutter-release button is pressed down fully.

AE/AF, no AE lock sets ✱ to start or stop AI Servo AF operation; the exposure is not set until you press the shutter-release button down fully.

› C.Fn IV-11 Assign ⑤ET button

The ⑤ET button can be reprogramed so that a different function is selected when you're in shooting mode. Assigning a particular function to ⑤ET can help make your use of your camera more efficient, but which option you choose will depend on your shooting style.

Image quality calls up the image quality screen, allowing you to swap quickly between JPEG and Raw.

Flash exposure comp. displays flash exposure compensation, which will apply either to the built-in flash or an external Speedlite if one is fitted and switched on.

LCD monitor On/Off lets you turn the LCD on and off by pressing ⑤ET.

Menu display duplicates the function of the MENU button and calls up the last menu screen you viewed.

ISO speed displays the ISO setting screen when you press ⑤ET.

You can also **Disable** ⑤ET so that no function is assigned to the button.

3

› C.Fn IV-12 LCD display when power ON

This option sets the status of the LCD screen when you switch your camera on. When **Display on** is selected, the shooting settings screen is displayed. If you select **Previous display status**, when your camera is switched off with the LCD screen turned off (by pressing **INFO.**) the LCD screen will not come on initially when you turn your camera back on. The LCD screen is only switched on by pressing **INFO.** This is a useful way to save power, albeit in a minor way.

› C.Fn IV-13 Multi function lock

By default, when the **LOCK▶** switch is moved left it locks the ◌ to prevent the wrong function being set by accident. You can set **LOCK▶** to lock ⬡ as well, or to lock neither control. Highlight the control you want to set as lockable (or to protect from being locked) and press ⑤. A ✓ is shown at the left of the control's description when it's locked.

Multi function lock is only available on the EOS Rebel T6s/760D.

› C.Fn IV-14 Retract lens on power off

A few of Canon's newer STM lenses have front elements that extend beyond the end of the lens barrel. To protect the front element you can set your camera to automatically **Retract lens on power off** (you can still manually retract the lens before you power off if required).

Retracting the lens not only protects the lens, it also makes it physically smaller, so it is easier to fit into a camera bag or jacket pocket. Set this option to **Disable** if you want the lens front element to stay extended when you power off.

Retract lens on power off is **C.Fn IV-13** on the EOS Rebel T6i/750D.

Warning!

Do not try to retract the front element when the camera is switched off or when the lens is off the camera—this will damage the lens.

› Copyright information

Every image you shoot belongs to you, unless you assign the copyright to another person or party. This means that if someone uses one of your images without permission you have the legal right to request payment (although actually receiving the payment is another matter, and unfortunately it's often not worth the time or effort pursuing minor infractions).

The first step in establishing your legal right of ownership is to add your copyright details to the metadata of your images. To make this process easier, you can set your camera to automatically add those details to every image you shoot.

A very current issue for photographers is the concept of the "orphan" image. These are digital images that apparently belong to no one because information about ownership has been lost. This can lead to the images being used without attribution and—more importantly—without recompense to the photographer. To avoid this happening to you, it is highly recommended that you add **Copyright information** when setting up your camera.

3

Setting copyright information
1) Select **Copyright information**.

2) Select either **Enter author's name** or **Enter copyright details**.

3) On the text entry page, press ⒬ to jump between the text entry box and the rows of alphanumeric characters below. Press ✛ or turn ⚙ to highlight the required character, and then press ⒮ᴇᴛ to add it to the text entry box. Alternatively, press the required letters on the LCD screen. If you accidentally insert the wrong character, press 🗑 to delete it.

Select **Aa≠1@** to switch between lower case letters, numbers/symbols 1, numbers/symbols 2, and upper case letters.

4) When you've completed the text entry, press MENU to save the details and return to the main **Copyright information** menu, or press **INFO.** to return to the main **Copyright information** screen without saving your changes.

Other Copyright information settings
Selecting **Display copyright info.** shows the currently set copyright information. If no copyright information is set, the option is grayed out and cannot be selected.

Selecting **Delete copyright information** removes the copyright information set on the camera (but not from the metadata of any images already saved to the memory card). Again, if no copyright information is set, this option is grayed out and cannot be selected.

› Clear settings

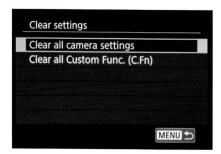

Clear settings allows you to either reset your camera back to its original factory settings, or to clear all the custom functions you may have changed. Think carefully before you select either option, as you cannot undo this decision!

Clearing settings
1) Select **Clear settings**.

2) Select either **Clear all camera settings** or **Clear all Custom Func. (C.Fn)**, then select **OK** to reset your camera.

Alternatively, choose **Cancel** to return to the **Clear settings** sub-menu without clearing the settings.

› Firmware ver.

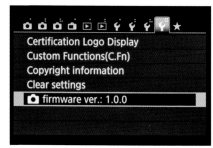

Your camera has built-in software—known as "firmware"—that ensures everything runs as it should. However, no camera is flawless and bugs in firmware inevitably come to light. At the time of writing there are no known issues with either the EOS Rebel T6s/760D or the EOS Rebel T6i/750D, but that doesn't mean that there aren't any. Should serious bugs come to light, Canon will release new firmware to cure these problems. The company may also issue new firmware to add features to a camera.

Canon will announce when an update to the firmware is available on its web site, as well as by email to registered users. This information is also generally relayed via photography news sites. Full instructions on how to update your camera will be included with the firmware, but if you're not confident about doing this yourself, you can have it updated for you at a Canon Service Center (although you will be charged a fee for the privilege).

My Menu allows you to compile a list of six of your most commonly used menu settings, so they can be found and altered quickly and conveniently.

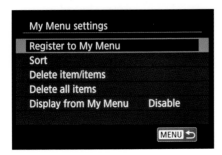

Adding options to My Menu
1) Press MENU and navigate to the ★ tab.

2) Select **My Menu settings**, followed by **Register to My Menu**.

3) Press ▲ / ▼ or touch the arrows on the LCD screen to move up and down the function list.

4) Press ⑤ when an option you want to add to My Menu is highlighted. Select **OK** to continue, or **Cancel** to return to the **Register to My Menu** screen without adding the function. When a function has been added, it will be grayed out and can no longer be selected.

5) Continue to add functions as required and then press MENU to return to the My Menu settings menu.

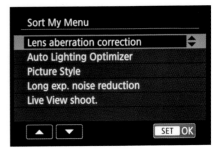

Sorting options registered to My Menu
1) Press MENU and navigate to the ★ tab.

2) Select **My Menu** settings, and then choose **Sort**.

3) Highlight the item that you want to move and press ⑤. Press ▲ / ▼ or touch the arrows on the rear LCD screen to move the item up and down the list. Press ⑤ when you're done.

4) Repeat step 3 to move other items up or down the list.

5) Press MENU to return to the main **My Menu** screen.

» MOVIE SHOOTING 1

Deleting options registered to My Menu
1) Press MENU, navigate to the ★ tab, and select **My Menu settings**.

2) To delete individual options from the list select **Delete item/items**. Highlight the option you want to delete, press ⑯, and then select **OK** to delete the option, or **Cancel** to return to the option list.

3) To delete every option on the list select **Delete all items**, followed by **OK**.

› AF method

AF options for movie shooting based on Live View AF. See page 43–44 for details.

› Movie Servo AF

Setting **Movie Servo AF** to **Enable** activates continuous focus during movie recording. However, unless you are using an external microphone or one of Canon's new STM lenses, there's a real risk that the noise of the lens' AF motor will be recorded on your movie's soundtrack.

The other drawback with using AF during movie recording with a standard lens is that focusing isn't particularly quick—it can take a second or more for focus to lock successfully. If you do need to refocus (and there's a reasonable distance from the first focus point to the second), then it is often better to pause recording, refocus, and possibly even recompose your

shot as well. The two movie clips could then be stitched together in postproduction to make a seamless sequence.

Set **Movie Servo AF** to **Disable** to stop AF during movie recording. However, you can also stop AF temporarily during movie recording by pressing ⚡ or by tapping 🔲SERVOAF on the LCD screen (and then re-tapping 🔲SERVOAF to enable AF again). Pressing halfway down on the shutter-release button will always force the camera to focus, regardless of which option you choose on **Movie Servo AF**.

› AF with 👁 during movie rec.

You can shoot still images when recording movies by pressing down fully on the shutter-release button. Setting **AF with 👁 during movie rec.** to **One-Shot AF** will force the camera to focus before the shutter is fired. **Disable** allows you to shoot a still image whether the lens is focused correctly or not.

› Grid display

See page 117 for details.

› Metering timer

See page 118 for details.

» ROLLING

There's nothing more off-putting than watching movie footage that rolls and sways constantly (it can cause nausea in the viewer, which is similar to sea-sickness). If possible, shoot movie footage with your camera on a tripod.

Settings
> Focal length: 200mm
> Aperture: f/8
> Shutter speed: 1/1000 sec.
> ISO: 400

› Movie rec. size

Movie rec. size lets you set the resolution and frame rate of your movies. The options that are shown will vary depending on whether **Video System** on the menu is set to **PAL** or **NTSC**.

Resolution (pixels)	
FHD (1920 x 1080)	Full HD recording with a 16:9 aspect ratio.
HD (1280 x 720)	HD recording with a 16:9 aspect ratio.
VGA (640 x 480)	Standard definition recording with a 4:3 aspect ratio. Suitable for analog TV and Internet use.
Frame rate	
29.97P/59.94P	For use in NTSC TV standard areas (North America and Japan).
25.00P/50.00P	For use in PAL TV standard areas (Europe, Russia, and Australia).
23.98P	For conversion to motion picture/cine film standard. Arguably, 24fps footage looks more natural, although there may be issues converting footage shot at 24fps to 25fps or 30fps for standard HDTV broadcasting.

› Digital zoom

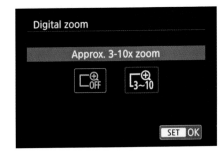

This option allows you to zoom into a scene as you record a movie, effectively extending the reach of any lens you fit to your camera by 3–10x.

Unfortunately, there are limitations: you have to be shooting a **FHD** movie, and **Digital zoom** is achieved by cropping the movie and then resizing the cropped area back to the selected movie resolution. The resizing is achieved through "interpolation," which is a method of filling in gaps in data by inserting values that logically bridge that gap—basically, the camera makes its best guess as to the pixels that need adding. The more you zoom digitally, the more the image data is interpolated, which means there will be fewer "true" pixels in the image. This will result in a noticeable drop in quality.

The higher the ISO, the more ugly any interpolation will look, so for this reason,

the maximum ISO is limited to ISO 6400. Even so, if you plan to use **Digital zoom**, it is best to set the ISO as low as possible.

If you're aware of the limitations of **Digital zoom**, and can work round them, you'll find it a useful feature. It will help you get close-up footage that wouldn't be possible unless you invested heavily in extremely long focal length lenses.

Digital zoom is only available on the EOS Rebel T6s/760D.

indicates that the digital zoom is at its maximum setting (10x).

3) Press ▼ to zoom out. As you zoom out, the bar will drop toward 🔽. When it reaches 🔽 you've set digital zoom to its minimum setting (3x).

4) Set **Digital zoom** to **Disable** to return to standard movie shooting mode.

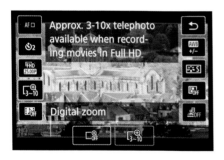

Using Digital zoom
1) Set **Digital zoom** to **Approx. 3-10x zoom** and press lightly down on the shutter-release button to return to movie shooting mode.

2) Press ▲ to zoom in. As you zoom in, a bar at the right side of the screen will rise toward 🔼. When the bar reaches 🔼, this

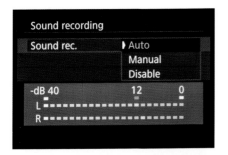

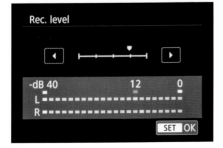

have your peak (or loudest) sound level reach the -12dB level; any higher and the recorded sound may be distorted. When **Sound rec.** is set to **Disable**, no sound will be recorded.

If you set **Wind filter** to **Enable**, your camera will try to eliminate wind noise from your movie's soundtrack during recording. This achieves the same effect digitally as a foam windshield on an external microphone. **Disable** the function if you're shooting indoors or in calm conditions in order to avoid degrading the quality of the recorded sound.

When set to **Enable**, **Attenuator** tries to reduce the effects of random loud noises that may occur during movie recording. As with **Wind filter**, switch **Attenuator** to **Disable** if you're confident there won't be any problems with sound during recording.

> **Note:**
> If you are using a Basic Zone mode you can only turn **Sound recording** **On** or **Off**.

A movie's soundtrack is as vital to its success as the visuals. **Sound rec.** gives you control over the volume of your movie's soundtrack as it's recorded, either when using the built-in microphone or when an external microphone if fitted.

When you set **Sound rec.** to **Auto**, your camera will adjust the volume automatically as you record, while **Manual** allows you to set the volume level between 1 and 64. When **Manual** is selected, select **Rec. level** and then press ◄ / ► or tap the arrows on the LCD screen to set the volume. Aim to

› Video snapshot

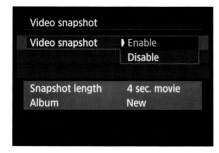

A video snapshot is a short video clip that can be a **2 sec. movie**, **4 sec. movie**, or **8 sec. movie**—the choice of clip length is made when **Video snapshot** is switched to **Enable**.

Once activated, the snapshots that you shoot are collected together into albums that you create by choosing **Create a new Album** from the **Album Settings** menu. Every time you subsequently record a movie, the clip will last for the specified duration. You can then choose how the snapshot is saved (right).

When you've created several snapshots in an album you can view them together by pressing ▶. An album is distinguished from a standard movie by **SET** **🕮** appearing at the top left corner of the LCD screen. You can alter the order or delete snapshots using the Edit panel described earlier in this chapter, saving the results as a complete movie.

Option	Notes
🎬	**Save as album** The snapshot is saved as the first clip in an album.
🎬	**Add to album** The snapshot is added to the last album selected.
⤵	**Save as new album** A new album is created and the snapshot is saved as the first clip in the new album.
📺	**Playback video snapshot** Replay the newly created snapshot.
🚫	**Do not save to album/ Delete without saving to album** The snapshot is discarded without saving.

4 LENSES

Canon has been producing EOS lenses since 1987. This means there's a huge range of lenses available for your camera—if you're prepared to consider pre-owned and third-party lenses, the choice is in the hundreds.

Canon currently produces over 70 different lenses, covering everything from ultra-wide-angle lenses that are suitable for architecture and landscape photography, through to extremely long focal lengths that are ideal for wildlife photography, sports, and photojournalism. Some of the lenses available are even more specialist; Canon produces four tilt-and-shift lenses that probably wouldn't be used every day, but are invaluable when you need them.

This chapter is an introduction to EOS EF and EF-S compatible lenses, including those produced by third parties. It will cover some of the concepts you'll need to understand in order to make an informed decision about other types of lenses you may want to add to your camera bag.

CELEBRATION ⌃
In 2014 Canon announced that it had manufactured its 100 millionth EF lens.

KIT LENS »
The EOS Rebel T6s/760D and EOS Rebel T6i/750D are both sold with kit lenses: either an 18–55mm or 18–135mm zoom. These lenses are good for everyday use, but they are not the finest lenses that Canon produces.

4 » ANATOMY OF A LENS

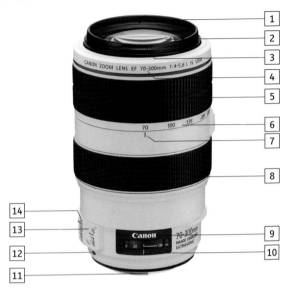

1	Filter thread	**11**	Lens mount
2	Front lens element	**12**	Lens mount index
3	Lens hood mount	**13**	AF/MF switch
4	Lens information (model/focal length/maximum aperture/features)	**14**	Image Stabilization switch
5	Zoom ring[1]		
6	Focal length range		
7	Focal length index mark		
8	Focus ring		
9	Focus distance window[2]		
10	Focus distance index		

[1] Some zoom lenses (typically L-series) have the zoom ring at the front of the lens, with the focus ring to the rear. Other zooms (typically "consumer" lenses) reverse this. This makes it less intuitive to swap between different types of lens.

[2] Not every Canon lens features a distance scale. EF-S lenses typically don't have a focus distance indicator.

⟩⟩ LENS RANGES

Canon's EOS lens range is split into three main groups. The first—EF-M lenses—are designed purely for Canon's M compact system, so are of little use on either the EOS Rebel T6s/760D and EOS Rebel T6i/750D.

More relevant is the second group: the EF-S range. These are lenses designed specifically for Canon's DSLRs that use APS-C sensor cameras, which includes the EOS Rebel T6s/760D and EOS Rebel T6i/750D. These lenses cannot be fitted to Canon's full-frame cameras.

The third group—EF lenses—can be fitted to both APS-C and full-frame DSLRs (and to EF-M cameras via an adaptor). EF lenses make up the bulk of the Canon lens range, with a lineage that stretches back to the introduction of the first EOS camera in 1987. There are many discontinued EF lenses that are still compatible with your camera, and buying pre-owned is a useful and inexpensive way of expanding the range of lenses you own.

The EF range is further subdivided into L-series lenses and non-L lenses. L-series lenses are the very best lenses Canon produces, which is reflected in their price. Many L-series lenses use expensive technology such as fluorite glass lens elements and diffraction optics.

There are currently no L-series lenses in Canon's EF-S range.

Notes:
As EF-S lenses are incompatible with full-frame cameras, it may be wise not to buy too many if you anticipate using or owning a full-frame camera at some point.

Third-party lens manufacturers, such as Sigma, use their own naming convention to designate whether a lens is suitable for all EOS cameras or just for APS-C cameras. In Sigma's case, DC is equivalent to EF-S.

INCOMPATIBLE ⌃
The 18–55mm and 18–135mm kit lenses sold with the EOS Rebel T6s/760D and EOS Rebel T6i/750D are EF-S lenses, so they will not physically fit Canon's full-frame cameras.

 » **LENS TECHNOLOGY**

Canon employs a number of technologies to improve the handling, focusing speed, and optical performance of its lenses. Here, we explain these technologies, as well as outlining some of the problems that are overcome by them.

Dust and water resistance (DW-R)

Some of Canon's lenses are fitted with thin rubber seals around the periphery of the lens mount. This creates a dustproof and watertight seal when the lens is attached to a camera. DW-R is typically found on L-series lenses.

Diffractive Optics (DO)

DO lenses are smaller and lighter than an equivalent conventional lens, yet still boast a high optical quality. This is achieved through the use of special—and expensive—glass elements. There are currently two DO lenses in Canon's line-up, which can be distinguished by a green band around the lens barrel.

Fluorite glass

The use of fluorite glass in a lens helps to significantly reduce the effects of chromatic aberration. However, it takes four times as long to grind a fluorite glass lens element than one made of standard glass, which makes fluorite lens elements very expensive to produce. For this reason, fluorite glass is currently only found on L-series lenses, and even then it does not feature on every one.

Fluorine coating

Fluorine is used to provide a micro-thin, anti-static coating on the external glass elements of some Canon lenses. The coating is water repellent and makes cleaning the glass easier.

Image Stabilization (IS)

A growing number of Canon lenses—both primes and zooms—are equipped with the company's Image Stabilization (IS) technology. An IS system in a lens detects the slight movements that naturally occur when you handhold your camera and optical elements in the lens are constantly adjusted to compensate for this movement.

The most up-to-date iteration of Canon's IS system—Hybrid IS—can compensate for shutter speeds that are 5-stops slower than would normally cause camera shake. It can also compensate for angular velocity and shift.

IS should be turned off when the camera is mounted on a tripod.

Stepper Motor (STM)

STM is a type of AF motor that is designed to make focusing smoother, although it is

less speedy than USM. STM is more useful if you regularly shoot movies than if you principally shoot sports action still images.

Tripod collar

When a long, heavy lens is mounted to a camera, the center of gravity is shifted forward, away from the camera. When the camera is then attached to a tripod, this places a strain on the camera's lens mount and makes the entire system less stable. Attaching the camera/lens combination to the tripod using a collar around the lens reduces the strain, as the combination is better balanced.

Ultrasonic Motor (USM)

An autofocus motor built into the lens that allows fast, quiet, and accurate focusing. Canon uses two types of USM—ring-type and micro. The big advantage of the ring-type USM is that it allows full-time manual focusing in autofocus mode.

WILDLIFE ⌃
Although IS can reduce the risk of camera shake, it doesn't stop blur caused by subject movement. Use a fast shutter speed if it's likely that your subject will move as you shoot.

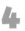

4 » LENS PROPERTIES

› Focal length

When parallel rays of light enter a lens focused at infinity (∞), they converge and form a sharp image at the focal plane. The sensor in a camera is placed at the focal plane, indicated by the ⊖ symbol at the left of the viewfinder housing on top of the camera (EOS Rebel T6i/750D) or at the right of the viewfinder (EOS Rebel T6s/760D). The focal length of a lens is the distance—in millimeters—from the optical center of the lens to the focal plane.

The focal length of a lens never changes, regardless of whether it is mounted on an APS-C camera or attached to a full-frame camera—focal length is a measurement of distance, nothing more. What does change when a lens is swapped between an APS-C and full-frame camera is the angle of view of the lens. This is referred to as the "crop factor."

› Angle of view

The angle of view is a measurement—in degrees (°)—of the extent of a scene that is projected by the lens onto the film or sensor. The angle of view can refer to either the horizontal, vertical, or diagonal coverage, but if just one figure is used it's generally safe to assume that it's referring to the diagonal coverage.

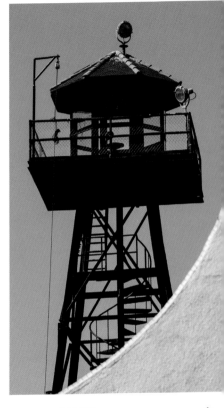

RESTRICTED VIEW ⌃
The longer the focal length of a lens, the narrower the angle of view. This scene was shot with a 120mm focal length, restricting the composition to just a few simple elements.

› Crop factor

The angle of view of a particular lens is typically given in reference to a full-frame sensor. This is because a full-frame sensor is the same size as a 35mm film frame, which was historically familiar to many photographers making the transition from film to digital.

However, it's extremely expensive to make full-frame sensors (which accounts for the high price of cameras such as Canon's EOS 5D series). Consequently, most DSLR cameras—including the EOS Rebel T6s/760D and EOS Rebel T6i/750D—use sensors that match a slightly smaller standard: APS-C (a smaller film format than 35mm).

The smaller sensor records less of the image projected by the lens, effectively "cropping" the scene. This means that a crop factor needs to be applied when calculating the angle of view of a lens on an APS-C format camera.

In the case of Canon's APS-C format cameras the crop factor is 1.6x, so a 50mm focal length will deliver an angle of view equivalent to an 80mm lens (50 x 1.6), and a 100mm focal length would deliver an angle of view more like a 160mm lens (100 x 1.6).

In practical terms, this means that a lens will appear to have a longer focal length. However, it's important to remember that the focal length has not changed, just the angle of view. All other aspects of the lens— such as the available depth of field at each aperture—is the same, no matter what the sensor size is.

CROPPED »
This image was shot on a full-frame camera with a 24mm focal length lens attached. The yellow inner rectangle shows the reduced angle of view that would have been recorded if I had used the same lens on an APS-C format camera, such as the EOS Rebel T6s/760D or EOS Rebel T6i/750D.

4 » LENS TYPES

› Prime lenses versus zooms

Lenses can be made so that they have a fixed focal length—a type of lens referred to as a "prime" lens—or they can have a variable focal length, which is commonly known as a "zoom" lens.

With a fixed focal length (such as 28mm, 50mm, 100mm, or 200mm), a prime lens makes you work harder as a photographer. You can't simply turn a zoom ring to change a composition—you have to move physically closer to or further from your subject to change the look of a shot.

That may not sound appealing, but it's part of the charm of using a prime lens, and the effort involved makes a successful image much more rewarding. With practice, it becomes easier to "see" shots that suit a particular prime lens—some street photographers use prime lenses exclusively, for this reason.

Another drawback to using prime lenses is that you will need multiple lenses to cover a good focal length range, and will likely find yourself changing lenses more often than if you were using a zoom (especially a "superzoom" covering an expansive focal length range).

Prime lenses have advantages, though. They tend to offer a larger maximum aperture than a zoom lens covering the same focal length, for example, which is advantageous if you regularly shoot in low-light conditions, or if you like to use a shallow depth of field for esthetic reasons.

Superior optical quality is another prime lens advantage. Zoom lenses are mechanically and optically more complicated than primes, and the need for them to work well across a range of focal lengths can mean compromises have to be made in their design. Although modern zooms are generally excellent, they are typically still beaten by primes when it comes to optical quality.

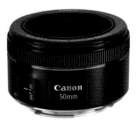

PRIMETIME
Canon's 50mm STM prime lens has a maximum aperture of f/1.8, which no zoom lens can match (with one notable exception shown on page 171).

› Wide-angle lenses

A wide-angle lens is generally thought of as any lens with a wider angle of view than a standard (50mm equivalent) focal length. The widest EF-S lens currently produced by Canon is the 10–22mm f/3.5–4.5 USM, which has an equivalent angle of view to a 16–35mm lens. If you wish to go wider still (into the realms of fish-eye lenses) the EF 8–15mm f/4L USM is the lens for you.

The wider the focal length of a lens, the more unnatural the perspective of an image will look, as you will typically be working from a much closer distance to your subject. As the camera-to-subject distance decreases, spatial relationships between elements in a scene are stretched, and distant objects will appear far smaller than they would if you were looking directly at the scene in question.

Landscape photographers frequently use wide-angle lenses, as their optical properties can help to create a sense of space in an image. However, wide-angle lenses are not flattering for portraits.

The most extreme wide-angle lenses are "fish-eye" lenses, which typically have a 180° angle of view.

BIG SKY »
Wide-angle lenses are an essential part of a landscape photographer's equipment. They can help to convey the epic sweep of a landscape or, as in this shot, the effects of a dramatic sky.

› Standard lenses

› Telephoto lenses

A standard lens is one with a focal length that approximately matches the diagonal measurement of the digital sensor in the camera to which it is mounted. On an APS-C camera, such as the EOS Rebel T6s/760D and EOS Rebel T6i/750D, the diagonal measurement of the sensor is 26.7mm, making a 28mm lens close to the definition of a standard lens.

"Standard" lenses get their name from the fact that images created with them have a pleasing, natural perspective. Unfortunately, this is often seen as a negative, because images don't have the same immediate impact as those shot with a wide-angle (or even a telephoto) lens. However, when an unfussy, documentary style is required, a standard lens is ideal.

The term telephoto has now become a synonym for any lens with a focal length longer than a "standard" lens. A telephoto lens magnifies the image on the sensor, and because of the increased working distance it appears to bring distant objects closer (narrowing the angle of view, so less of the scene is captured).

Longer telephoto lenses are popular with wildlife photographers who generally need to maintain a reasonable distance between themselves and their subject. Shorter telephoto lenses work well as portrait lenses as they produce a more pleasing perspective for facial features than a wide-angle lens.

SUPER-TELEPHOTO 〈〈
Canon's 100–400mm f/4.5–5.6L zoom lens is compact and highly portable.

» STANDARD FARE

The naturalistic qualities of a standard lens make it ideal for documentary subjects. The visual qualities of the lens don't draw attention to your technique to the detriment of the subject.

Settings
> Focal length: 42mm
> Aperture: f/3.2
> Shutter speed: 1/50 sec.
> ISO: 800

Parkin Biscuits
8 oz oats
8 oz flour
2 oz sugar
4 oz butter
8 oz treacle
pinch of salt
1 tsp bicarb of soda
½ tsp ground ginger

4 » OTHER LENS OPTIONS

› Teleconverters

A teleconverter is a secondary lens that fits between a camera body and the main lens (Canon uses Extender as a synonym of teleconverter). A teleconverter increases the focal length of the main lens by a given factor, and Canon currently makes two EOS teleconverters: a 1.4x model that increases the focal length by a factor of 1.4, and a 2x model that doubles focal length.

Teleconverters are a relatively inexpensive way of increasing the usefulness of your lens collection, but they have several drawbacks. For a start, not all Canon lenses can be used with a teleconverter. Indeed, some lenses will be damaged if you try and use them with a teleconverter (see the lens charts at the end of this chapter for details).

Image quality is also reduced in comparison to a non-extended lens of the same focal length.

Finally, a teleconverter reduces the amount of light passing through the lens system, effectively making the lens slower. In low light this can reduce the

effectiveness of the AF system considerably (as well as making the viewfinder darker). A 1.4x teleconverter loses 1 stop of light, while a 2x teleconverter loses 2 stops.

EXTENDER EF 1.4X III ⌃

EXTENDER EF 2X III ⌃

Teleconverter	Specifications	Dimensions (mm)	Weight (g)
Extender EF 1.4x III	7 elements / 3 groups	72 (w) x 27 (h)	225
Extender EF 2x III	9 elements / 5 groups	72 (w) x 53 (h)	325

› Tilt-and-shift lenses

A tilt-and-shift lens (or TS-E to use Canon's abbreviation) is a specialist, manual focus lens, and the company currently produces four options: a 17mm f/4L, 24mm f/3.5L II, 45mm f/2.8, and a 90mm f/2.8. Each of these can be used as a "normal" lens, or they can be set to perform one or both of two useful functions. The first function—tilt—allows you to angle the front element of the lens relative to the camera. The second function—shift—lets you move the front lens element up or down, left or right, relative to the camera.

Tilting the front element of a lens enables you to control the plane of focus in an image. This technique can be used to either throw large areas of an image out of focus (similar to the effect produced by the **Miniature effect** Creative Filter) or to increase sharpness throughout an image without resorting to the use of small apertures. This latter trait is useful when front-to-back sharpness is required, but you want to avoid diffraction.

Shifting the front element of a lens can be used to avoid "converging verticals." This is an optical effect caused when a camera is tilted backward (or forward) to fit a vertical subject into a composition. This results in the vertical lines of a subject

no longer appearing parallel to each other—typically seen when looking up to photograph tall buildings. Shifting a lens allows you to keep the sensor parallel to the subject (avoiding distortion), while adjusting your composition to include the required elements of your subject.

CANON TS-E 17MM ⌃
On the EOS 7D Mark II, the angle of view of the 17mm TS-E is equivalent to a 27mm lens on a full-frame camera. This makes it a useful wide-angle lens for architectural interiors. However, it is less useful as a "landscape" lens, as the bulbous front element makes it very difficult to fit filters.

You don't have to stick to Canon lenses if you decide to expand your lens collection. There are three main third-party manufacturers of lenses for the EOS system: Sigma, Tamron, and Tokina. Sigma and Tamron have extensive lens ranges that include both prime and zoom lenses, while Tokina's range is more modest, and is mainly composed of zoom lenses (the exception being a 100mm macro lens). A more niche range of lenses is produced by Zeiss, which manufactures manual focus prime lenses with superb optical quality.

Although third-party lenses were once seen as a "second-rate" option, modern offerings are often just as good—and sometimes even better—than the Canon equivalents. Not only that, but these lenses are typically cheaper than their Canon counterparts as well (the exception being the Zeiss lenses), providing you with a more cost-effective way of assembling a collection of lenses.

There are a few downsides when using a third-party lens, though. Canon doesn't support third-party lens profiles in-camera (and is unlikely to), so **Lens aberration correction** will not work. However, many image-editing programs can solve this problem relatively easily (at least when shooting Raw).

Another potential problem is the long-term compatibility of a third-party lens with a Canon camera. Canon doesn't license its AF technology to others, so if at some point in the future it decided to change the way its autofocus systems worked, third-party lenses could become incompatible. It's a very small risk, but one that's worth thinking about.

SIGMA 18–35mm f/1.8 DC HSM ⌃
Currently the fastest zoom lens available for Canon's APS-C cameras.
© Sigma

» VERTICALLY

Tilt-and-shift lenses are very useful when shooting architecture. By shifting the lens you can keep the verticals of a building straight and parallel to the edges of the image.

Settings
> Focal length: 32mm
> Aperture: f/11
> Shutter speed: 1/125 sec.
> ISO: 200

4 » DIFFRACTION

Lenses are typically at their best optically when they are 2 or 3 stops from their maximum aperture. Once past this "sweet spot," images can start to look softer, with a reduction in fine detail. This is due to an effect known as "diffraction." When light enters a lens it is randomly scattered ("diffracted"), as it strikes the edges of the aperture blades. Diffraction is at its worst when using a lens' minimum aperture.

For this reason it's a good idea to avoid using the smallest apertures on a lens if possible, which means you need to think carefully about depth of field. Fortunately, there's a technique that can be used to optimize the depth of field for a particular aperture: focus at a point known as the "hyperfocal distance."

By setting the lens to the hyperfocal distance, the image will be sharp from half that distance to infinity. By focusing this way and using the largest aperture that will comfortably cover the required depth of field, you reduce the risk of diffraction.

On the page opposite are hyperfocal distance tables that cover the focal length range of the 18–55mm kit lens commonly sold with both the EOS Rebel T6s/760D and EOS Rebel T6i/750D. However, the charts can also be used for any lens with a focal length that falls between 18mm and 55mm.

To use the charts, set the lens to the required focal length, then set the focus distance to the hyperfocal distance (HD). Note that some lenses don't have distance scales, so you may need to guess.

Finally, set the required aperture. It pays to be slightly conservative here, so if in doubt, set the aperture slightly smaller than that specified in the table. Now, depth of field will stretch from the Near point indicated in the chart to Infinity (∞). Note that all distances are in meters.

DETAIL ⌄
The drop in resolution caused by diffraction is seen as a reduction in the visibility of fine detail in an image.

18mm: Hyperfocal distance

f/2.8		f/4		f/5.6		f/8		f/11		f/16	
Near	HD	Near	HD	Near	HD	Near	HD	Near	HD	Near	HD
3	6	2	4	1.5	3	1	2	0.7	1.5	0.5	1

24mm: Hyperfocal distance

f/2.8		f/4		f/5.6		f/8		f/11		f/16	
Near	HD	Near	HD	Near	HD	Near	HD	Near	HD	Near	HD
5.4	11	3.7	7.5	2.7	5.4	2	3.8	1.4	2.7	1	2

35mm: Hyperfocal distance

f/2.8		f/4		f/5.6		f/8		f/11		f/16	
Near	HD	Near	HD	Near	HD	Near	HD	Near	HD	Near	HD
11.5	23	8	16	5.8	11.5	4	8	2.9	5.9	4	2

40mm: Hyperfocal distance

f/2.8		f/4		f/5.6		f/8		f/11		f/16	
Near	HD	Near	HD	Near	HD	Near	HD	Near	HD	Near	HD
15	30	10.5	21	7.5	15	5	10.5	4	8	3	5

50mm: Hyperfocal distance

f/2.8		f/4		f/5.6		f/8		f/11		f/16	
Near	HD	Near	HD	Near	HD	Near	HD	Near	HD	Near	HD
24	47	16	33	12	24	8	16	6	12	4	8

55mm: Hyperfocal distance

f/2.8		f/4		f/5.6		f/8		f/11		f/16	
Near	HD	Near	HD	Near	HD	Near	HD	Near	HD	Near	HD
28	57	20	40	14	29	10	20	7	14	5	10

4 » TELEPHOTO

A useful aspect of fast telephoto lenses is being able to limit depth of field by using a wide aperture. This helps to simplify compositions and focus attention entirely on your subject.

Settings
> Focal length: 70mm
> Aperture: f/2.8
> Shutter speed: 2 sec.
> ISO: 100

» CANON EF/EF-S LENSES

Lens	35mm equiv.	Filter size	L x W (mm)	Weight (grams)
EF 8–15mm f/4L USM	12.8–24mm	67mm	79 x 83	540
EF-S 10–18mm f/4.5–5.6 IS STM	16–28mm	67mm	75 x 72	240
EF-S 10–22mm f/3.5–4.5 USM	16–35mm	77mm	83 x 90	385
EF 11–24mm f/4L USM	18–38mm	–	110 x 133	1180
EF 14mm f/2.8L II USM	22mm	rear	80 x 94	645
EF 15mm f/2.8 Fish-eye	–	rear	73 x 62	330
EF-S 15–85mm f/3.5–5.6 IS USM	22–136mm	72mm	82 x 88	575
EF 16–35mm f/2.8L II USM	25–56mm	82mm	88 x 112	635
EF 16–35mm f/4L IS USM	25–56mm	77mm	83 x 113	615
TS-E 17mm f/4L	27mm	n/a	89 x 107	820
EF 17–40mm f/4L USM	27–64mm	77mm	83 x 97	500
EF-S 17–55 f/2.8 IS USM	27–88mm	77mm	83 x 111	645
EF-S 17–85mm f/4–5.6 IS USM	27–136mm	67mm	78 x 92	475
EF-S 18–55mm f/3.5–5.6 III	28–88mm	58mm	68 x 70	195
EF-S 18–55mm f/3.5–5.6 IS STM	28–88mm	58mm	69 x 75	205
EF-S 18–55mm f/3.5–5.6 IS II	28–88mm	58mm	68 x 70	200
EF-S 18–135mm f/3.5–5.6 IS	28–216mm	67mm	75 x 101	455
EF-S 18–135mm f/3.5–5.6 STM	28–216mm	67mm	77 x 96	480
EF-S 18–200mm f/3.5–5.6 IS	28–320mm	72mm	79 x 162	595
EF 20mm f/2.8 USM	32mm	72mm	77 x 71	405
EF 24mm f/1.4L II USM	38mm	77mm	93 x 87	650
EF 24mm f/2.8 IS USM	38mm	58mm	68 x 56	280
EF-S 24mm f/2.8 STM	38mm	52mm	68 x 23	125
TS-E 24mm f/3.5L II	38mm	82mm	78 x 87	570
EF 24–70mm f/2.8L II USM	38–112mm	82mm	88 x 113	805
EF 24–70mm f/4L USM	38–112mm	77mm	83 x 93	600
EF 24–85mm f/3.5–4.5 USM	38–136mm	77mm	73 x 69.5	380
EF 24–105mm f/3.5–5.6 IS STM	38–168mm	77mm	83 x 104	525
EF 24–105mm f/4L IS USM	38–168mm	77mm	83 x 107	670

Lens	35mm equiv.	Filter size	L x W (mm)	Weight (grams)
EF 24-105mm f/4L IS USM	38-168mm	77mm	83 x 107	670
EF 28mm f/1.8 USM	45mm	58mm	73 x 56	310
EF 28mm f/2.8 IS USM	45mm	58mm	68 x 51	280
EF 28-90mm f/4-5.6 II USM	45-144mm	58mm	67 x 71	190
EF 28-90mm f/4-5.6 III	45-144mm	58mm	67 x 71	190
EF 28-105mm f/3.5-4.5 II USM	45-168mm	58mm	72 x 75	375
EF 28-105mm f/4-5.6 USM	45-168mm	58mm	67 x 68	210
EF 28-135mm f/3.5-5.6 IS USM	45-216mm	72mm	78 x 97	540
EF 28-200mm f/3.5-5.6 USM	45-320mm	72mm	78 x 90	500
EF 28-300mm f/3.5-5.6L IS USM	45-480mm	77mm	92 x 184	1670
EF 35mm f/1.4L USM	56mm	72mm	79 x 86	580
EF 35mm f/2	56mm	52mm	67 x 42	210
EF 40mm f/2.8 STM	64mm	52mm	68 x 27	130
TS-E 45mm f/2.8	72mm	72mm	81 x 90.1	645
EF 50mm f/1.2L USM	80mm	72mm	86 x 65	580
EF 50mm f/1.4 USM	80mm	58mm	74 x 50	290
EF 50mm f/1.8 II	80mm	52mm	68 x 41	130
EF 50mm f/2.5 Compact Macro	80mm	52mm	67 x 63	280
EF 55-200mm f/4.5-5.6 II USM	88-320mm	77mm	92 x 184	1670
EF-S 55-250mm f/4-5.6 IS II	88-400mm	58mm	70 x 108	390
EF-S 55-250mm f/4-5.6 IS STM	88-400mm	58mm	70 x 111	375
EF-S 60mm f/2.8 Macro USM	96mm	52mm	73 x 70	335
MP-E 65mm f/2.8 1-5x Macro	104mm	58mm	81 x 98	730
EF 70-200mm f/2.8L IS II USM*	112-320mm	77mm	89 x 199	1490
EF 70-200mm f/2.8L USM*	112-320mm	77mm	76 x 194	1310
EF 70-200mm f/4L IS USM*	112-320mm	67mm	76 x 172	760
EF 70-200mm f/4L USM*	112-320mm	67mm	76 x 172	705
EF 70-300mm f/4.5-5.6 DO IS USM	112-480mm	58mm	82 x 99	720
EF 70-300mm f/4-5.6 IS USM	112-480mm	58mm	76 x 143	630

* Indicates that a lens is compatible with Canon's teleconverters. + Drop-in filter size

Lens	35mm equiv.	Filter size	L x W (mm)	Weight (grams)
EF 70–300mm f/4–5.6 IS USM	112–480mm	58mm	76 x 143	630
EF 70–300mm f/4–5.6L IS USM	112–480mm	67mm	89 x 143	1050
EF 75–300mm f/4–5.6 III	120–480mm	58mm	71 x 122	480
EF 75–300mm f/4–5.6 III USM	120–480mm	58mm	71 x 122	480
EF 80–200mm f/4.5–5.6 II	128–320mm	52mm	69 x 78.5	250
EF 85mm f/1.2L II USM	136mm	72mm	91 x 84	1025
EF 85mm f/1.8 USM	136mm	72mm	91 x 84	1025
TS-E 90mm f/2.8	144mm	58mm	74 x 88	565
EF 100mm f/2 USM	160mm	58mm	75 x 73	460
EF 100mm f/2.8 Macro USM	160mm	58mm	79 x 119	600
EF 100mm f/2.8L Macro IS USM	160mm	67mm	78 x 123	625
EF 100–400mm f/4.5–5.6L IS USM*	160–640mm	77mm	92 x 189	1380
EF 100–400mm f/4.5–5.6L IS II USM*	160–640mm	77mm	94 x 193	1570
EF 135mm f/2.8 soft focus	216mm	52mm	69 x 98	390
EF 135mm f/2L USM*	216mm	72mm	82 x 112	750
EF 180mm f/3.5L Macro USM*	288mm	72mm	82 x 186	1090
EF 200mm f/2L IS USM*	320mm	52mm+	128 x 208	2520
EF 200mm f/2.8L II USM*	320mm	72mm	83 x 136	765
EF 200–400mm f/4L IS*	320–640mm	58mm	73 x 122	3620
EF 300mm f/2.8L IS II USM*	480mm	52mm+	128 x 248	2400
EF 300mm f/4L IS USM*	480mm	77mm	90 x 221	1190
EF 400mm f/2.8L IS II USM*	640mm	52mm+	163 x 343	3850
EF 400mm f/4 DO IS USM*	640mm	52mm+	128 x 233	1940
EF 400mm f/4 DO IS II USM*	640mm	52mm+	128 x 233	1200
EF 400mm f/5.6L USM*	640mm	77mm	90 x 256.5	1250
EF 500mm f/4L IS II USM*	800mm	52mm+	168 x 449	3920
EF 600mm f/4L IS II USM*	960mm	52mm+	168 x 448	3920
EF 800mm f/5.6L IS USM*	1280mm	52mm+	163 x 461	4500
EF 600mm f/4L IS II USM*	960mm	52mm+	168 x 448	3920
EF 800mm f/5.6L IS USM*	1280mm	52mm+	163 x 461	4500

5 FLASH

Both the EOS Rebel T6s/760D and EOS Rebel T6i/750D feature a built-in, pop-up flash. They can also be used with a wide range of external Canon and third-party flashes.

When the light levels are low you can either adjust the exposure or physically increase the amount of light illuminating the scene. The simplest way to add light is to use flash, but this is often considered to be rather complex. However, as you will see in this chapter, once you understand a few key concepts, the mysteries of flash become clear.

Before you begin, there are two limitations that you need to appreciate when it comes to using the built-in flash on your EOS Rebel T6s/760D or EOS Rebel T6i/750D. The major limitation is power. The built-in flash doesn't emit a great deal of light, which makes its effective range relatively small. The second limitation is that the built-in flash is a frontal light. This isn't particularly appealing, as it appears to flatten the subject, making them look less three-dimensional. Thankfully, there are a few simple steps that you can take to improve your flash photography.

> **Note:**
> Canon uses the word Speedlite as a synonym for an external flash unit, and that's the convention we'll use in this chapter.

RAISED ⌃
The built-in flash (when raised) is relatively close to the lens. This can cause problems such as red-eye, discussed later in the chapter.

OFF-CAMERA FLASH »
The built-in flash can be used to trigger a compatible Speedlite wirelessly. This makes it easier to use flash creatively.

5 » FLASH BASICS

There are two ways to control the amount of light emitted by a flash. You can either allow your camera to calculate the correct flash exposure automatically, or you can set the flash to manual and adjust the exposure yourself.

Canon uses a proprietary exposure system known as E-TTL II to automatically determine the correct exposure of flash. E-TTL II is an accurate system, but that does not mean it is entirely foolproof—the flash exposure can change between shots, depending on the reflectivity of your subject, giving inconsistent results. Setting the flash exposure manually is slightly more complicated, but it does mean that the results are more predictable, and therefore consistent.

When a flash is set to manual, there are two ways to control its effective distance (the maximum distance that flash can effectively illuminate a subject). The first control is the power output of the flash. This can be set using your camera's **Flash control** menu (or directly on a Speedlite if the option is available). At 1/1 (full power), the flash is discharged at maximum power; set it to ½ and the power output is halved; at ¼ it is halved again, and so on.

The second exposure control is the aperture setting. The smaller the aperture used, the shorter the effective distance of the flash. If a subject is further than the effective flash distance for the selected aperture it will be underexposed. To remedy this you would need to use a larger aperture. Alternatively, if your subject is overexposed this can be corrected by using a smaller aperture.

> **Notes:**
> The shutter speed has no influence on flash exposure. However, the shutter speed you use will affect the exposure of any area of a scene not lit by light from the flash. This is useful for slow sync exposures, as described later in this chapter.
>
> Increasing the ISO also increases the effective distance of flash.

WB
When using flash, set the white balance to ⚡.

» GUIDE NUMBER (GN)

The power or maximum amount of light a flash can produce is referred to as its "guide number" or "GN." The GN helps you calculate the effective range of the flash in either meters or feet. If you increase the ISO on your camera, the GN increases. To avoid confusion, camera and flash manufacturers use ISO 100 as the standard reference when quoting a GN.

If you know the GN of a flash, you can use this to determine either the required aperture value for a subject at a given distance, or the effective range of the flash at a specified aperture. The formula to calculate both is respectively:

Aperture=GN/distance
Distance=GN/aperture

The built-in flash of the EOS Rebel T6i/750D and 760D/Rebel T6s has a GN of 12m/39.4ft at ISO 100. The grid below will give you a guide to the effective range of the flash at a typical range of apertures and distances.

ISO	f/2.8	f/4	f/5.6	f/8	f/11	f/16
	Aperture					
100	14ft 4.2m	9.8ft 3m	7ft 2.1m	4.9ft 1.5m	3.6ft 1m	2.5ft 0.75m
200	20ft 6m	14ft 4.2m	9.8ft 3m	7ft 2.1m	4.9ft 1.5m	3.6ft 1m
400	28ft 8.6m	20ft 6m	14ft 4.2m	9.8ft 3m	7ft 2.1m	4.9ft 1.5m
800	40ft 12m	28ft 8.6m	20ft 6m	14ft 4.2m	9.8ft 3m	7ft 2.1m
1600	56ft 17m	40ft 12m	28ft 8.6m	20ft 6m	14ft 4.2m	9.8ft 3m
3200	80ft 24m	56ft 17m	40ft 12m	28ft 8.6m	20ft 6m	14ft 4.2m
6400	112ft 34m	80ft 24m	56ft 17m	40ft 12m	28ft 8.6m	20ft 6m
12,800	159ft 48m	112ft 34m	80ft 24m	56ft 17m	40ft 12m	28ft 8.6m

5 » THE BUILT-IN FLASH

A flash with a GN of 12m/39.4ft at ISO 100 is a relatively weak light, especially when you compare it to even a mid-range Speedlite. However, any flash is better than none when you need a little extra illumination. The most effective use for the built-in flash is as a fill-in light when shooting subjects close to the camera that are backlit.

In the Basic Zone modes, the built-in flash will either rise and fire automatically as required; have a limited number of options; or will not be available at all (⚡). To have complete control over the flash—including the option of modifying its power and setting red-eye reduction—your camera needs to be set to a Creative Zone mode.

Raising and using the flash

1) Press the ⚡ button just above the lens-release button.

2) Press halfway down on the shutter-release button to focus as normal. If the flash is ready for use, ⚡ will be displayed at the bottom left corner of the viewfinder.

3) The flash needs to charge up after use, so there may be a short delay before the next photo can be shot. During this time, ⚡ buSY will be displayed in the viewfinder and **BUSY** ⚡ will be shown on the rear LCD screen.

4) Press down fully on the shutter-release button to take the photo.

> ## Warning!
>
> Remove any lens hood or filter holder that is attached to your lens before you use the built-in flash.
>
> Do not try to raise the built-in flash if you have an external flash fitted to the camera's hotshoe.

› Red-eye reduction

Red-eye occurs when direct on-camera flash is used to illuminate a (human or animal) subject looking straight at the camera. Red-eye is caused by the light from the flash bouncing off the back of your subject's eyes toward the camera, picking up the color of the blood vessels inside the eyes as it does so. The problem is made worse by the fact that flash is most often used in low-light conditions, when the pupils in your subject's eyes are likely to be at their widest.

Red-eye correction (**Red-eye reduc.**) illuminates the camera's red-eye reduction lamp before the final exposure is made. This causes the pupils of your subject's eyes to contract, reducing the risk of red-eye.

Enabling Red-eye reduc.
1) Select **Red-eye reduc.** on the ▣ menu.

2) Select **Enable**. Press the shutter-release button lightly to return to shooting mode.

3) Press the shutter-release button down halfway to focus your camera. The orange red-eye reduction lamp will light. Look through the viewfinder of your camera; a bar will replace the exposure scale. Keep your finger on the shutter-release button, and when the bar disappears, press down fully on the shutter-release button to take the shot.

> ***Notes:***
> The further the flash is from the camera lens, the less chance there is of red-eye. It is impossible to move the built-in flash, but taking a Speedlite off-camera with an extension cable or firing it wirelessly is an effective way to combat red-eye.
>
> **Red-eye reduc.** is not available in ▣, ▲, ⚘, ▣, or ▓ modes.

Flash exposures can be locked in a similar way to using AE lock (to differentiate the two, flash exposure lock is referred to as FE lock). However, before a flash exposure can be locked, a pre-flash needs to be fired, so FE lock is not subtle.

FE lock can be applied to both the built-in flash and an attached Speedlite. FE lock is particularly useful when your subject is off-center and when the background may make normal flash exposures unreliable.

Setting FE lock
1) Raise the built-in flash, or attach and switch on your Speedlite.

2) Press the shutter-release button down halfway to focus. Check that ⚡ is displayed in the viewfinder.

3) Aim the camera at your subject, so it is central in the viewfinder.

4) Press ✱. The flash will fire and the exposure details will be recorded. The word **FEL** will be displayed briefly in the viewfinder and ⚡* will replace ⚡.

5) Recompose your shot and press the shutter-release button down fully to make the final exposure.

6) FE lock will still be set: press ▓ to cancel it and resume normal shooting.

> **Notes:**
> If ⚡ blinks in the viewfinder, your subject distance exceeds the effective flash distance. Either move closer to your subject, use a wider aperture, or increase the ISO.
>
> You cannot use FE lock when using Live View.

NEW READING «
Repeatedly press ✱ and the flash will fire and new exposure details will be recorded.

» FLASH CONTROL MENU

The **Flash control** menu (found on 📷) allows you to set the shooting parameters of both the built-in flash and compatible Speedlites (when fitted and switched on).

› Flash firing

In order to use flash, **Flash firing** must be set to **Enable**. When set to **Disable**, neither the built-in flash or attached Speedlite will fire, although the AF assist beam on the Speedlite will still activate if available.

› E-TTL II metering

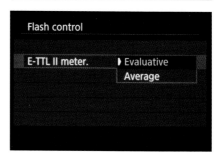

E-TTL II is short for "evaluative through-the-lens metering." E-TTL II hands the responsibility of the flash exposure entirely to your camera. This makes flash exposures more accurate, particularly if the flash is used off-camera and when filters are used.

E-TTL II works by firing two bursts of light from the flash: the first burst is used to determine the exposure, and the second burst is used to make the exposure. This happens so quickly that you and your subject won't even be aware that there were two bursts of flash.

You can choose between two E-TTL II metering methods. The default is **Evaluative** and is the recommended method. If you are using a lens that doesn't supply focus distance information, **Average** may be marginally preferable, but experimentation will determine which is most suitable for your purposes.

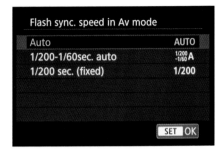

The sync speed (or X-sync) on a camera is the fastest shutter speed at which an image is evenly lit by flash. The sync speed of both the EOS Rebel T6s/760D and EOS Rebel T6i/750D is 1/200 sec., and neither camera lets you set a faster shutter speed when flash is used (although there is one exception to this rule, as described later in this chapter).

However, that doesn't mean you have to use a 1/200 sec. shutter speed every time flash is used. If you're shooting in low light, you may find that 1/200 sec. doesn't allow background details (outside the area illuminated by flash) to be exposed correctly. In this case, using a slower shutter speed will allow your camera to expose background details correctly, while the flash illuminates your subject—this technique is known as "slow sync" flash. The lower the ambient light levels, the longer the shutter speed will need to be, and this increases the risk of camera shake (requiring the use of a tripod). **Flash sync. in Av mode** lets you change how your camera sets the shutter speed when shooting in **Av** mode.

Setting Flash sync. in **Av** mode
1) Press MENU and choose **Flash sync. in Av mode** from the **Flash Control** menu.

2) Highlight the option you require (as outlined below) and press ⑤. Press down lightly on the shutter-release button to return to shooting mode and set the mode dial to **Av**.

Option	Result
Auto	Your camera uses a shutter speed between 30 sec. and 1/200 sec. to provide the correct exposure for non-flash-lit areas. High-speed sync with a compatible Speedlite is still possible.
1/200–1/60 sec. auto	To minimize the risk of camera shake, your camera only uses a shutter speed between 1/60 sec. and 1/200 sec. This may result in areas that are not illuminated by flash being underexposed.
1/200 sec. (fixed)	Only the 1/200 sec. sync speed is available. Non-flash-lit areas may be underexposed, but the risk of camera shake is minimized.

» BUILT-IN FLASH SETTINGS

If you select **Built-in flash** on the **Flash control** menu you'll be taken to another screen of options. These options enable you to further refine the use of the built-in flash.

› Built-in flash

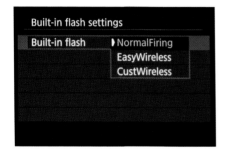

When **Built-in flash** is set to **NormalFiring**, the built-in flash is fired alone. However, if you have a compatible Speedlite, setting **Built-in flash** to **EasyWireless** or **CustWireless** will allow you to fire the flash wirelessly, as outlined on the following page.

In a wireless setup like this, the flash that is used to trigger another is known as a "master" flash, while the triggered flash is referred to as a "slave." It's worth noting that the trigger signal uses infrared, rather than radio waves, which means that all flashes have to be able to "see" each other. Because of this, a hidden flash may not be triggered successfully.

The infrared sensor on Canon's Speedlites is found below the flash head. One way to maintain line-of-sight is to turn the head of the Speedlite toward the subject and keep the infrared sensor on the front pointed toward the camera. The use of infrared light also limits the distances that wireless flash can be used; wireless flash is generally more efficient indoors than outdoors.

To avoid triggering the wrong flash units (if another photographer is working in the same area, for example), you can assign your flashes a channel number from 1–4. Each unit (camera and Speedlite) needs to be set to the same channel.

Notes:
You can use third-party radio-triggers with your camera. These are less fussy about placement and range, although they are invariably a more expensive option.

When using wireless flash, keep the Speedlite within 30ft (10m) and 80° of the camera indoors or 15ft (5m) and 80° of the camera outdoors.

EasyWireless is the simplest way to configure a wireless flash system—choose this option and virtually all the work is done for you except setting the channel number and applying any required exposure compensation.

CustWireless is slightly more involved, but it does give you more control over the camera and Speedlite(s).

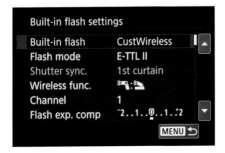

Built-in flash settings

Built-in flash	CustWireless
Flash mode	E-TTL II
Shutter sync.	1st curtain
Wireless func.	
Channel	1
Flash exp. comp	⁻2..1..0..1..⁺2

MENU

Setting up EasyWireless
1) Select **Built-in flash settings** on the **Flash Control** menu.

2) Choose **Built-in flash**, followed by **EasyWireless**. All of the options on the screen—with the exception of **Channel** and **exp. comp.**—will be grayed out. Alter either setting as required. If you alter the channel number you will also need to set the same channel on your Speedlite. Press down halfway on the shutter-release button to return to shooting mode.

3) Set your Speedlite to wireless mode and press to raise your camera's flash.

4) Press down fully on the shutter-release button to focus and take the shot.

Setting up CustWireless
1) Select **Built-in flash settings** from the **Flash control** menu.

2) Select **Built-in flash** followed by **CustWireless**. Set the wireless flash functions on the **Built-in flash settings** menu as required. See the grid opposite for an explanation of the options.

3) Set your Speedlite to wireless mode and press to raise your camera's flash.

4) Press down fully on the shutter-release button to focus and take the shot.

Function	Options
Wireless func.	▤▜ : ▟ Uses both the built-in flash and Speedlite(s) to illuminate the subject. The ratio (how much one illuminates the subject more strongly than the other) can be set further down the menu screen (see below). ▤▜ uses just the Speedlite(s) to illuminate the subject. If you're using multiple Speedlites, these can be split into groups for greater control over the lighting (see below). ▤▜ + ▟ allows you to adjust the exposure of the built-in flash and Speedlite(s) separately.
Firing group (when **Wireless func.** is set to ▤▜)	▜ **All** treats multiple Speedlites as one unit, so the exposure settings are common to all. ▜ **(A:B)** allows you to split multiple Speedlites into two groups (A and B). You can alter the ratio between the two groups.
Firing group (when **Wireless func.** is set to ▤▜ + ▟)	▜ **All and** ▟ allows you to set the output of the built-in flash and Speedlite(s) separately. ▜ **(A:B)** ▟ lets you set the output of the built-in flash and grouped Speedlite(s) separately.
▜ : ▟	Sets the ratio of the built-in flash to the Speedlite(s). **1:1** means that the power of the flashes is equal. **8:1** means that one flash has 1/8 of the power of the other.

› Flash mode

You can either set your Speedlite to use **E-TTL II** metering (the default option) or switch to **Manual flash** exposure. Once set to **Manual flash** you must determine the flash exposure yourself, taking into account the guide number of the flash, its power output, the ISO, and the aperture.

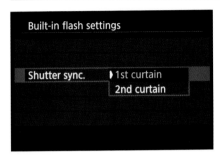

Built-in flash settings

Shutter sync. ▶1st curtain
2nd curtain

Note:
2nd curtain synchronization is only available when the shutter speed is slower than 1/30 sec.

Select **1st curtain** synchronization (sync) and the flash will be fired immediately, at the start of an exposure. This means that if your subject moves across the frame during the exposure, the light from the flash will instantly freeze the movement. If the shutter speed is sufficiently long, the rest of the exposure will be lit by available light and subsequent subject movement will be recorded as a blur in front of the subject.

If you select **2nd curtain** sync, the flash won't be fired until the end of the exposure (although an E-TTL pre-flash will still be fired when you press down on the shutter-release button). This means that any subject movement is frozen by the flash at the end of the exposure, resulting in it being recorded as a blur behind the subject. Of the two settings, **2nd curtain** sync usually looks more naturalistic.

› Flash exposure compensation

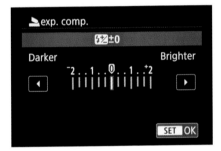

exp. comp.

±0

Darker Brighter

⁻2..1..0..1.⁺2

SET OK

E-TTL II flash metering isn't infallible, so as with standard exposures you can apply exposure compensation to your flash images. The maximum flash exposure compensation is ±2 stops, which can be set in one of two ways.

Flash exposure compensation: Method 1
1) In shooting mode, press the **Q** button and highlight ⚡.

2) Turn 🎛 to the left to decrease the power of the flash or to the right to

increase it. When compensation has been applied, ⚡️ will be shown in the viewfinder.

3) Press down lightly on the shutter-release button to return to shooting mode.

Flash exposure compensation: Method 2

1) Press MENU and select **Flash control** from the 📷 menu.

2) Select **Built-in flash settings**.

3) Select ▶ **exp. comp.** and then press ◀ to decrease the power of the flash or ▶ to increase it.

4) Press ⑤ to apply the changes and go back to the **Built-in flash settings** screen.

> **Notes:**
> Although you can apply exposure compensation to your flash, you will not be able to increase the effective flash distance for your chosen aperture unless you also increase the ISO.
>
> You may be able to adjust the flash exposure compensation on the Speedlite (depending on the model), as well as on the camera.

» EXTERNAL FLASH

On the top plate of your camera is a hotshoe that is used to attach Speedlites. The basic hotshoe is a standard design used by most camera manufacturers, but the position of the electrical connections differ. For this reason you should only fit flashes designed for EOS cameras.

Canon currently produces five Speedlites, which it refers to as the EX series. An easy way to calculate the GN (in meters) of a Speedlite is to divide the model number by 10—the 430EX II has a GN of 43m at ISO 100, for example.

Although Canon recommends that you don't use third-party Speedlites with your camera, companies such as Sigma and Metz produce compatible flashes, some of which support advanced functions such as wireless flash.

Certain Speedlite functions can be set via the **External flash func. setting** option found on the **Flash control** menu screen, while some functions may need to be set on the Speedlite itself.

5

Fitting an external flash

1) Make sure that both your camera and Speedlite are switched off.

2) Slide the Speedlite shoe into the hotshoe of the camera. If your Speedlite has a locking collar, press the locking button and slide the collar round until it clicks into the lock position.

3) Turn the Speedlite on first, followed by your camera.

4) A ⚡ symbol will be displayed in the viewfinder of your camera, or on the LCD screen if you are using Live View.

5) To remove the Speedlite, switch off both your camera and Speedlite, and reverse the procedure in step 2.

> *Note:*
> You can alter the Speedlite's custom functions either in-camera or on the Speedlite. The available custom functions vary between different Speedlite models.

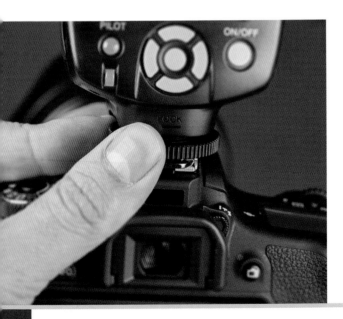

SECURE **«**
If your Speedlite has a locking collar, tighten it or press the locking button and slide the collar round until it clicks into the lock position.

❯❯ EXTERNAL FLASH FUNC. SETTING

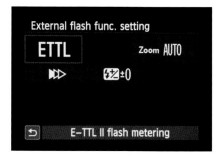

External flash func. setting

ETTL Zoom AUTO

⏪ ⚡±0

↩ E–TTL II flash metering

The **External flash func. setting** screen allows you to set the various functions of compatible Speedlites in-camera, rather than on the flash.

Changing External flash func. setting
1) Fit your Speedlite, as described on the previous page, and turn on both your camera and flash.

2) Press MENU on your camera, select **Flash control** from the 📷 menu, followed by **External flash func. setting**. Anything you change will be applied automatically to the Speedlite.

3) Highlight the function you want to change using ✛ and then press (SET). Select the required option by pressing ◀ / ▶ followed by (SET), and then press (SET) to continue.

4) If you want to change the custom functions of the Speedlite, these can be altered using the **Flash C.Fn settings** sub-menu. The available custom functions will vary between Speedlite models.

5) Press MENU to return to the main 📷 menu, or press lightly down on the shutter-release button to return to shooting mode.

> **Note:**
> The **External flash func. setting** options that are available to you depend on the Speedlite you use.

› ETTL

As with the built-in flash setting screen, this option allows you to set whether the flash uses E-TTL II metering, or whether the exposure is determined manually.

› Zoom

If your flash has a compatible zoom head, setting **Zoom** to **Auto** will ensure that it adjusts automatically to match the focal length of the lens, ensuring even coverage across the image frame. You can, however,

choose to adjust the focal length of the zoom head on the flash yourself. This would usually be done if you used a lens that didn't supply the necessary focal length information for **Auto** zoom.

ZOOMED
You can zoom the flash head for creative effect, enabling you to focus the light more on your subject, leaving the area around the edge of the frame darker.

› Flash exposure bracketing

Bracketing with a Speedlite is similar in concept to standard exposure bracketing, although it is not a feature that you will find on every Speedlite (it's certainly not available when using the built-in flash). Instead of the exposure for the ambient light altering, the flash output is altered between shots. Bracketing can usually be applied in ⅓-, ½-, or 1-stop increments.

› High-speed sync

When shooting in low light, the EOS Rebel T6s/760D and EOS Rebel T6i/750D' sync-speed of 1/200 sec. is rarely a problem. However, you may want to use flash as a supplementary light in bright conditions (to reduce contrast, for example). When using flash in this way it is all too easy to require a shutter speed faster than 1/200 sec., especially if you also want to use a wide aperture to minimize depth of field.

The solution is High-speed sync (HSS). This is a mode found on all of Canon's current Speedlites (with the exception of the 90EX) and it lets you use flash with shutter speeds up to 1/4000 sec.

High-speed sync works by pulsing the Speedlite's output to "build up" the exposure as the shutter curtains travel across the sensor, effectively turning the flash into a constant light source. This is an invaluable technique for creative flash photography, but you need to appreciate that the power of the flash is reduced, as the Speedlite discharges many times, rather than once. Therefore, you will need to keep your subject relatively close to the camera.

> *Note:*
> HSS isn't available when using the built-in flash.

» SKY

HSS flash can be used to darken the background relative to your subject. The key is to use a shutter speed that will underexpose the background, while keeping the aperture wide enough for the flash to illuminate your subject.

Settings
> Focal length: 58mm
> Aperture: f/22
> Shutter speed: 1/250 sec.
> ISO: 100

5 » SPEEDLITE RANGE

There are currently five models in Canon's Speedlite range. The smallest, simplest, and least powerful of these is the 90EX, which was designed originally for use with the EOS M camera. Unusually for such a simple Speedlite it can be used as a master flash to trigger other compatible flashes.

Better specified is the 270EX II. Although still relatively small, it features a zoom and bounce head, and can be fired remotely by the built-in flash of the EOS Rebel T6s/760D and EOS Rebel T6i/750D. However, unlike the 90EX, it cannot be used as a master flash to trigger other Speedlites.

The 320EX is Canon's mid-range Speedlite. Unlike other Speedlites, it features a built-in LED that provides a constant light source. This is useful when shooting video, but the LED light is not especially strong, so you need to keep your subject close to the camera. Like the 270EX II, the 320EX can be used as a slave flash, but does not have master flash capabilities.

The next model in the line-up—the Speedlite 430EX II—is a pro-spec flash that allows high-speed and 1st/2nd curtain flash sync, plus the option to control other flash units. There are also comprehensive exposure compensation options.

Finally, the 600EX-RT is the largest, heaviest, and best-specified Speedlite model. It has integrated radio-triggering,

infrared wireless flash control, improved weather sealing, high-speed sync, and a total of 18 custom functions.

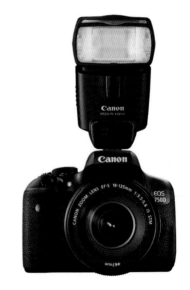

SPEEDLITE 430EX II ⌃

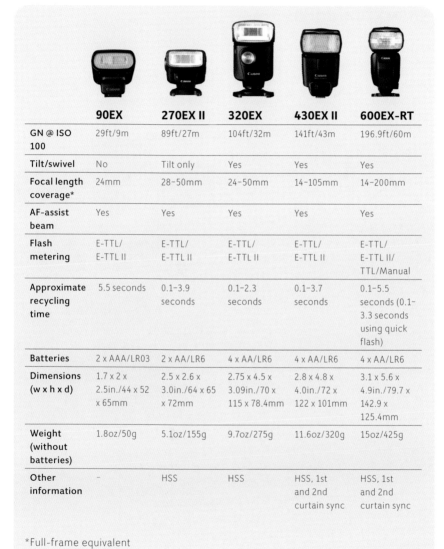

	90EX	270EX II	320EX	430EX II	600EX-RT
GN @ ISO 100	29ft/9m	89ft/27m	104ft/32m	141ft/43m	196.9ft/60m
Tilt/swivel	No	Tilt only	Yes	Yes	Yes
Focal length coverage*	24mm	28–50mm	24–50mm	14–105mm	14–200mm
AF-assist beam	Yes	Yes	Yes	Yes	Yes
Flash metering	E-TTL/ E-TTL II	E-TTL/ E-TTL II	E-TTL/ E-TTL II	E-TTL/ E-TTL II	E-TTL/ E-TTL II/ TTL/Manual
Approximate recycling time	5.5 seconds	0.1–3.9 seconds	0.1–2.3 seconds	0.1–3.7 seconds	0.1–5.5 seconds (0.1–3.3 seconds using quick flash)
Batteries	2 x AAA/LR03	2 x AA/LR6	4 x AA/LR6	4 x AA/LR6	4 x AA/LR6
Dimensions (w x h x d)	1.7 x 2 x 2.5in./44 x 52 x 65mm	2.5 x 2.6 x 3.0in./64 x 65 x 72mm	2.75 x 4.5 x 3.09in./70 x 115 x 78.4mm	2.8 x 4.8 x 4.0in./72 x 122 x 101mm	3.1 x 5.6 x 4.9in./79.7 x 142.9 x 125.4mm
Weight (without batteries)	1.8oz/50g	5.1oz/155g	9.7oz/275g	11.6oz/320g	15oz/425g
Other information	–	HSS	HSS	HSS, 1st and 2nd curtain sync	HSS, 1st and 2nd curtain sync

*Full-frame equivalent

5 » FLASH TECHNIQUES

› Bounce flash

Direct, on-camera flash can be harsh and unflattering, regardless of whether you're using your camera's built-in flash or a top-of-the-range Speedlite. Bounce flash is a technique that modifies the light from the flash so it is more esthetically pleasing.

To shoot using bounce flash you need two things: a Speedlite with a flash head that can be angled up and down, or left and right, plus a reflective surface. The reflective surface doesn't need to be metallic or mirrored—bounce flash works well when a low ceiling or wall is used instead. The key to success is that the reflective surface is neutral in color; if it isn't, the light from the flash will be tinted the color of the surface.

The head of the Speedlite should be angled toward the reflective surface so that the light bounces down (or across) onto your subject. This does two things. Firstly, it changes the angle of the light from the Speedlite so that it's more flattering to your subject. Second, the light is softened, which reduces the contrast and makes any shadows less hard and deep.

A potential problem that you need to be aware of when using bounce flash is that the flash-to-subject distance increases. Therefore your image will be underexposed if your flash is insufficiently

powerful or if you use too small an aperture (which reduces the effective distance of your Speedlite further still).

BOUNCED ⌃
The toy at the top was shot using direct flash (note the hard shadows behind the arms). The toy at the bottom was shot with light from a Speedlite bounced off a reflector that was held overhead.

» FROZEN

The burst of light from a flash is so rapid that it can be used to freeze movement very effectively. For this shot, the camera was panned vertically during the exposure. The sharpest parts of the picture are those where the subject was briefly illuminated by light from the flash.

Settings
> Focal length: 100mm
> Aperture: f/11
> Shutter speed: 1/8 sec.
> ISO: 100

6 ACCESSORIES

A camera, lens, and memory card are the three most important pieces of equipment you can buy as a photographer: own all three, and with a fully charged battery you can begin to make photos. However, there are many other photographic accessories that may prove tempting.

There are essentially three types of accessory: the never-be-without type; the not-strictly-necessary-but-useful type; and the why-did-I-buy-this variety.

Into the first category go tripods and filters (if you're a landscape photographer) or a flash (if you prefer portraiture). Battery grips fall into the second. What fits into the third depends on your shooting routine, but virtually all photographers will own at least one piece of equipment that has been used once before being shoved to the back of a cupboard.

The key is to be choosy when you buy accessories for your camera. This involves being honest with yourself about your way of working, and whether your purchase will enhance your photography or whether it will merely be a one-day wonder.

INTERPRETATION ⏫
The photographs you make will be a record of your personal interpretation of the world. Choose accessories that will make your style of shooting easier and more pleasurable.

WINDOW »
My favorite piece of equipment is my tripod. It forces me to think more carefully about composition and the final photograph.

6 » FILTERS

A filter is a shaped piece of glass, gelatin, or optical resin that is designed to affect the light that passes through it to one degree or another. Filters are sold in two different forms: round and threaded, so the filter can be screwed to the front of a lens, or square/rectangular, to be slotted into a holder attached to the lens. Both types have advantages and disadvantages.

Round filters are usually less expensive than those designed for a filter holder, but if you have more than one lens (and those lenses have different sized filter threads), you may need to buy the same filter several times over. Alternatively, you can buy the filter for the lens with the largest filter thread size and then buy an adaptor so that it fits on the smaller lens(es) as well.

A number of companies produce filter holder systems. Perhaps the most well known of these is Cokin, which produces four filter holder sizes: the A-system, which takes 67mm filters; the 84/85mm P-system; the 100mm Z-Pro system; and the 120mm X-Pro system. Smaller holder systems are less expensive, but can cause vignetting at the corners of images, particularly when used on wide-angle lenses.

Another company that makes a well-regarded filter holder system is Lee Filters. The holder system takes 100mm filters, making the filters compatible with Cokin's Z-Pro system and vice versa. Both systems use inexpensive adaptor rings that allow you to use the same filter holder (and therefore the same filters) on your various lenses.

> **Notes:**
> Don't use **AWB** if you use a colored filter (even one with a faint coloring such as a skylight filter). This is because **AWB** will try to correct for the color of the filter.
>
> The filter thread size is shown on the front face of all Canon lenses. It can also be found inside the lens cap.

FILTER HOLDER ⌃
Lee's 100mm filter holder system.

› UV and skylight filters

UV and skylight filters absorb ultraviolet light, which is typically found at high altitude and on hazy days, and can add a distinctive blue cast to an image. Skylight filters have a slightly pink tint to them, helping to warm up the image, while UV filters are more neutral. Neither filter affects the exposure, and for this reason they are often left permanently attached to a lens to protect the front element from damage. Clear "protection" filters are also available for this purpose.

› Neutral density (ND) filters

ND filters are semi-opaque and restrict the amount of light that passes through the filter by a set factor (effectively simulating lower light conditions). This is achieved without altering the color of the light, hence the name. ND filters are available in a variety of strengths, ranging from 1-stop to very dense 10- or 12-stop filters.

As long as the ND filter isn't too dense, your camera's exposure and AF system should be able to cope with an ND filter without a problem. If the AF system struggles (and this is inevitable when a 10- or 12-stop filter is used), focus before fitting the filter and then switch to MF so that focus doesn't shift when the filter is fitted.

Tip

ND filters are often sold using an optical density figure. A 1-stop ND filter has an optical density of 0.3, a 2-stop ND filter is 0.6, and so on.

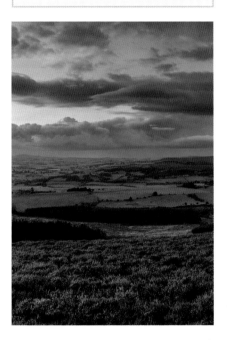

BALANCED ⌃
ND graduated filters are related to ND filters. They have a semi-opaque top half and a clear bottom half and are used to balance the exposure between two areas of a scene— typically a bright sky and dark foreground in a landscape photograph.

6 > Polarizing filters

A sun-kissed beach with fluffy white clouds lazily drifting across a deep blue sky is a clichéd tourist brochure image. It's highly probable that the blue of the sky was achieved through the use of a polarizing filter (commonly shortened to "polarizer").

Polarizers deepen the blue of sky when they are at a 90-degree angle to the sun, with a diminishing effect at lower and higher angles than this (at a 180-degree angle to the sun a polarizer has no effect on the blueness of the sky). The height of the sun will also affect how strongly the polarizing filter appears to work.

Another use for a polarizer is to control the amount of light reflected by non-metallic surfaces. This includes water, gloss paint, and even the leaves of trees. This effect works best when the polarizer is at an angle of 35 degrees to the surface.

The glass part of a polarizer is mounted in a holder that can be rotated through 360 degrees. This allows you to vary the strength of the effect by rotating the holder. It's sometimes possible to darken a sky to the point that it appears almost black. Unless this is an effect you are looking for, rotating the filter round further will reduce the strength of polarization making the sky appear more natural.

A polarizing filter also reduces the amount of light reaching the sensor, which means it can be used very effectively as an ND filter. It also means that you'll need to adjust the exposure when using **M**—the amount of exposure compensation required varies, but 2 stops is a good starting point.

Tip

Polarizers are sold in linear or circular form. This has nothing to do with the shape, but the way in which they polarize light. Linear polarizers can affect the focusing and metering on a DSLR, so it is a good idea to only use a circular polarizer with the EOS Rebel T6s/760D and EOS Rebel T6i/750D.

» CLOUDY

The effects of a polarizer are readily apparent when the sky is dotted with billowing cumulus clouds. The thicker the cloud cover, the less visible the effects of the polarizer will be. Oddly, the worst time to use a polarizer (except when cloud cover is total) is when the sky is completely clear of cloud. This can result in a sky that appears overly saturated and unnatural.

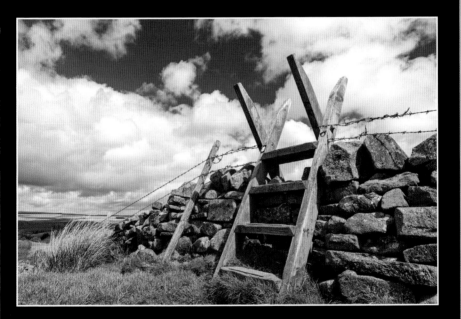

Settings
> Focal length: 16mm
> Aperture: f/11
> Shutter speed: 1/60 sec.
> ISO: 100

⊙ » STEADY ON

Camera shake is caused by the camera moving during an exposure. A tripod is a simple cure, but camera shake can still occur if it is used incorrectly. Ideally, a tripod should reach the required height without the need to raise the tripod's center column—raising the center column makes the tripod's center of gravity higher, increasing instability.

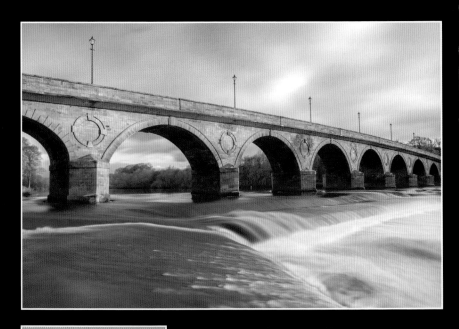

Settings
> Focal length: 16mm
> Aperture: f/11
> Shutter speed: 10 sec.
> ISO: 100

» SUPPORTING THE CAMERA

› Tripods

Despite the development of image-stabilized lenses and sensors capable of shooting at ultra-high ISO settings, tripods still have a place in 21st century photography. Indeed, there are certain techniques where a tripod is indispensable.

If you decide that a tripod is for you, then you'll need to think carefully about your needs. You should consider carefully a tripod's weight and leg-length, the type of material it's made from, and the leg-angles that are possible.

In the landscape, where you may be exposed to windy conditions, camera shake from a flimsy tripod is a possibility. Weight adds stability to a tripod, but if you buy a tripod that is too heavy, you may be less inclined to carry it with you to start with. Modern construction materials, such as carbon fiber, allow the construction of sturdy, high-quality, light-weight tripods, but the downside is the cost—carbon fiber tripods are often twice the price of an equivalent aluminum tripod.

Leg length determines how high a tripod can be raised, offering increased options when it comes to choosing a shooting angle. However, long-legged tripods are heavier and more cumbersome. One compromise is to buy a tripod with four or five leg sections, rather than a tripod with three leg sections. This reduces the "collapsed" size of the folded tripod, but it takes longer to set up, so again a compromise must be made.

The possible angles a tripod's leg can be set is also important, as the wider the angle that can be achieved, the more stable the tripod will be, helping to achieve sharper images. Tripods with legs that can be adjusted to extreme angles can often be used very close to the ground, which makes it much easier to shoot natural subjects, such as flowers or fungi.

GROUNDED ⌃
Shooting subjects such as flowers requires a tripod that allows you to set up your camera close to the ground. On some tripods this can be achieved by reversing the center column so that your camera is held upside down between the tripod legs.

Tripods are sold either as a single unit, with the head included, or as a set of legs to which a separate head must be attached. The latter option is more expensive (you need to buy two things rather than one), but it does give you more choice in how your tripod operates—the head from one manufacturer can be combined with the legs from another, for example.

There are three main types of tripod head: ball heads, three-way (or pan-and-tilt) heads, and geared heads. Each has advantages, as well as disadvantages.

Ball heads are light and strong. A single lever or knob will free the head and the camera, allowing it to be positioned quickly. However, this makes it tricky when small, precise adjustments are required.

Three-way heads are easier to position accurately, as the head can be adjusted in three different axes, each of which can be locked and released individually. The flipside is that they are slower to setup than a ball head.

Slower still are geared tripod heads, although they are also the easiest to make fine adjustments to. The geared mechanism generally makes them heavier than either ball or three-way heads, so they are typically reserved for studio environments, rather than on location.

› Monopods

An alternative to a tripod is a monopod. As the name suggests, a monopod has just one leg (although like a tripod, this leg can be extended). Monopods are less stable than a tripod, so you wouldn't use one when shutter speeds are measured in whole seconds, but at moderately slow speeds they offer far more support than handholding your camera. Some monopods can also be used as walking poles, which is useful if you're a landscape photographer who climbs hills regularly.

Tips

If you're using a tripod and your lens has Image Stabilization, turn IS off.

Tripods are most useful when paired with a remote release. If you don't have a remote release, using mirror lock-up combined with the camera's self-timer will help to reduce the risk of movement during an exposure

» OTHER ACCESSORIES

Remote switch

A remote switch allows you to trigger the shutter without touching your camera. They are not suitable for all types of photography—you wouldn't use one for sports, for example—but they are almost essential if you use a tripod.

Canon currently produces two remote switches that are compatible with both the EOS Rebel T6s/760D and EOS Rebel T6i/750D. The first (the RS-60E3) connects via a cable, while the other (the RC-6) uses an infrared signal.

The RS-60E3 lets you fire the shutter, as well as lock it open when using **B**. The RC-6 uses an infrared beam to fire the shutter (the sensor in the grip on the front of the camera needs to "see" the beam), but its functions are limited to firing the shutter immediately or after a two-second delay. The RC-6 also has a limited range, particularly outdoors.

Angle finder C

An angle finder allows you to look through the eyepiece of your camera from above or from the side, which is useful when the camera is low to the ground. It can also be used as a 1.25x and 2.5x magnifier to allow more accurate manual focusing.

Microphone

A good external microphone (or "mic") is a must if you regularly use your camera to shoot movies. An external mic can be positioned away from the camera (out-of-range of any noises made by the camera) and closer to your subject. If the mic has a foam cover this will help to reduce the effect of wind noise, as well as protecting the microphone head itself.

REMOTE »
Canon's RS-60E3 remote release.

Battery grip (BG-E18)

The BG-E18 grip increases the size of your camera, making it more comfortable to hold in a vertical orientation (various controls are mirrored on the grip, including the shutter-release button, which improves a camera's ergonomics considerably). The grip also allows you to fit two LP-E17 batteries, for extended shooting sessions.

GPS receiver (GP-E2)

The GP-E2 fits into your camera's hotshoe and records the location information (longitude, latitude, elevation, and direction) of your images to the EXIF metadata as you shoot. This information can be read by software such as Adobe Lightroom, so your images can be sorted by location and shown on a world map. The GP-E2 will also automatically update the clock in your camera if necessary.

WATER ⌃

Polarizers reduce reflections on non-metallic surfaces, which includes the sheen on wet leaves and rocks.

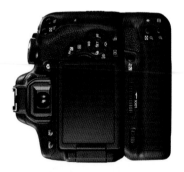

BATTERY GRIP BG-E18 ⌃

» LONG EXPOSURE

One type of filter that's currently very popular is an extreme ND filter. These are generally 6–10 stops in strength, which allow extremely long shutter speeds to be used, even in good light. The exposure for this photograph was extended to 100 seconds through the use of a 10-stop ND filter.

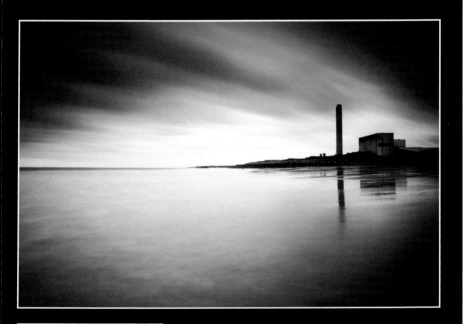

Settings
> Focal length: 14mm
> Aperture: f/16
> Shutter speed: 100 sec.
> ISO: 100

7 CLOSE-UP

There is close-up photography, and there is macro photography: the two are subtly different, but both involve looking closely at details that often go unnoticed.

Lenses vary in their close focusing abilities. The average minimum focusing distance is somewhere in the range of 8–20in (approx. 20–50cm), but a true macro lens allows you to focus much closer than this.

Macro lenses have another, more important, distinguishing feature: the ability to project an image onto a sensor that is life-size or larger. This means that if you were able to measure the projected image of your subject on the sensor it would be exactly the same size as (or larger than) the subject itself.

A life-size image is said to have a reproduction ratio of 1:1, twice life-size is 2:1, and so on. Although the 18–55mm STM kit lens is able to focus down to just under 10in (25cm), the projected image only has a reproduction ratio of 1:2.7, which means it isn't a true macro lens.

The reproduction ratio is one of two ways that manufacturers show the macro capabilities of a lens. The other is with a magnification figure. Unfortunately lens manufacturers generally use one or the other, but rarely both, making it difficult to compare different lenses.

To convert a reproduction ratio to a magnification figure, divide the number on the left of the reproduction ratio by the number on the right (so 1:4 would give a magnification figure of 0.25x). To convert in the other direction, divide 1 by the magnification to get the figure that should be placed at the right side of the reproduction ratio.

QUEEN'S HEAD ⌃
This coin detail was shot using extension tubes combined with a macro lens at an approximate 2:1 magnification ratio.

FROG'S HEAD »
Telephoto lenses typically don't create a macro image, even though you can often fill the frame with detail that would be difficult to see with the naked eye.

7 » MACRO SOLUTIONS

Macro lenses are specialized pieces of equipment (although most can be used for non-macro purposes as well). This makes them relatively expensive, but you don't necessarily need a macro lens to shoot macro images. The focusing capabilities of any lens can be extended using inexpensive and easy-to-use accessories. These accessories won't give you the image quality of a true macro lens, but they're a fun way to experiment to see whether macro is for you.

› Close-up attachment lenses

The simplest method of adding a macro capability to a lens is to add a supplementary close-up attachment lens to the filter thread. Close-up attachment lenses are essentially magnifying glasses for lenses, which work by reducing the minimum focusing distance of the lens They're easy to use as they don't interfere with either the autofocus or exposure system of the camera.

Close-up attachment lenses are available in a variety of strengths, which is indicated by the diopter value: the higher the diopter value, the greater the magnification. It's possible to stack close-up attachment lenses to increase the strength of magnification, but image quality will take a noticeable drop. For

optimum image quality it's better to use a single close-up attachment lens with a prime lens, rather than a zoom.

Canon currently produces two close-up attachment lenses: a +2 diopter (Type 500D) to fit 52mm, 55mm, 72mm, and 77mm filter threads, and a +4 diopter (Type 250D) to fit 52mm and 55mm filter threads.

FILTER ⌃
Third parties, such as Polaroid, offer alternatives to Canon's close-up attachment lenses.

› Reversing ring

A very simple way to add macro capability to any lens is to reverse it, so that the front element of the lens faces into the camera. You could simply hold the lens back-to-front, but a much better solution is to use a reversing ring. One side of a reversing ring has a bayonet fitting that attaches to the lens mount of your camera, while the other side has a screw thread that allows

you to fit the lens to the ring using the filter thread.

A problem with using a reversing ring is that it won't carry an electronic signal from the lens to the camera. This means that AF will be disabled and you won't be able to set the required aperture. One solution is to use an old manual focus lens with an aperture ring. Canon FD lenses are ideal for this—as they don't (normally) fit Canon EOS cameras, there's a plentiful supply of low-cost, pre-owned lenses.

To use a reversed lens, turn the mode dial on your camera to **M**, set the shutter speed you want to use, and then adjust the aperture ring until the correct exposure has been obtained.

> **Note:**
> Canon's FD manual focus lenses pre-date the EOS AF lens system and were ultimately replaced by it in 1987.

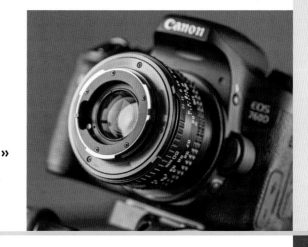

OTHER LENSES »
You don't need to stick to Canon lenses (or even EOS-fit lenses) when using a reversing ring. This is an old 50mm Minolta prime lens attached to an EOS Rebel T6s/760D.

Extension tubes (also known as extension rings) are hollow metal tubes that sit between the camera and a lens. This decreases the minimum focusing distance, increasing the magnification of the projected image.

Extension tubes from third-party manufacturers are often sold in sets of three rings of different lengths. These rings can be used separately or combined to create the maximum magnification. As there is no glass in an extension tube there is very little loss of image quality, regardless of how many rings are used.

The majority of third-party extension tubes don't maintain the electrical connection between the lens and the camera. This means that AF and aperture control are disabled.

However, Canon produces two extension tubes that retain full AF and aperture control of the lens: the EF 12II (a 12mm extension tube) and the RF/25II (which is a 25mm extension tube).

LENSES **«**
You can use extension tubes with any EOS lens, but the best results are generally achieved by attaching the tube to a prime lens. If you fit extension tubes to a macro lens you can extend the close-focusing capabilities of the macro lens.

» CLOSER STILL

The ultimate macro accessory for a DSLR is a set of bellows. These are similar in principle to extension tubes, but can be extended or compressed along a guide rail. This makes it easier to set the desired amount of magnification. This image, shot using bellows, was at a 4:1 magnification ratio—the component at the center of the image is approximately 2mm across.

Settings
> Focal length: 50mm (plus bellows)
> Aperture: f/16
> Shutter speed: 2.3 sec.
> ISO: 200

Macro photography is deceptively similar to "standard" photography, but it brings unique challenges. These require a certain amount of patience and a willingness to solve problems.

› Working distance

The working distance of a macro lens is the distance from the lens to the subject needed to achieve the required reproduction ratio. The longer the focal length, the greater the working distance: a 50mm macro lens has a working distance that is half that of a 100mm lens, and a quarter that of a 200mm lens at a 1:1 reproduction ratio.

The longer the working distance, the further back you can stay from your subject. For some subjects this is relatively unimportant, but if your subject is likely to be disturbed easily (an insect or animal for example), a longer working distance can be invaluable.

The downside of using a longer focal length macro lens is that they are inevitably heavier and more cumbersome. They are also far more expensive than macro lenses with a shorter focal length. Choosing a macro lens will therefore involve thinking about your budget and what your primary subjects are likely to be.

KEEPING BACK «
Air currents can disturb delicate subjects easily as you set up. Using a long focal length macro lens allows you to work from a greater distance, which will keep any disturbance to a minimum.

› Depth of field

Overall sharpness is relatively easy to achieve if your macro subject is flat and parallel to the camera. You could focus anywhere on the subject and achieve a satisfactory level of sharpness across the frame, even with a moderately small aperture. However, shoot a three-dimensional subject and keeping the entire subject sharp becomes harder. This is due to the limited depth of field caused by the short camera-to-subject distance. Even using a lens at its minimum aperture setting may not be enough.

Choosing an appropriate point of focus is therefore very important. Where the point of focus needs to be will depend on your subject. With insects or small animals this would most often be the eye, while the tips of the stamens is a good starting point when shooting flowers. Live View is particularly useful when focusing, as you can zoom into the Live View image to check that focus is accurate (switching to MF is also advised, as this will make it easier to fine tune the focus).

Because depth of field is so small, moving subjects can be difficult to deal with—it doesn't take much movement for the subject to drift out of focus. If your subject is blowing in the wind, try to shelter it with your body. You can also use Continuous shooting and AF Servo to expose a number of frames and edit the sequence later, deleting those images that don't have critical sharpness.

MOVEMENT »
This leaf bud was blowing about in a breeze. In order to keep it sharp, I combined a fast shutter speed with Continuous shooting and AF Servo, so the camera tracked the movement.

As depth of field is an issue when shooting macro photographs, you often need to use very small apertures. However, this typically means using a slow shutter speed (which risks blur if your subject is moving), or a high ISO setting (which affects image quality). A third option is to add more light, as close as possible to your subject.

The most obvious source of light is your camera's built-in flash, but this isn't ideal—the lens will invariably get in the way and cast a shadow on your subject. A better solution is to use off-camera flash, firing it via a cable connection or wirelessly.

Even more useful are ring lights. Ring lights "wrap" around the front of a lens creating a subtle and soft illumination for macro subjects. The Canon Macro Ring Lite MR-14EX is a ring flash designed specifically for this purpose.

Another solution is an LED ring light. This type of lighting is arguably easier to use than a flash. Because the light is constant, it's easier to see the effect of the light on your subject, and exposures are easier to calculate as your camera's standard exposure metering can be used. Canon doesn't produce an LED ring light, but they are readily available from third-party manufacturers.

BOUNCED ⌃
A useful accessory is a reflector, which can be used to "bounce" light into shadows, either to raise the overall light level or to even out contrast. Here, the top image was shot without a reflector, while the bottom image was created with a reflector (out of shot at the bottom), which has lightened the deep shadows.

» LIGHTING

The angle of illumination is important when shooting flat, but complex, subjects such as this fossil fish. Illuminating a subject from above will tend to flatten detail. Side lighting (from the left in this instance) helps to reveal detail by creating subtle, but important, highlights and shadows.

Settings
> Focal length: 100mm (macro lens)
> Aperture: f/16
> Shutter speed: 1/4 sec.
> ISO: 100

7 » MACRO LENSES

› Canon lenses

Canon currently produces six macro lenses that can be used on both the EOS Rebel T6s/760D and EOS Rebel T6i/750D. The lenses are all prime focal lengths; all but one offers a 1:1 (or better) reproduction ratio; and all but one can be used as a conventional lens for non-macro photography as well.

The EF-S 60mm f/2.8 Macro USM is unique in that it's Canon's only macro EF-S lens. This means that it can only be fitted to cropped-sensor cameras such as the EOS Rebel T6s/760D and EOS Rebel T6i/750D.

The quirkiest of Canon's macro lenses is the MP-E 65mm f/2.8 1–5x Macro. This lens has a reproduction ratio of 5:1, allowing you to capture macro images that are five times life-size. A further quirk is that the lens is manual focus only and it cannot be used for general photography.

In 2009, Canon updated its popular EF 100mm macro lens by improving the optical system. As well as achieving L-lens status, the lens also has a new Image Stabilization system (Hybrid IS), which is designed to be effective when shooting macro (this is not necessarily something that applies to older IS systems or those from other manufacturers). Both the original and updated 100mm lenses are currently available.

The largest, heaviest, and most expensive Canon macro lens is the EF 180mm f/3.5L Macro USM. With the longest working distance of all the Canon macros, this is the perfect lens when shooting subjects that are easily disturbed by your presence.

Note:
The sixth Canon "macro" lens is the EF 50mm f/2.5 Compact Macro. However, while it is described as a macro lens, it has a reproduction ratio of 1:2, so it is not a macro lens in the strictest sense.

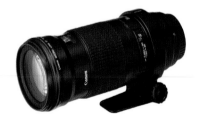

CANON EF 180MM F/3.5L ⌄

› Third-party lenses

Third-party lens manufacturers also produce macro lenses that are compatible with Canon's EOS lens mount. The grid below shows the current range of lenses produced by Samyang/Rokinon, Sigma, Tamron, and Tokina.

Lens	Minimum focus distance (cm)	Reproduction ratio	Filter thread size (mm)	Dimensions (diameter x length; mm)	Weight (g)
Samyang/Rokinon					
100mm f/2.8*	30	1:1	67	73 x 123	720
Sigma					
50mm f/2.8 EX DG	19	1:1	55	71 x 64	320
70mm f/2.8 EX DG	25	1:1	62	76 x 95	527
105mm f/2.8 APO EX DG OS HSM	31	1:1	62	78 x 126	725
150mm f/2.8 EX DG OS HSM	38	1:1	72	80 x 150	1150
Tamron					
60mm f/2 Di II LD SP AF	23	1:1	55	73 x 80	390
90mm SP f/2.8 SP Di	29	1:1	55	72 x 97	405
180mm f/3.5 SP Di	47	1:1	72	85 x 166	920
Tokina					
35mm f/2.8 AT-X PRO DX	14	1:1	52	73 x 60	340
100mm f/2.8 AT-X	30	1:1	55	73 x 95	540

* Manual focus only

⑧ CONNECTION

To see the images you shoot at a larger size than is possible on your camera's LCD screen, you'll eventually need to copy them to a computer, prepare them for print, or display them on a television. This means that your camera (or memory card) will need to make connections.

› Color calibration

When you shoot, you will (hopefully) be exposing your photographs carefully and setting the white balance as precisely as possible. However, once your images are on a computer, you won't be able to assess and adjust an image with any degree of accuracy unless your monitor is calibrated.

There are several ways to calibrate a monitor. The most precise way is to use a hardware-based color calibrator. These devices are relatively inexpensive and are particularly useful if you intend to print your images. Combined with accurate profiles for your printer, calibrators can soon pay for themselves by saving on wasted print paper.

A cheaper way to calibrate your monitor is to use a software-based calibrator, such as Display Color Calibration (Windows) or Display Calibrator Assistant (Mac OS X). Although software calibration is less accurate than using a hardware calibrator it is better than no calibration at all. As the tools come with your operating system, there is also no cost involved, so you have nothing to lose.

SOFTWARE ⌃
Display Calibrator Assistant on an Apple Mac.

DERELICT »
Connecting your camera means having access to an electricity supply and possibly a Wi-Fi hotspot. These aren't always readily available when you are out in the field.

» CANON SOFTWARE

Both the EOS Rebel T6s/760D and EOS Rebel T6i/750D are supplied with Digital Photo Professional, EOS Utility, and Picture Style Editor on the EOS DIGITAL Solution Disk. You can ignore this software and use third-party alternatives, such as Adobe Lightroom, but don't be too quick to dismiss Canon's offerings. There is not enough space to provide an in-depth guide to the software here, but Canon supplies comprehensive manuals in PDF format on the disk that came with your camera. To install the software, follow the instructions below.

Installing on Windows:

1) Log on as normal (or as Administrator if required to do so to install software).

2) Insert the Canon CD-ROM disk into your computer's CD-ROM drive.

3) The Canon software installation screen should appear automatically. Click on **Easy Installation** to automatically install all the software, or choose **Custom Installation** if you want to select which programs you install. Follow the on-screen instructions.

4) When the installation is complete, click on either **Finish** or **Restart** as required.

5) Remove the CD-ROM.

> ## Warning!
>
> The software is only compatible with Windows 7, 8, and 8.1, and Intel Mac OS X 10.8–10.10.
>
> Uninstall any previous versions of ZoomBrowser or ImageBrowser from your PC before installing the new software.

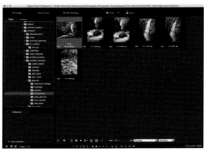

DIGITAL PHOTO PROFESSIONAL ⌃
DPP running on Mac OS X.

Installing on Mac OS X:

1) Log on as normal (or as Administrator if this is necessary to install software).

2) Insert the Canon CD-ROM disk into the CD-ROM drive.

3) Double-click on the CD-ROM icon on your Mac's desktop.

4) Double-click on **Setup**. The Canon software installation screen should now appear. Follow the on screen instructions to select your geographical region and country. On the "Selecting an Installation Type" screen, click on **Easy Installation** to automatically install all the software on the disk, or click **Custom Installation** to choose which programs to install. Follow the on-screen instructions to continue.

5) When the installation is complete, click on **Restart** (your Mac must be rebooted before you can begin using the software).

6) Once your Mac has rebooted, the installed software can be found in the "Applications" folder of your hard drive, with launch icons added automatically to the dock.

Notes:
The latest iMacs don't have optical drives. This means you will need to download and install the software from your local Canon web site, or purchase an external optical drive.

You can register for CANON iMAGE GATEWAY during installation. This is a free service that allows you to post your images and videos online for other members to view. There are also technique articles to read and benefits such as free shipping when products are bought through Canon's online store.

INSTALLATION ⌃
Installing DPP on Mac OS X.

Digital Photo Professional

Digital Photo Professional (DPP) is most useful for editing and converting your camera's .CR2 Raw files and then saving them as either a JPEG or TIFF, or transfering the files directly to Adobe Photoshop. If you've set Dust Delete Data (see chapter 3) you can also use DPP to automatically clone out dust spots.

EOS Utility

This utility enables you to import your images from your camera onto your computer, or organize the images on the memory card. It can also be used to capture images directly onto your computer when your camera is attached. EOS Utility (and the EOS Lens Registration Tool) must also be installed if you want to change the registered lenses available on your camera when selecting **Lens aberration correction** on ⚫.

Picture Style Editor

Picture Styles can be edited, saved, and then copied to your camera for use when shooting JPEGs.

PICTURE STYLE EDITOR «
Picture Style Editor allows you to create and save your own Picture Styles.

» CONNECTING TO A PC

1) Attach the USB cable to the A/V OUT terminal in the side of your camera.

2) Insert the other end of the USB cable to a USB port on your computer.

3) Turn your camera on.

4) On Windows PCs, click on **Download Images From EOS Camera using Canon EOS Utility**. Canon EOS Utility should now automatically launch. Check **Always do this for this device** if you want to make this a default action when you connect your camera. On Mac OS X, Canon EOS Utility should run automatically when the camera is attached.

5) Follow the on-screen instructions on Canon EOS Utility.

6) Quit Canon EOS Utility when you're finished, turn your camera off, and unplug it from your computer.

> ### Warning!
>
> Before connecting your camera to your computer, install the Canon software and make sure that the camera is switched off and the battery is fully charged.

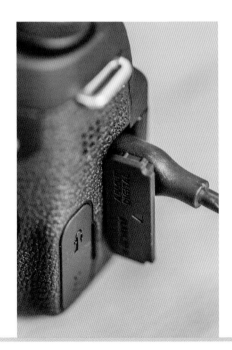

USB PORT »
Your camera's A/V OUT terminal is behind the cover on the left side your camera.

Tethered shooting allows you to view a Live View image on your computer's monitor, make adjustments to the camera via your PC, and then shoot remotely. The resulting image is then transferred directly to your computer, rather than to a memory card. The drawback is that you're limited to shooting within a USB cable's range of a computer.

Enabling tethered shooting

1) Connect your camera to your computer, as outlined previously.

2) Launch EOS Utility (if it doesn't automatically launch) and click on **Camera Setting/Remote Shooting**.

3) Click **Preferences** and select **Destination Folder** from the pop-up menu (Mac) or tab (Windows) at the top of the dialog box. Select the folder that you want your images to be saved to. Alter the other settings as desired.

4) Select **Linked Software** from the pop-up menu (Mac) or tab (Windows) at the top of the dialog box. Select the software that you want to use to edit your images.

5) Click **OK** to continue.

6) Click the **Live View shoot...** button to see the camera's output on your computer's monitor.

7) Adjust settings such as **White Balance** and **Focus** as required. These are found at the right and below the Live View window.

8) Click on the software shutter-release button to capture the image.

> **Note:**
> Tethered shooting requires EOS Utility to be installed on your PC.

EOS UTILITY «
Tethered shooting is less straightforward to do on location, but it is not impossible.

» WI-FI

With built-in Wi-Fi, neither the EOS Rebel
T6i/750D nor the EOS Rebel T6s/760D need
a cable to transfer files from the camera to
a computer. In fact, you don't even need a
computer—if you have a wireless-enabled
device, such as a smartphone or tablet, you
can connect wirelessly to those, and with a
suitable app you can copy files and control
your camera using the device. Canon has
also released the Wi-Fi-enabled Canon
Connect Station CS100, which has a built-
in 1TB hard drive for storing photos.

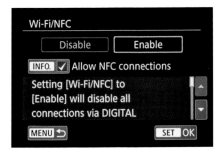

Enabling Wi-Fi
1) Select **Wi-Fi/NFC** from the ♻ menu.

2) Select **Enable** to turn Wi-Fi on. If you
take your camera into an area where
a Wi-Fi-enabled device wouldn't be
welcome (such as a hospital or on an
aircraft) set Wi-Fi to **Disable**.

3) Press **INFO.** to activate NFC connections.
Press MENU to return to the ♻ menu.

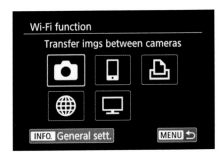

4) Select **Wi-Fi function**.

5) The first time you view **Wi-Fi function**
you'll be prompted to enter a nickname.
The text entry system works in the same
way as entering your copyright details
(see pages 145–146). If you want to change
the nickname at a later date, press **INFO.** to
view the **General sett.** screen after you've
selected **Wi-Fi function**.

6) Select one of the five options on
the **Wi-Fi function** screen: **Transfer
images between cameras**; **Connect to
smartphone**; **Print from Wi-Fi printer**;
Upload to Web service; or **View images
on DLNA devices**. Select the appropriate
function and follow the instructions given
on screen.

› Wi-Fi function

› NFC

If you're interested in controlling your camera remotely, the most useful function on the **Wi-Fi function** screen is the **Connect to smartphone** option. To make the most of this option you'll need to download the free Canon Camera Connect app produced by Canon. This app is available for Apple iOS and Android devices. Once installed, you can view a Live View feed from your camera on your device, set shooting functions, and make exposures.

After you have made an exposure, you can use your device to browse the pictures on the camera's memory card and copy them to your device (the images will be automatically shrunk to suit the size of your device's screen). However, you cannot copy movie files to your device (although this is unsurprising, as movie file sizes are generally far larger than still images and would require far longer to transmit, even with a fast connection).

NFC stands for Near Field Connection and is a new way to connect two devices wirelessly. In the base of both the EOS Rebel T6s/760D and the EOS Rebel T6i/750D is an NFC connection point, which is indicated by the ℕ icon. By bringing this connection point in close proximity to another NFC-compatible device, such as Canon's Connect Station CS100 and most modern smartphones, a connection will be established (once you've enabled NFC connection on both your camera and the device). You can then use Camera Connect as described left.

CANON CAMERA CONNECT »
Canon Camera Connect enables you to control your camera using an app on an iOS or Android device.

» EYE-FI

Eye-Fi is a proprietary type of SD memory card with a built-in Wi-Fi transmitter. This allows you to transfer files between your camera and a Wi-Fi enabled computer or hosting service. To set up the Eye-Fi card, check the manual that came with your card before use: for more information about Eye-Fi, go to www.eye.fi.

Enabling Eye-Fi
1) Press MENU and select **Eye-Fi settings** from the ♥ menu.

2) Set **Eye-Fi trans.** to **Enable** (when **Eye-Fi trans.** is set to **Disable**, the Eye-Fi card won't automatically transmit your files and 🛜 will be shown).

3) Shoot a picture. The Eye-Fi symbol will turn from a gray 🛜 to one of the icons shown below. When an image has been transferred, 🖾 will be displayed on the shooting information screen.

Displayed symbol	Status
🛜 [GRAY]	Not connected
🛜[BLINKING]	Connecting
🛜 [SOLID WHITE]	Connection to access point established
🛜(↑)	Transferring

Checking an Eye-Fi connection
1) Press MENU and select **Eye-Fi settings** from the ♥ menu.

2) Select **Connection info.** to display the connection information screen.

3) Press MENU to return to the main **Eye-Fi settings** menu.

> **Notes:**
> When using an Eye-Fi memory card your camera's battery may be depleted more quickly than usual.
>
> **Eye-Fi settings** only appears on the ♥ menu when an Eye-Fi card is installed in the camera.
>
> **Auto power off** is disabled during file transfer.

Both the EOS Rebel T6s/760D and EOS Rebel T6i/750D can be connected to either analog or HD televisions. What isn't supplied with either camera is the necessary RCA video cable for use with an analog TV, or the Type C mini-pin HDMI cable for connection to an HDTV set. Canon supplies the former (AVC-DC400ST) through their usual outlets; the latter can be found readily in good consumer electronics stores.

Connecting to an analog TV

1) Ensure that both your camera and TV are switched off.

2) Open the camera's rear terminal cover and plug the AV cable plug into the A/V OUT port.

3) Plug the three RCA plugs into the relevant connections on your television, matching the plug color to the connection color. If the connectors on your TV are not color coded, check the television's instruction manual before proceeding.

4) Turn on your TV and set it to the correct channel for external devices.

5) Turn your camera on and press the ▶ button. The image from the camera should now be displayed on the TV, rather than the camera's LCD screen.

6) When you have finished, turn off both the camera and television before disconnecting the AV cable.

> **Note:**
> Be sure to set **Video system** on ❖ to the correct setting for your geographical region.

CONNECTED ❯❯
RCA plugs are color-coded: yellow for video, and white and red for the left and right audio inputs respectively.

Connecting to an HDTV

1) Ensure that both your camera and TV are switched off.

2) Open your camera's rear terminal cover and connect the HDMI cable plug to the HDMI OUT port.

3) Plug the other end of the HDMI cable into a free port on your TV.

4) Turn on your TV and switch to the correct channel for external devices.

5) Turn your camera on and press ▶ to view your images on the HDTV.

6) When you are finished, turn off both the camera and TV before disconnecting the HDMI cable.

› HDMI TV remote control

If your television is compatible with the HDMI CEC standard, you can use the TV's remote to control the playback function on your camera.

1) Follow steps 1–5 above to connect your camera to an HDTV.

2) Use the TV remote's ◄ / ► buttons to select the desired option displayed on the TV. If you select **Return** and then press **Enter** you will be able to use the remote's ◄ / ► buttons to skip through images on your camera.

Menu options

↰	Return
⊞	9 image index
▶🎞	Play movie
⊕	Slide show
INFO.	Show image shooting information
⟲	Rotate

Note:
Set **Ctrl over HDMI** on 🖵 to **Enable** if you want to use your HDTV's remote to control your camera.

HDMI ⌃
TVs often have multiple HDMI ports. Switch to the correct auxiliary device on your TV to see the image from your camera.

You can connect the EOS Rebel T6s/760D and EOS Rebel T6i/750D directly to a PictBridge compatible printer, so you can print still images without the need for a computer. Both cameras are supplied with the required USB cable.

Connecting to a printer

1) Check that the camera battery is fully charged before starting to print.

2) Ensure that both the camera and printer are switched off. Insert the memory card of images you want to print into your camera if it is not already installed.

3) Open your camera's rear terminal cover and connect the supplied USB cable to the A/V OUT port.

4) Connect the cable to the printer, following the instructions in the manual supplied with the printer.

5) Turn on the printer, followed by your camera. Press ▶ on the camera. The PictBridge icon will be displayed at the top left corner of the LCD to indicate that a connection has been made successfully.

6) Press ◀ / ▶ to find the image you want to print, and then press (SET).

7) The print options screen will now appear (see opposite). Set the required options, followed by **Print**. Printing should now begin.

8) Repeat steps 6 and 7 to print out additional images.

9) Turn off your camera and printer and disconnect the USB cable.

Notes:
The available settings will depend on your printer.

Some printers have slots for SD memory cards. Images can therefore be printed by removing the card from your camera and plugging it directly into the printer. Both JPEG and Raw files can be printed when the camera is connected to a printer via a USB cable. However, only JPEGs can be printed when using a printer's memory card slot.

Printing effect	Description
☺ On	Print will be made using the printer's standard setup. Automatic correction will be made using the image's shooting metadata (EXIF).
☺ Off	No automatic correction applied.
☺ Vivid	Greens and blues are more saturated.
☺ NR	Noise reduction is applied before printing.
B/W B/W	Black-and-white image is printed with neutral blacks.
B/W Cool tone	Black-and-white image is printed with bluish blacks.
B/W Warm tone	Black-and-white image is printed with yellowish blacks.
◙ Natural	Prints an image with natural colors.
◙ Natural M	Finer control over colors than ◙ Natural.
☺ Default	Printer dependant (see your printer manual for details).
INFO. ▤	Press **INFO.** to apply Brightness, Levels, ☀ Brightener, and Red-eye correction when available.
Date /File No. imprinting	Choose between overlaying the date, file number, or both on the print.
Copies	Specify the number of prints to made.
Cropping	Allows you to trim and rotate your image before printing.

Paper settings	Description
Paper size	Select the size of the paper loaded in the printer.
Paper type	Select the paper type.
Page layout	Select how the image will look on the printed page.

Page layout	Description
Bordered	The print will be made with white borders.
Borderless	The print will go to the edge of the page if your printer supports this facility.
Bordered ⓘ	Shooting information will be imprinted on the border of prints that are 9 x 13cm or larger.
xx-up	Print 2, 4, 8, 9, 16, or 20 images on a single sheet.
20-up ⓘ 35-up ▢	20 or 35 images will be printed as thumbnails on A4 or Letter-sized paper. 20-up ⓘ adds shooting information.
Default	Your printer's default settings will be used.

If you've shot a selection of JPEG images, you can prepare these for printing using DPOF (Digital Print Order Format). DPOF adds instructions to your camera's memory card that can be read and acted upon by a compatible printer or by a photographic printing service. These instructions include which images to print, how many of each image to print, and whether the shooting date and/or the file name should be overlaid on the image.

Once DPOF instructions have been added to the memory card you either plug the memory card directly into a compatible printer or take it to your chosen photographic printing service to get your images printed.

Setting DPOF

1) Press MENU, navigate to ▶, and select **Print order**.

2) Select **Set up**.

3) Set the **Print type** by choosing **Standard** for a normal print, **Index** for a sheet of thumbnails, or **Both**.

4) If you set **Date** to **On**, the date your images were taken will be added on your prints; select **Off** if you don't want the date to appear.

5) Set **File No.** to **On** if you want the image file numbers added to your prints; select **Off** if this is not necessary.

6) Press MENU to return to the **Print order** menu screen.

Marking all images in a folder for printing

1) Open the **Print order** screen and select By ▉.

2) Select **Mark all in folder**, followed by the required folder. Select **OK** to continue. A print order for one copy of each compatible image in the folder will be set.

3) To clear the print order, select **Clear all in folder**. Choose the required folder, followed by **OK**.

Marking all images for printing

1) Open the **Print order** screen and select **All image**.

2) Choose **Mark all on card**, followed by **OK**. A print order for one copy of each compatible image on the memory will be set.

3) To clear the print order select **Clear all on card**, followed by **OK**.

Print ordering individual images

1) Select **Sel. Image** from the **Print order** screen and turn either ⚙ or press ◀ / ▶ to skip between the images on the memory card. To view three images at once press ▦ / ⊖; to view a single image press ⊕.

2) If you selected **Standard** from the **Set up** menu (see page 238), press (SET) followed by ◀ / ▶ to set the number of prints to be made from the currently displayed image.

3) If you selected **Index** from the **Set up** menu, press (SET) to add the currently displayed image to the DPOF instructions to be printed in index form. An ✔ in the box next to the ⚟ icon indicates that the image has been selected. Press (SET) to deselect it again if required.

4) Repeat as required from step 2, and then press MENU to return to the main **Print order** menu screen.

Direct printing

If your camera is connected to a PictBridge printer, select **Print** from the **Print order** menu screen (note that the **Print** option *only* appears when you connect the camera to a PictBridge printer. Follow the on-screen instructions and the printer will print according to the DPOF instructions you have set.

» LEARNING TO SEE

A camera is a tool that teaches you to look at the world around you. For that reason, it's good to get into the habit of carrying your camera with you whenever you can. This shot was created on a country walk shortly after a rainstorm. I'd have regretted missing the opportunity if I hadn't brought my camera with me.

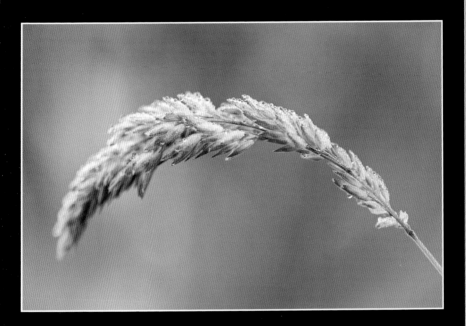

Settings
> Focal length: 100mm (macro lens)
> Aperture: f/2.8
> Shutter speed: 1/180 sec.
> ISO: 400

» GLOSSARY

Aberration An imperfection in a photograph, usually caused by the optics of a lens.

AEL (automatic exposure lock) A camera control that locks in the exposure value, allowing a scene to be recomposed.

Angle of view The area of a scene that a lens takes in, measured in degrees.

Aperture The opening in a camera lens through which light passes to expose the sensor. The relative size of the aperture is denoted by f-stops.

Autofocus (AF) A reliable through-the-lens focusing system allowing accurate focus without the photographer manually adjusting the lens.

Bracketing Taking a series of identical pictures, changing only the exposure, usually in ⅓-, ½-, or 1-stop increments.

Buffer The in-camera memory of a digital camera.

Center-weighted metering A metering pattern that determines the exposure by placing importance on the light meter reading at the center of the frame.

Chromatic aberration The inability of a lens to bring spectrum colors into focus at a single point.

CMOS (Complementary Metal Oxide Semiconductor) A type of imaging sensor, consisting of a grid of light-sensitive cells. The more cells, the greater the number of pixels and the higher the resolution of the final image.

Codec A piece of software that is able to interpret and decode a digital file.

Color temperature The color of a light source expressed in degrees Kelvin (K).

Compression The process by which digital files are reduced in size. Compression can retain all the information in the file ("lossless compression"), or it can discard data for greater levels of file-size reduction ("lossy compression").

Contrast The range between the highlight and shadow areas of a photo, or a marked difference in illumination between colors or adjacent areas.

Depth of field The amount of a scene in front of and behind the point of focus that appears acceptably sharp. Depth of field is controlled primarily by the aperture (the smaller the aperture, the greater the depth of field), but focal length and the camera-to-subject distance also play a part.

Diopter Unit expressing the power of a lens.

dpi (dots per inch) Measure of the resolution of a printer or scanner. The more dots per inch, the higher the resolution.

DPOF Digital Print Order Format.

Dynamic range The ability of the camera's sensor to capture a full range of shadows and highlights.

Evaluative metering A metering system where light reflected from several subject areas is calculated based on algorithms.

Exposure The amount of light allowed to hit the digital sensor, controlled by aperture, shutter speed, and ISO. Also, the act of taking a photograph, as in "making an exposure."

Exposure compensation A control that allows intentional over- or underexposure.

Fill-in flash Flash combined with daylight in an exposure. Used with naturally backlit or harshly side-lit or top-lit subjects to prevent silhouettes forming, or to add extra light to the shadow areas of a well-lit scene.

Filter A piece of colored or coated glass, or plastic, placed in front of the lens.

Focal length The distance, usually in millimeters, from the optical center of a lens to its focal point.

fps (frames per second) A measure of the time needed for a digital camera to process one photograph and be ready to shoot the next.

f-stop Number assigned to a particular lens aperture. Wide apertures are denoted by small numbers (such as f/1.8 and f/2.8), while small apertures are denoted by large numbers (such as f/16 and f/22).

HDR (High Dynamic Range) A technique that increases the dynamic range of a photograph by merging several shots taken with different exposure settings.

Histogram A graph representing the distribution of tones in a photograph.

Hotshoe An accessory shoe with electrical contacts that allows synchronization between a camera and a flash.

Hotspot A light area with a loss of detail in the highlights. This is a common problem in flash photography.

Incident-light reading Meter reading based on the amount of light falling onto the subject.

Interpolation A method of increasing the file size of a digital photograph by adding pixels, thereby increasing its resolution.

ISO The sensitivity of the digital sensor measured in terms equivalent to the ISO rating of a film.

JPEG (Joint Photographic Experts Group) JPEG compression can reduce file sizes to about 5% of their original size, but uses a lossy compression system that degrades image quality.

LCD (Liquid Crystal Display) The flat screen on a digital camera that allows the user to preview digital photographs.

Macro A term used to describe close focusing and the close-focusing ability of a lens.

Megapixel One million pixels is equal to one megapixel.

Memory card A removable storage device for digital cameras.

Noise Interference visible in a digital image caused by non-image-forming electrical signals during exposure.

PictBridge The industry standard for sending information directly from a camera to a printer, without the need for a computer.

Pixel Short for "picture element"—the smallest bit of information in a digital photograph.

Predictive autofocus An AF system that can continuously track a moving subject.

Raw The file format in which the raw data from the sensor is stored without permanent alteration being made.

Red-eye reduction A system that causes the pupils of a subject's eyes to shrink, by shining a light prior to taking the main flash picture.

Remote switch A device used to trigger the shutter of the camera from a distance, to help minimize camera shake. Also known as a "cable release" or "remote release."

Resolution The number of pixels used to capture or display a digital photo.

RGB (red, green, blue) Computers and other digital devices understand color information as combinations of red, green, and blue.

Rule of thirds A rule of composition that places the key elements of a picture at points along imagined lines that divide the frame into thirds, both vertically and horizontally.

Shutter The mechanism that controls the amount of light reaching the sensor, by opening and closing.

Soft proofing Using software to mimic on screen how an image will look once output to another imaging device. Typically this will be a printer.

Spot metering A metering pattern that places importance on the intensity of light reflected by a very small portion of the scene, either at the center of the frame or linked to a focus point.

Teleconverter A supplementary lens that is fitted between the camera body and lens, increasing its effective focal length.

Telephoto A lens with a large focal length and a narrow angle of view.

TIFF (Tagged Image File Format) A universal file format supported by virtually all relevant software applications. TIFFs are uncompressed digital files.

TTL (through the lens) metering A metering system built into the camera that measures light passing through the lens at the time of shooting.

USB (universal serial bus) A data transfer standard used by most digital cameras and other peripherals when connecting to a computer.

Viewfinder An optical system used for composing and sometimes for focusing the subject.

White balance A function that allows the correct color balance to be recorded for any given lighting situation.

Wide-angle lens A lens with a short focal length and, consequently, a wide angle of view.

» USEFUL WEB SITES

CANON

Canon Worldwide
www.canon.com

Canon US
www.usa.canon.com

Canon UK
www.canon.co.uk

Canon Europe
www.canon-europe.com

Canon Middle East
www.canon-me.com

Canon Oceania
www.canon.com.au

GENERAL

David Taylor
Landscape and travel photography
www.davidtaylorphotography.co.uk

Digital Photography Review
Camera and lens review site
www.dpreview.com

Photonet
Photography discussion forum
www.photo.net

EQUIPMENT

Adobe
Image-editing software (Photoshop,
Photoshop Elements, and Lightroom)
www.adobe.com

Apple
Hardware and software manufacturer
www.apple.com

Sigma
Third-party lens manufacturer
www.sigma-photo.com

Tamron
Third-party lens manufacturer
www.tamron.com

Tokina
Third-party lens manufacturer
www.tokinalens.com

PHOTOGRAPHY PUBLICATIONS

**Photography books &
Expanded Camera Guides**
www.ammonitepress.com

Black & White Photography magazine
Outdoor Photography magazine
www.thegmcgroup.com

» INDEX